A Picasso Portfolio

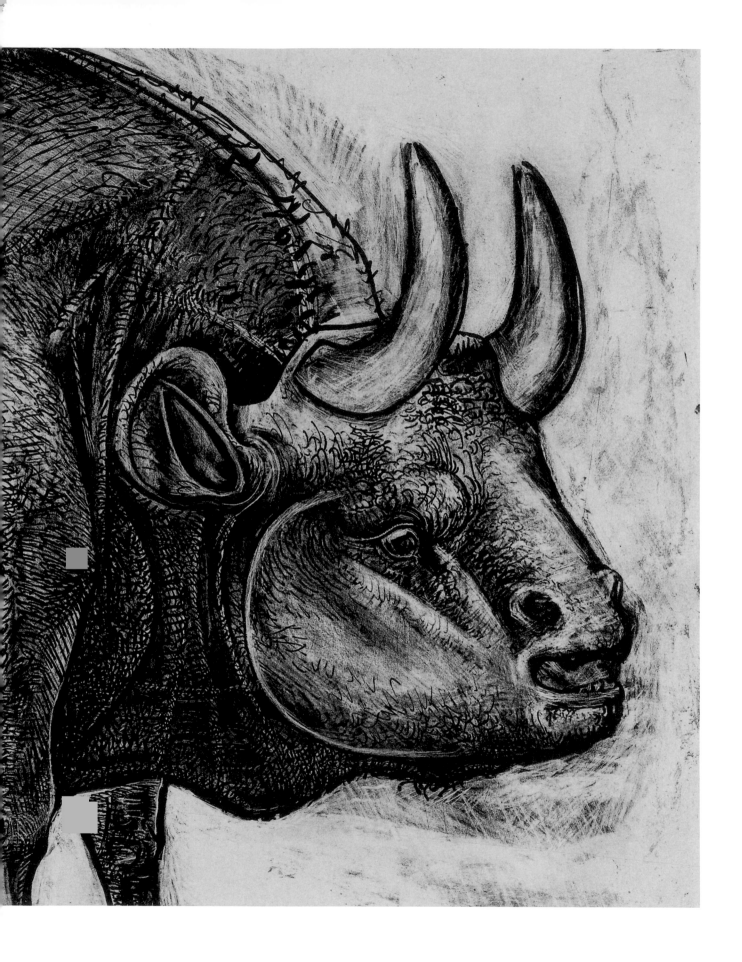

DEBORAH WYE

A Picasso Portfolio

PRINTS *from*
THE MUSEUM *of* **MODERN ART**

The Museum of Modern Art, New York

Published in conjunction with the exhibition *Picasso: Themes and Variations*, organized by Deborah Wye, The Abby Aldrich Rockefeller Chief Curator, Department of Prints and Illustrated Books, at The Museum of Modern Art, New York, March 24–September 6, 2010

Generous support for this publication is provided by the Research and Scholarly Publications Program of The Museum of Modern Art, which was initiated with the support of a grant from The Andrew W. Mellon Foundation. Publication is made possible by an endowment established by The Andrew W. Mellon Foundation, the Edward John Noble Foundation, Mr. and Mrs. Perry R. Bass, and the National Endowment for the Humanities' Challenge Grant Program.

Produced by the Department of Publications, The Museum of Modern Art, New York

Edited by Diana Stoll
Designed by Amanda Washburn
Production by Christopher Zichello
Printed and bound by Trifolio S.R.L., Verona, Italy

This book is typeset in Fedra Serif and Fedra Sans. The paper is GardaPat Kiara.

Published by The Museum of Modern Art,
11 W. 53 Street, New York, New York 10019

© 2010 The Museum of Modern Art, New York

Distributed in the United States and Canada by D.A.P./ Distributed Art Publishers, Inc., New York
Distributed outside the United States and Canada by Thames & Hudson Ltd, London

Library of Congress Control Number: 2009940254
ISBN: 978-0-87070-780-3

Printed in Italy

Photograph Credits

All works by Pablo Picasso: © 2010 Estate of Pablo Picasso/Artists Rights Society (ARS), New York.

The Museum of Modern Art, New York, Digital Imaging Studio. Rob Gerhardt: plates 41, 62, 63, 69, 74–77, 97, 99, 118, 133, 137; figs. 3, 4, 17, 20. Thomas Griesel: plates 27, 30, 37, 38, 55, 56, 59, 66, 67, 100, 116, 121–26, 132; fig. 15. Kate Keller: plates 42, 58, 131, 134; figs. 1, 2, 10, 11, 13, 21, 29. Paige Knight: figs. 31, 36. Jonathan Muzikar: plates 2–9, 12–14, 16–26, 28, 29, 32, 33, 36, 39, 40, 44–54, 68, 70, 78–91, 93–96, 98, 101, 103–5, 119, 120, 127–30, 135, 136; figs. 5–7, 16, 18, 23–25, 27, 30. Mali Olatunji: plate 102; figs. 14, 28. John Wronn: plates 1, 10, 11, 31, 34, 35, 43, 57, 60, 61, 64, 65, 71–73, 92, 106–14, 117; figs. 9, 12, 22.
　　© 2009 Artists Rights Society (ARS), New York/ ADAGP, Paris: fig. 12.
　　© Bildarchiv Preussischer Kulturbesitz/Art Resource, N.Y. Photograph: Joerg P. Anders: fig. 32.
　　© Kunsthistorisches Museum, Vienna: fig. 33.
　　© Réunion des Musées Nationaux/Art Resource, N.Y. Photograph: Hervé Lewandowski: fig. 34.
　　© Réunion des Musées Nationaux/Art Resource, N.Y. Photograph: Gérard Blot: fig. 35.

Front cover: *Face of Marie-Thérèse* (detail). c. October 1928. Lithograph. Composition: 8 x 5 9/16" (20.3 x 14.1 cm). See plate 93

Back cover: *Head of a Woman No. 5. Dora Maar* (detail). January–June 1939. Aquatint and drypoint. Plate: 11 3/4 x 9 3/8" (29.8 x 23.8 cm). See plate 103

Frontispiece: *Bull*, state IV (detail). December 18, 1945. Lithograph. Sheet: 13 5/16 x 20 5/16" (33.8 x 51.6 cm). See plate 46

Contents

Foreword

Pablo Picasso is among the artists most closely associated with The Museum of Modern Art. We take great pride in our extraordinary collection of his paintings, sculptures, drawings, prints, and posters, as well as in the range of exhibitions we have mounted and the landmark studies undertaken by our curators. It was the Museum's founding director, Alfred H. Barr, Jr., who set the standard, beginning with a pioneering exhibition in 1939, which was followed with several other important shows. William S. Rubin, formerly Director of the Department of Painting and Sculpture, carried on that tradition with his own superb contributions to Picasso scholarship. And many other curators over the years have explored various facets of Picasso's oeuvre in both exhibitions and publications.

In many of the Museum's exhibitions of Picasso's work, the artist's prints have played an integral role. In addition, those mounted by William S. Lieberman and Riva Castleman, former heads of the print department, and their staffs have presented more focused views of the medium. All the while, the Museum's collection of Picasso's prints has grown, now numbering some 1,100 works and representing all facets of his career. Examples from that collection are regularly exhibited in the Paul J. Sachs Galleries for Prints and Illustrated Books, and also occasionally appear in the Museum's galleries devoted to painting and sculpture. In addition, Picasso's prints are available to the public (by appointment) through the Abby Aldrich Rockefeller Print Room.

When Deborah Wye assumed the role of Chief Curator in the Department of Prints and Illustrated Books, in 1996, among her early projects was the systematic assessment of the print collection. The Museum's holdings by Picasso were already outstanding. Yet she determined that the collection could be enhanced not only by filling gaps but also by keeping in view the artist's thematic series, as well as his creative process, which is particularly discernible through his printmaking. While Ms. Wye succeeded in acquiring major masterworks, such as the monumental *Weeping Woman* of 1937, she also has added numerous examples of Picasso's themes, and his evolving states and variants, all of which provide a fuller understanding of his remarkable creativity.

Ms. Wye was assisted in this Picasso study, and the accompanying exhibition, by a dedicated curatorial team within her department, as well as by a devoted Trustee Committee. That Committee is led by Edgar Wachenheim III, Chair; Harvey S. Shipley Miller, Vice Chair; and Joanne M. Stern and Anna Marie Shapiro, Chairs Emerita. This catalogue gives the Museum audience a broad sampling of Picasso's many accomplishments in printmaking, and Ms. Wye's thoughtful text adds immeasurably to our understanding of this work.

GLENN D. LOWRY
Director, The Museum of Modern Art

Acknowledgments

In the history of printmaking, there are only a few artists whose works constitute true hallmarks of the medium. Picasso is among that select group. His passion for printmaking grew as he realized its potential for expanding his creativity; he ultimately made approximately 2,400 prints. It has been a privilege to research The Museum of Modern Art's superlative collection of some 1,100 works by this master of the medium.

The staff of the Department of Prints and Illustrated Books shares my enthusiasm for Picasso's work. Over the years, we have assessed our holdings and determined collecting priorities. Our focus has been on illuminating Picasso's thematic approach and documenting his evolving compositions. Since I have been the department's Chief Curator, we have acquired thirty-eight prints by the artist. This volume presents a selection from MoMA's collection.

The scholarly literature on Picasso is vast, and Curatorial Assistant Emily Talbot was enormously helpful in locating books and keeping track of them. Ms. Talbot was, in fact, of great assistance on all aspects of the catalogue preparation, including constantly pulling prints from our storage area, and refiling them, as my study ensued. In addition, she served as assistant for the accompanying exhibition in the Paul J. Sachs Galleries for Prints and Illustrated Books.

Our Department Cataloguer, Caitlin Condell, was scrupulous in her documentation of Picasso's prints, and her thoroughness was indispensible. Assistant Curator Sarah Suzuki oversaw the staff for all catalogue preparations and also coordinated the accompanying website, which documents an even larger portion of MoMA's Picasso print collection. Jeff White, Preparator, showed his usual care with matting and framing, while Preparator Hooper Turner was also of help. Department administrators Sarah Cooper, Coordinator, and Gillian Young, former Assistant, were essential to our success. Interns who deserve thanks are John Beeson, Olivia DeCarlo, Megan McCarthy, Abbe Schrlber, and Kathleen Reckling.

Outside the print department, I owe thanks to Erika Mosier, Paper Conservator, and Robert Kastler, Imaging Services Production Manager. Christopher Hudson, Publisher, was most encouraging when I proposed this volume, and I thank him and Editorial Director David Frankel for their support. Amanda Washburn, Senior Book Designer, devised the sensitive organization of the texts and illustrations, and Marc Sapir, Production Director, handled a range of details, along with Christopher Zichello, who oversaw the book's printing. I am particularly grateful to Diana Stoll, the editor who so sympathetically read and improved the text. I would also like to thank the distinguished Picasso scholar Michael FitzGerald for serving as outside reader. Finally, appreciation goes to my husband, Paul Brown, for his longstanding patience and encouragement.

DEBORAH WYE
The Abby Aldrich Rockefeller Chief Curator,
Department of Prints and Illustrated Books

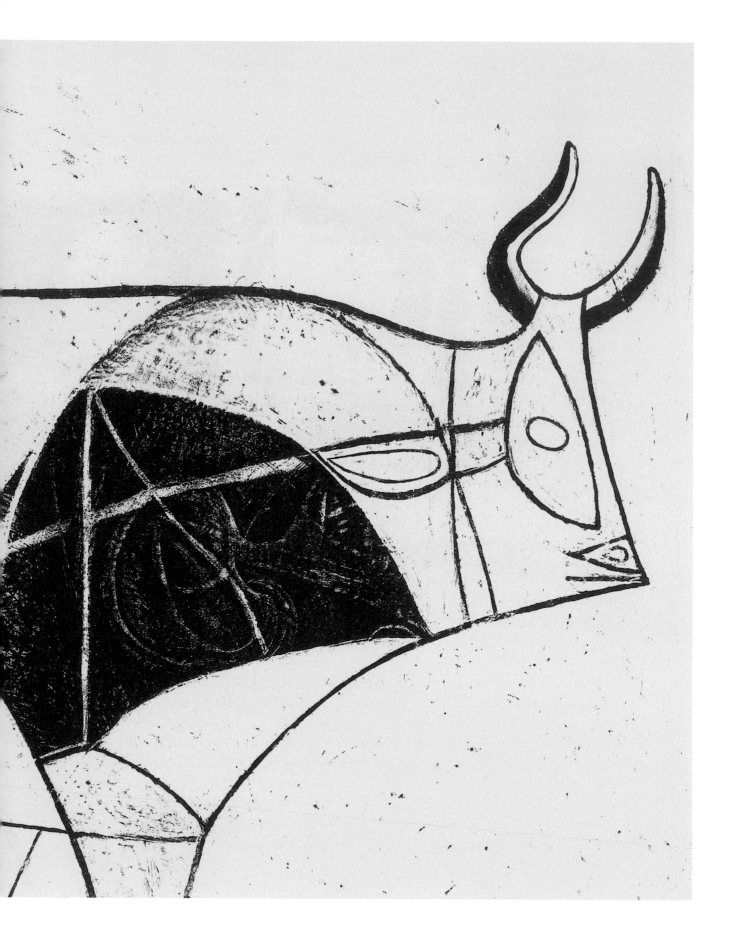

DEBORAH WYE

Introduction

Picasso's Printmaking

A CATALYST *for* CREATIVITY

"We are not merely the executors of our work; we *live* our work."
—Pablo Picasso[1]

Picasso's life and art were inseparable from the beginning. As a young man, after mastering what his artist father, José Ruiz y Blasco, could teach him, he set about finding the people, art, ideas, and practices that would continue to fuel his creativity. He was endlessly curious, always surrounding himself with a circle of engaging friends and lovers. Over the course of more than seven decades, he made use of his art to grapple with the joys and passions, tensions and fears of life. Often, his own psychological state provided the lens through which he saw the world around him, and that vision gave shape to his work.

OPPOSITE: *Bull*, state XI (detail). January 2, 1946. Lithograph. Composition: 12 $^7/_{16}$ x 19 $^3/_{16}$" (31.6 x 48.8 cm). See plate 50.

All works illustrated are from the collection of The Museum of Modern Art, unless otherwise noted.

Picasso also tirelessly investigated the terms and possibilities of artistic expression, his pictorial vocabulary extending from a vivid naturalism to a range of distorted and abstracted forms. He once said, "If the subjects I have wanted to express have suggested different ways of expression I have never hesitated to adopt them."[2] Consider, for example, two masterworks in very different styles, yet both created in the summer of 1921: *Three Women at the Spring* and *Three Musicians* (figs. 1 and 2).

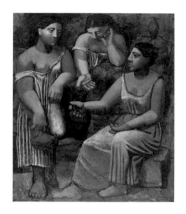

As a young man, Picasso learned from the art of his contemporaries, and also absorbed traditions of the past. He was further stimulated by his poet friends—among them Max Jacob and Guillaume Apollinaire. Picasso's rapports with people of poetic sensibilities encouraged his own sense of narrative and an approach to imagery that juxtaposed disparate forms and motifs. Beginning in the mid-1930s, he carried that poetic understanding over into writing his own verses, making a significant literary contribution.[3] And all along, in the spirit of camaraderie with his writer friends, he contributed prints to their publications.

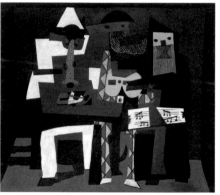

The women in Picasso's life constituted another important factor in his developing art. Each time he entered into a serious new relationship, there were bursts of creative activity and changes of direction, not only in subject matter, but also often in pictorial approach. He was inspired to investigate—indeed, to subsume into his artistic lexicon—the physical attributes and characters of the women in his life, but his manner of depicting them was often determined by his own changing emotional states. The features of these women, which Picasso knew so intimately, could also serve as departure points for what seem to be strictly formal investigations, as their likenesses disappear into a myriad of lines, shapes, and patterns. The various periods of his career are sometimes referred to by women's names—for example, the "Jacqueline Epoch," after Jacqueline Roque, the woman he met in 1953 and married in 1961.[4] Indeed, the biographical details of his personal relationships, with their cycles of happiness and turmoil, provide one valid point of entry for interpreting Picasso's art.

Certainly, contemporary and historical visual art also had an ongoing effect on Picasso. Among the artists who influenced his thinking, the most prominent was Georges Braque, his partner during the development and evolution of Cubism. In 1914, when World War I broke out, Picasso experienced a deep rupture when Braque (as well as Apollinaire) left for military service. Soon, however, he began to form a new group of friends, and to discover new creative trajectories. In 1917 he traveled to Italy for the first time, with Jean Cocteau, to meet the collaborators for the ballet *Parade*. The classical art Picasso encountered in Rome and Naples would be a touchstone in his work for decades to come. And in the

TOP: **FIG. 1.** *Three Women at the Spring.* 1921. Oil on canvas. 6' 8 ¹/₄" x 68 ¹/₂" (203.9 x 174 cm). Gift of Mr. and Mrs. Allan D. Emil, 1952

BOTTOM: **FIG. 2.** *Three Musicians.* 1921. Oil on canvas. 6' 7" x 7' 3 ³/₄" (200.7 x 222.9 cm). Mrs. Simon Guggenheim Fund, 1949

1920s and 1930s, Picasso's art and thinking moved in yet another direction, clearly drawn toward Surrealism—absorbing, as always, whatever he needed for his own expanding view.

It was only in the 1940s, when the art world's focus turned to various forms of abstraction, that Picasso's path became more singular. At that point, he also began to spend more time in the South of France, away from the intellectual and artistic currents of Paris. During the passing years, he was very aware of Abstract Expressionism, Pop art, Minimalism, and Conceptual art as they unfolded in the public arena, yet he kept to his own vision. Among the inspirations for Picasso's art in these later years were the old masters, from Diego Velázquez and Eugène Delacroix to Édouard Manet, Jean-Auguste-Dominique Ingres, and Edgar Degas—to name only a few whose work he turned to. These masters of the past became, in effect, Picasso's collaborators in the present.

The Role of Prints and Editions

Picasso's insatiable curiosity, combined with his constant need to create, led him to a variety of mediums beyond painting and drawing. He embraced sculptural techniques, from modeled plaster, welded steel, and assemblages of found objects to constructions of wood and metal. In the later 1940s, he began making ceramics and produced an extensive body of work in that medium. Printmaking was yet another catalyst for his creativity, especially as he interacted with master printers who continuously challenged him. In all, he made approximately two thousand four hundred prints. While the individual techniques—etching, lithography, linoleum cut—offered him distinct expressive possibilities, the issues he explored were never confined to a single medium. As he once confessed, "When I begin a series of drawings . . . I don't know whether they're going to remain just drawings, or become an etching or a lithograph, or even a sculpture."[5]

The first time Picasso undertook a series of printed images was in 1904–5, as his Blue period evolved into his Rose period. The primary subjects of that first sequence were the itinerant acrobats known as *saltimbanques*. Those prints were integral to the artist's development of this theme generally, and served to cross-fertilize related paintings and drawings.[6] At that time, Picasso asked a professional printer to make a certain number of impressions from his plates, perhaps hoping they could earn him some extra money; unfortunately, they were not a financial success, and many ended up as presents to friends. Only later were the Saltimbanque prints made into large editions, when art-dealer and publisher Ambroise Vollard—who had acquired the plates from the artist in 1911—published them in 1913. Well before that, in 1907, realizing prints could play a role in his artistic explorations, the artist had acquired a small printing press for himself.

Picasso, who appreciated printmaking for its potential to expand his developing art, was never particularly interested in the editioning aspect of the medium. His dealers, however, recognized a market for his prints and requested plates for editions. The artist usually agreed, either choosing from among print projects he was working on at the moment, or providing something he had created years before.[7] Still, a large number of prints remained uneditioned and unpublished at his death in 1973, when the plates and proofs were discovered in his studio.

In addition to their place in the art market, prints have a long history of spreading the word for social and political causes effectively, as they can be made in multiple examples. In the 1930s, at the time of the Spanish Civil War and the growing unrest across Europe, Picasso lent his printmaking talents to several such campaigns.[8] The most important resulting project is *The Dream and Lie of Franco* (*Sueño y mentira de Franco*), a portfolio containing two prints and a poetic text written by Picasso himself (fig. 3).[9] An edition of 850 examples was offered for sale at the Spanish Pavilion of the Paris World's Fair in 1937, to aid the Republican cause.[10] Picasso's masterwork *Guernica* was also installed there. Later in his career, particularly through his membership in the Communist party, Picasso made numerous posters for conferences advocating world peace.

The Print Publisher

Generally, prints are commissioned, editioned, and distributed by art dealers who function as publishers. Far less costly than paintings to acquire, prints can encourage buyers to initiate a collection that may later widen. Prints can also help garner interest in an unrecognized artist. Most often, however, they are commissioned after an artist has reached some level of renown, making his or her prints a reliable investment for the publisher. As noted, Picasso's early Saltimbanques series was editioned by Vollard nearly a decade after the works were created—by which time the artist was known. But later, beyond their potential for sales, commissions from Vollard and others impelled Picasso to explore printmaking to a degree he might not have done on his own.

Daniel-Henry Kahnweiler, the dealer who most strongly championed Cubism, had begun collecting prints as a young man, and was a great admirer of the medium. He also appreciated Vollard's approach to publishing illustrated books that included prints by painters rather than professional illustrators. Committed to avant-garde literature as well as visual arts, Kahnweiler brought together like-minded authors and artists for his own publications. In 1910 he invited Picasso to illustrate *Saint Matorel*, by Max Jacob; this was followed

FIG. 3. *The Dream and Lie of Franco* (plate II). 1937. Etching and aquatint. Plate: 12 $^3/_8$ x 16 $^5/_8$" (31.5 x 42.2 cm). The Louis E. Stern Collection, 1964

by other print commissions for the artist, but that practice was halted in 1914 by the out-break of World War I, which necessitated that Kahnweiler, a German citizen, flee France. When the war ended four years later, the dealer returned to Paris and continued occasion-ally to publish prints by Picasso. It was, however, only after World War II (during which the dealer was again forced to leave the country) that Kahnweiler became Picasso's primary print publisher; he would remain so for the rest of the artist's life.[11]

But the true turning point for Picasso's printmaking came with two illustrated books initiated in the late 1920s and appearing within a week of each other in 1931. One, commissioned by Vollard, involved illustrations for Honoré de Balzac's *Le chef-d'œuvre inconnu* (*The Unknown Masterpiece*).[12] This story of an old painter in search of absolute beauty must have captivated Picasso, who had a perennial interest in the subject of the artist in his studio. As was often the case with his book illustrations, however, not all the images relate to Balzac's story, although several do show allegorical depictions of an artist's work-space. In a concurrent project, instigated by the young Swiss-born publisher Albert Skira, Picasso illustrated stories from Ovid's *Metamorphoses*.[13] With prints in a linear style akin to that found in Greek vase painting and Etruscan mirror designs, that book is considered an important part of Picasso's broader involvement with classicism.[14] Both the Vollard and the Skira publications gave Picasso the opportunity to explore narrative elements in his printmaking. From such experiences, he began to see the copperplate and the attendant tools as well suited to telling stories with a sequential component. Much later, near the end of his life, Picasso would acknowledge this role for printmaking, characterizing it as his own way of "writing fiction."[15]

Around this time, the artist also began a series of one hundred prints that would come to be known as the Vollard Suite. It likely came about in a trade: Picasso wished to acquire paintings by Paul Cézanne and Auguste Renoir that were in Vollard's possession, and created the series in exchange for them.[16] These prints were editioned just before the dealer's death, in 1939, but languished in his estate until transferred to other dealers. No matter what Vollard's intentions might have been for the individual prints (some seem to have been meant to accompany texts)[17]—the group as a whole, with their interlocking narratives, represents a milestone in Picasso's printmaking.[18] With this series, Picasso also began scrupulously dating his prints, with the idea that they constituted a kind of chron-icle of his process. As he said, "It is not sufficient to know an artist's works—it is also nec-essary to know when he did them, why, how, under what circumstances."[19]

The Master Printer

Picasso's camaraderie with master printers was a vital factor in his embrace of printmaking, as they possessed the technical expertise needed for any innovative approach to the medium.[20] The first printer with whom he had contact was Auguste Delâtre, whose reputation as a premier craftsman had been established in the nineteenth century. When the elderly printer died, Picasso worked for a time with his son, Eugène. Picasso also came to know Louis Fort, a favorite printer of Vollard's and employed by the dealer for his publications. Over the years, Fort and Picasso became close friends, though the two never had a truly collaborative relationship in the workshop. When Fort retired, in the early 1930s, Picasso bought his printing press, which he moved to his various studios over the years. Once, when showing it to a friend, he betrayed his deep affection for even the accoutrements of printmaking: "It's beautiful, isn't it?" he noted reverently. "Almost a museum piece. . . . It used to belong to Louis Fort, the printer. . . . I loved this press, so I bought it."[21]

Though Picasso greatly respected these men, neither the Delâtres nor Fort succeeded in igniting any real adventurousness in his printmaking. But when he began working closely with printer Roger Lacourière, in 1934, Picasso was truly inspired by the potential of the intaglio techniques (engraving, etching, drypoint, and aquatint).[22] Creative sparks flew between the artist and Lacourière, who had no compunction about challenging Picasso. Lacourière led the way, particularly with his specialty, aquatint, which creates tone rather than line. Using a technique known as "sugar-lift," Picasso was able to brush onto his copperplates, in much the same way as when making a composition in watercolor on paper (fig. 4). Lacourière also encouraged him to manipulate techniques in new ways, and Picasso created prints with a complexity and nuance not seen before in his work (fig. 5).

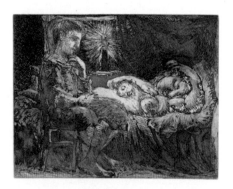

Now excited about the broad possibilities of printmaking, Picasso sought collaborative relationships with other printers. In November 1945, when he began to make lithographs at the Paris workshop of Fernand Mourlot, he became acquainted with a team of artisan printers, and worked closely with "Père" Tutin and Jean Célestin.[23] Tutin had a difficult temperament and an aversion to modern art—Picasso's in particular—but he could not resist the artist's engaging personality and the technical challenges that came with it. Célestin would later note that he and his fellow lithographers were awed by Picasso's unstoppable drive.[24]

TOP: **FIG. 4.** *The Hawk.* 1936. From *Histoire naturelle* (*Natural History*) by Buffon, published 1942. Aquatint and drypoint. Page: 14 ³/₁₆ x 11 ¹/₄" (36 x 28.5 cm). The Louis E. Stern Collection, 1964

BOTTOM: **FIG. 5.** *Pensive Boy Watching a Sleeping Girl.* 1934. Etching, engraving, and aquatint. Plate: 9 ⁵/₁₆ x 11 ⁵/₈" (23.6 x 29.5 cm). Abby Aldrich Rockefeller Fund, 1949

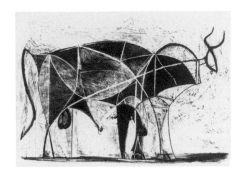

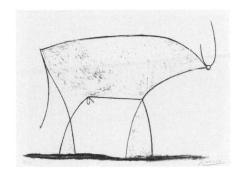

Picasso fully exploited lithography's inherent capacity to make progressive states of a composition (figs. 6 and 7). He had begun working in this systematic way with etching, but lithography lends itself more easily to the process, as it involves drawing on the surface of a stone or plate, rather than incising into it, and changes are more easily accommodated. At Mourlot's workshop, Picasso took this capability to great lengths with compositions that evolved through twenty or more states. By printing an example of each of these stages, he tracked his own creative process—a method of documentation that was increasingly important to him. As he said, "I've reached the moment . . . when the movement of my thought interests me more than the thought itself."[25] He bemoaned the fact that such a system of tracking was impossible in painting, where the traces of the process "disappear in the course of the work."[26]

During the 1950s and 1960s, Picasso located other printers who provided the creative stimulation he needed. Working alongside Hidalgo Arnéra in the South of France, he discovered the possibilities of linoleum cut. Bright, flat colors and bold patterning are typical effects with this technique, as ink sits easily on the surface of the linoleum, and the material's softness requires relatively little effort for gouging. These effects became part of Picasso's visual repertoire. Until then, he had been reluctant to work in color etching or lithography—though he had made occasional attempts—because of the necessity of laboriously making separate plates or stones for each color, and then lining them up to print properly.[27] While this is generally the method also with linoleum cuts, Arnéra proposed a different approach, in which a single block is gouged in a carefully planned order and printed at each stage with a different color.[28] Picasso took Arnéra's suggestion to extraordinary lengths, creating linoleum-cut prints that would become highlights of his printmaking œuvre (fig. 8). He did not stop there, but experimented with an unconventional rinsing technique that produced tonal effects in linoleum cut that are far more typical in aquatint (fig. 9). As Arnéra put it, Picasso "had a sort of aggressive delight in encountering an obstacle and surmounting it and conquering it."[29] He also touched on the personal nature of Picasso's collaborative relationships, which he characterized as "a confidence, between friends."[30]

Picasso's final creative involvement with printers came in the 1960s, when the brothers Aldo and Piero Crommelynck set up a print shop for the artist's use near his home in Mougins: from that convenient location, they carried proofs back and forth to Picasso's home daily. With this intensive routine, the Crommeryncks became part of the close-knit circle around the artist in his late years.[31] Among the many projects they undertook together was the Suite 347, named for the number of prints Picasso created in an

TOP: **FIG. 6.** *Bull*, state VII, variant. 1945.
Lithograph. Sheet: 12 15/16 x 17 1/2" (32.8 x 44.4 cm).
Mrs. Gilbert W. Chapman Fund, 1979

BOTTOM: **FIG. 7.** *Bull*, state XIV. 1946.
Lithograph. Sheet: 13 1/16 x 17 1/2" (33.2 x 44.4 cm).
Acquired through the Lillie P. Bliss Bequest, 1947

astonishingly concentrated period of less than seven months. In this series, he reviewed themes that had preoccupied him throughout his career, and experimented wildly with intaglio techniques, including rubbing the prepared plates with his fingers, adding drops of gasoline, and scraping their surfaces until they were ragged. On other occasions, he simply let his etching needle meander, creating compositions of flowing lines.

Picasso never stopped seeking new avenues of investigation to satisfy his creative drive and utilize his boundless energy. "You must take what you can, wherever you may find it," he said early on.[32] The people around him—including his publishers and printers—were part of what fueled his imagination. Printmaking was a greatly productive avenue for the artist: his output was vast, and the medium became one of his primary tools as he adopted its age-old practices—and then ignored them. He exploited the intimacy of prints, and also the long-standing traditions of thematic investigation and seriality that are part of the medium's heritage. Through sequential works, he told all manner of stories, probed changing moods in portraiture, and investigated pictorial issues step-by-step, while documenting his process along the way. With his remarkable capacity to exploit any medium beyond its purported limitations, Picasso took advantage of printmaking's characteristic visual effects—linear, tonal, painterly, or bold—and discovered new directions for them, enlarging his broader project as he did so.

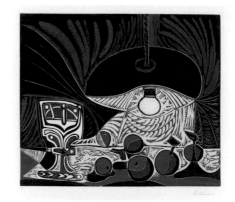

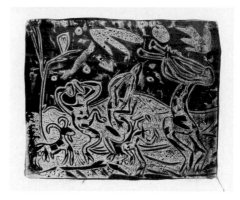

TOP: **FIG. 8.** *Still Life with Glass under the Lamp.* 1962. Linoleum cut. Composition: 20 $^7/_8$ x 25 $^3/_{16}$" (53 x 64 cm). Gift of Mrs. Donald B. Straus, 1964

BOTTOM: **FIG. 9.** *Nocturnal Dance with Owl.* 1959. Linoleum cut, rinsed 1963–64. Composition and sheet: 24 x 29 $^1/_4$" (61 x 74.3 cm). Gift of the Associates of the Department of Prints and Illustrated Books, 1999

TEXTS *and* PLATES

The plates in this book are arranged roughly chronologically. They were chosen to demonstrate the breadth of Picasso's printmaking as well as the thematic approach he took with the medium. Examples of his evolving states and variations shed light on his creative process. The introductions to the chapters place Picasso's prints within the context of his overall life and art.

NOTE TO THE READER:
Picasso did not provide titles for his prints. In the plate captions that follow, some descriptive or interpretive titles assigned by authors of catalogues raisonnés have been abbreviated and are given only in English. Full titles, exactly as they appear in those raisonnés—whether in French, Spanish, or English—are given in the checklist (pp. 182–92), which also includes information regarding publishers, printers, and edition sizes.

In the plate captions, dimensions are cited with height preceding width. For intaglio prints these dimensions refer to the plate; for lithographs and relief prints they refer to the composition. Occasionally, the full sheet or page is shown; in those cases, the full sheet or page dimensions are given. In the checklist, dimensions for plate or composition, as well as for sheet or page, are provided. All works illustrated are from the collection of The Museum of Modern Art unless otherwise noted; credit lines and accession numbers appear in the checklist.

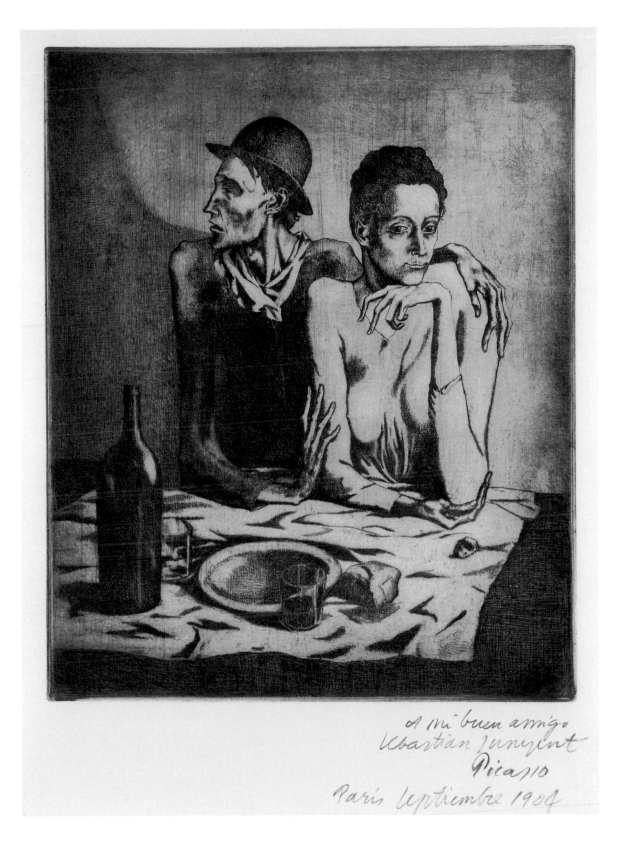

1. FRUGAL REPAST. September 1904.
Etching. Plate: 18 $^3/_{16}$ x 14 $^7/_8$"
(46.2 x 37.8 cm).

In this, his first major effort in print-making, Picasso demonstrates his patience and skill in building a composition of etched lines. The plate was printed at the Delâtre workshop and exhibits that studio's practice of inking and wiping to create lights and darks.[1] The figures, with their attenuated bodies and exaggerated limbs, show the influence of El Greco, whose work underwent a revival in the late nineteenth century.

1. Saltimbanques

The characters who began to appear in Picasso's paintings, drawings, and prints from late 1904 into 1905 are known as Saltimbanques. These itinerant performers and acrobats had a long history in Europe. Picasso devised scenes that placed them in indeterminate, allegorical spaces, evoking a timeless and universal quality. For prints, he used a simple Ingres-esque line that, in the words of his friend, poet Guillaume Apollinaire, "eludes, changes, and penetrates."[2] Picasso made only a few impressions (examples) of these prints, but later Ambroise Vollard, a celebrated art dealer and a champion of prints since the 1890s, bought the printing plates from these years. In 1913 Vollard issued a series called Saltimbanques, encompassing Picasso's Blue and Rose periods, which the dealer admired more than his Cubist style. He had been involved with Picasso's work since the artist's first Paris show in 1901, which, although arranged by a Spanish friend of Picasso's, was held at Vollard's gallery. He would again be instrumental to Picasso's printmaking in the late 1920s and 1930s, when the artist embraced a mode of classicism.

Picasso's Blue period lasted from 1901 to late 1904, as the artist forged his place in the Paris art world. For several years he traveled back and forth from Barcelona to the French capital, often returning to Spain discouraged, although he was showing his work and receiving some positive attention from the Paris press. His friend Carlos Casagemas traveled with Picasso on his first trip to Paris in 1900. Early the following year, Casagemas committed suicide over a failed love affair. The event deeply affected Picasso, and it was at this point that he moved away from scenes of gay and decadent café life and began to produce work of a far more somber tone, with moody blue coloration, and subjects that focused on the downtrodden of society.

By April 1904, when Picasso had finally settled in Paris, his Blue period was entering its last phase. He took up residence in a ramshackle building nicknamed the *Bateau Lavoir* (washing boat) because its ungainly shape resembled the laundry barges on the Seine. Many of its rooms were occupied by writers, artists, and models, and Picasso's life was soon filled with the company of this bohemian crowd. He formed close bonds with poets, including Apollinaire, André Salmon, and Max Jacob: at one point, Picasso even chalked on his door, *Au rendez-vous des poètes* (Poets' meeting place), in recognition of his growing camaraderie with this group. Evenings were often filled with poetry recitations, song, and dance, or were spent at the nearby Cirque Medrano, after which Picasso and his friends would mingle with the circus performers. At the popular haunt Le Lapin Agile, a painting by Picasso hung on the wall. It showed him with a companion and dressed in the colorful costume of Harlequin—the sly comic character who would serve as a kind of alter ego for the artist.

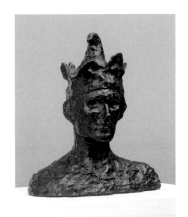

Picasso had various mistresses in this period, the most serious of whom is known only as Madeleine. Her thin, boyish frame and elegant facial structure are recognizable in many of the female figures in Picasso's Blue and Rose period works. Other friends are also reflected—including Jacob, as seen in the 1905 sculpture known as *The Jester*, which Picasso was inspired to make after the two had spent an evening at the Cirque Medrano (fig. 10).

Picasso also felt a kinship with Apollinaire's poetic imagination. As the artist once said about his friend, his genius "lit up the darkness and showed us the way."[3] But the influence between the two was mutual. Apollinaire wrote poems about *saltimbanques*, and also about Salomé—a theme that Picasso likewise took up in a print. One scholar claims that the poet "viewed Picasso's paintings as a reflection of his own inner universe and shifting identity."[4] And Picasso, for his part, dedicated a number of prints in the Saltimbanques series to Apollinaire with handwritten inscriptions. It has been surmised that the artist and poet may have planned to issue an illustrated book together on the theme. Perhaps it was Vollard who considered publishing such a volume,[5] although ultimately the series of prints was issued with neither text nor cover.

Although prints constituted only a modest part of Picasso's creative process at this juncture, their subjects were integral to his work as a whole. His first major etching, *The Frugal Repast*, has been widely acknowledged as the final great work of the Blue period, regardless of medium. It is noteworthy that a few examples were printed in blue ink. During the Rose period that followed, an etching, *The Acrobats*, played a role in the initial conception of his finest painting of the era, *The Family of Saltimbanques* (1905). One impression of the print includes squaring-off lines, which are used for transfer to canvas.[6]

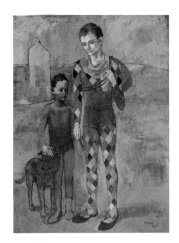

Other concurrent works, such as the gouache *Two Acrobats with a Dog* (fig. 11), show Picasso's consistent thematic focus at this time. In addition, his 1905 show at the Galeries Serrurier included prints along with paintings.

Yet printmaking adds distinctive elements to the characterization of Picasso's Saltimbanques. The small scale of the works encourages a sense of intimacy with the subjects. Also, even without the defining blue and rose colors of the period, the austere black ink on white paper creates an evocative atmosphere that is not bound by place or era. The delicate drypoint and etched lines capture essentials, whether they define the heft of a body, the texture of hair, a playful pose, or a tender gesture. Also, areas of light and shade punctuate certain scenes. The *saltimbanques*, who ordinarily existed on the fringes of society, are ennobled through Picasso's unique vision.

TOP: **FIG. 10.** *The Jester*. 1905. Bronze. 15 1/4 x 13 3/4 x 8 5/8" (38.7 x 34.8 x 21.9 cm). Louise Reinhardt Smith Bequest, 1995

BOTTOM: **FIG. 11.** *Two Acrobats with a Dog*. 1905. Gouache on board. 41 1/2 x 29 1/2" (105.5 x 75 cm). Gift of Mr. and Mrs. William A. M. Burden, 1985

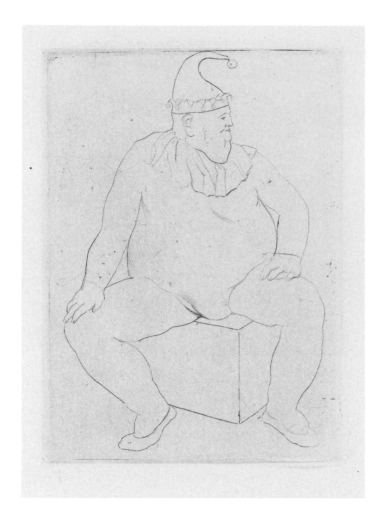

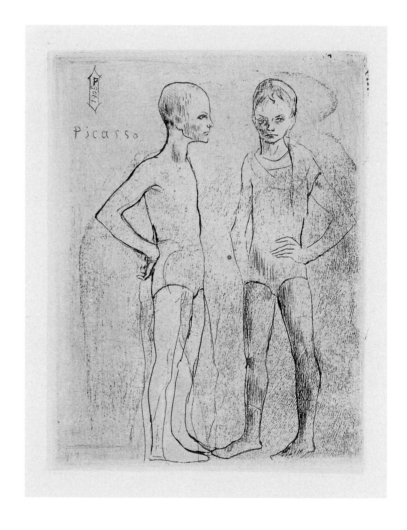

2. ACROBAT IN REPOSE. 1905.
Drypoint. Plate: 4 ³/₄ x 3 ⁷/₁₆" (12 x 8.8 cm)

3. TWO ACROBATS. 1905.
Drypoint. Plate: 4 ³/₄ x 3 ⁹/₁₆" (12 x 9 cm).

This clown has been interpreted as Picasso's friend the poet Guillaume Apollinaire.[7] But, in another work, the artist identified the figure as El Tio Pepe Don José, probably from the Cirque Medrano, which Picasso frequented.[8]

The print of two acrobats, showing traces of reworking and evidence of a previous image on the plate, served as the frontispiece for a book by André Salmon, another poet in Picasso's circle.

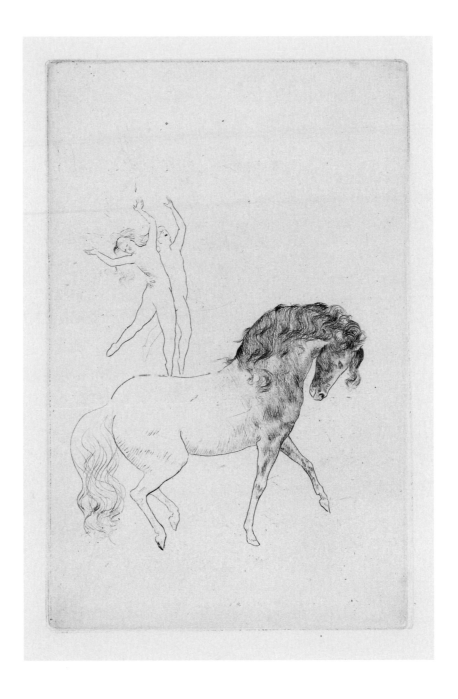

4. AT THE CIRCUS. 1905–6.
Drypoint. Plate: 8 5/8 x 5 9/16"
(21.9 x 14.2 cm).

Picasso usually depicted his performers in everyday activities rather than in action. This is an exception, but the scene is highly emblematic. The composition anticipates the artist's classicizing mode, which began in 1906, when balance and harmony become the focus and Arcadian settings prevail. Here, the two figures barely touch the back of the horse, in a stunt that evokes an abstract ideal rather than a feasible athletic feat.

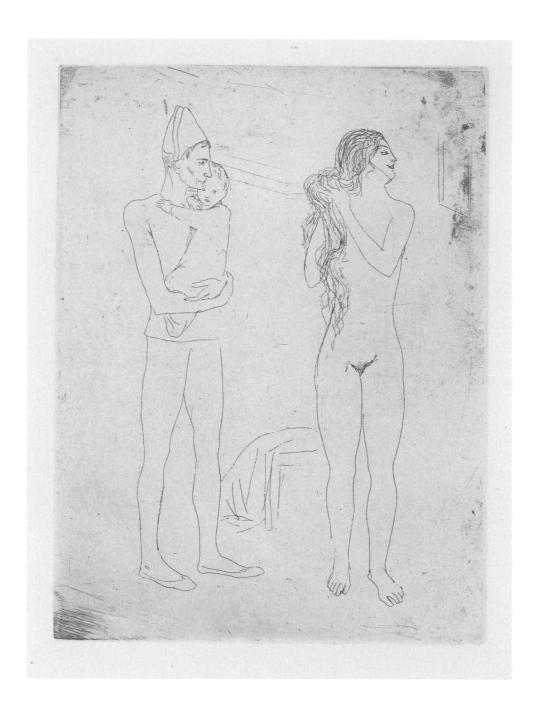

5. MOTHER AT HER *TOILETTE*. 1905.
Etching. Plate: 9 1/4 x 7" (23.5 x 17.8 cm).

Picasso identified with the figure of
Harlequin, and this scene might be
one of wistful fantasy. His mistress,
Madeleine, was pregnant at around this
time, but did not go to full term.[9] Here,
the figure of the mother, with flowing

locks, seems a self-absorbed femme
fatale. Apollinaire hints at the sense
of isolation in such scenes, which he
described as "meditations . . . laid bare
in silence."[10]

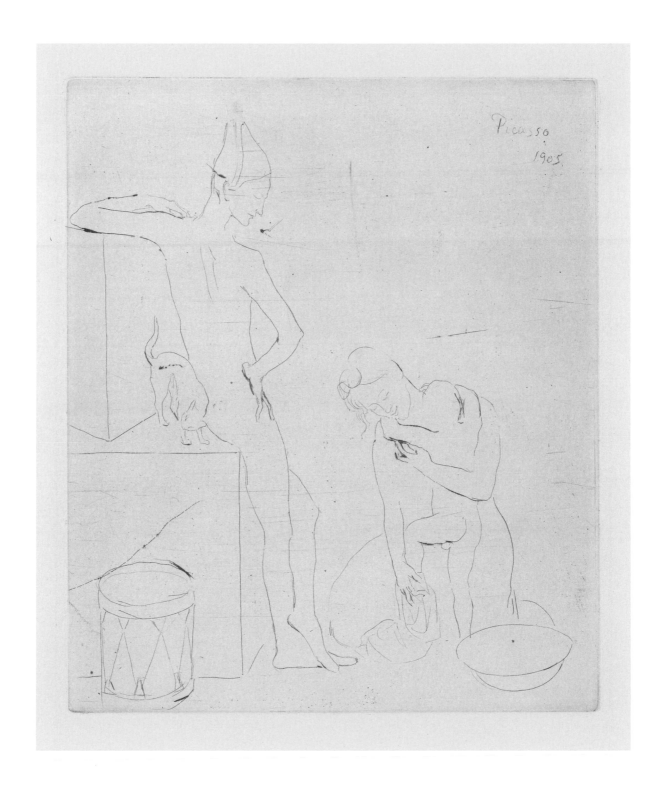

6. BATH. 1905.
Drypoint. Plate: 13 $^{7}/_{16}$ x 11 $^{5}/_{16}$"
(34.2 x 28.7 cm).

In contrast to *Mother at Her* Toilette, in this family scene it is the father who is aloof. Such a reversal is underscored by the seeming androgyny of the figure—a factor in several of the Saltimbanque images. As Apollinaire put it: "Some harlequins match the splendor of the women whom they resemble, being neither male nor female . . . the sexes are indistinct."[11]

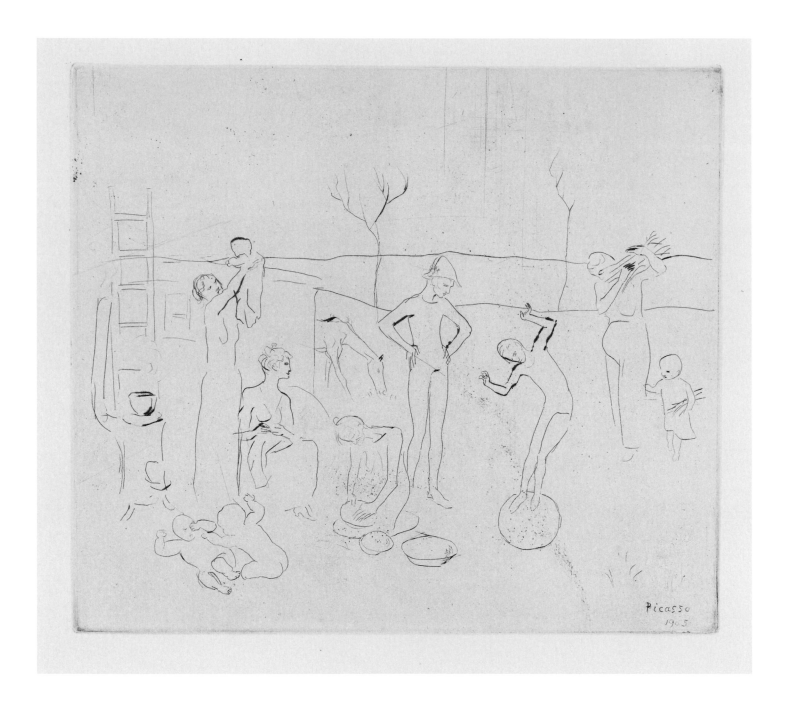

7. ACROBATS. 1905.
Drypoint. Plate: 11 1/4 x 12 7/8"
(28.6 x 32.7 cm).

Several vignettes come together here to constitute an allegorical scene that goes beyond the depiction of the everyday life of circus performers. The women in particular present an unfolding drama of the various stages of life, beginning with the pregnant woman at the right and ending with the elderly woman washing dishes at the center. The composition is considered a summation of Picasso's Saltimbanque motifs.[12]

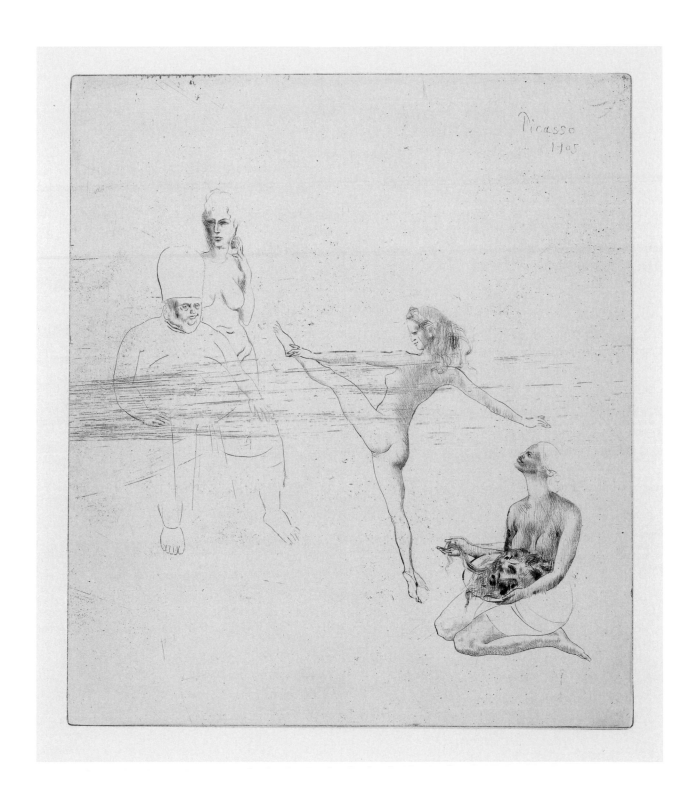

8. SALOMÉ. 1905.
Drypoint. Plate: 15 $^7/_8$ x 13 $^{11}/_6$"
(40.3 x 34.7 cm).

Although included in the Saltimbanques series, this print has a different subject.[13] Salomé enticed Herod by dancing before him, then demanded the head of John the Baptist to placate her vengeful mother. Picasso has reconceived the story to resemble a circus scene, with the stout Herod as jester, and Salomé as an acrobat. This subject provides another link to Apollinaire, whose poem "Salomé" also appeared in 1905.

2. The Cubist Spirit
In the pre–World War I years, Paris was the center of the burgeoning world of modern art, which also included other European capitals. When Picasso settled there in 1904, he found a highly stimulating mix of artists and writers, salon exhibitions, galleries, museums, and engaged patrons. He took full advantage of everything at hand, and forged many friendships that would endure for years after. Cubism began percolating in 1906, as various artistic influences came to bear on his work—among them the paintings of Paul Gauguin and especially those of Paul Cézanne, tribal art from Africa, and also ancient Iberian sculpture.

In 1907, his friend the poet Guillaume Apollinaire brought artist Georges Braque to Picasso's studio, where Braque saw the masterwork *Les Demoiselles d'Avignon*. Already an accomplished Fauve painter in the circle of Henri Matisse, Braque soon joined ranks with the Spaniard in the search for a new aesthetic. The two artists were in daily contact, fully absorbing what transpired in each other's studios. As Braque described it, they were "rather like a pair of climbers roped together,"[1] as they pursued their joint vision. It was Braque's 1908 exhibition at the gallery of Daniel-Henry Kahnweiler that prompted a critic to speak disparagingly of "cubes" in his paintings, thus giving rise to the movement's name.

At certain points in the development of Cubism, it is difficult to tell a Picasso painting from a Braque. This is true also of their prints, as seen in two drypoints of nearly identical size, commissioned in 1911 by Kahnweiler (fig. 12 and plate 11). The two artists composed these examples of Analytic Cubism while summering together in Céret, in the French Pyrenees. Although the artists began to veer toward abstraction in the process of examining their motifs and surrounding spaces, neither was seeking to dispense with reality; instead, they were striving to deepen their understanding of it. Picasso said, "It's not a reality you can take in your hand. It's more like a perfume—in front of you, behind you, to the sides. The scent is everywhere, but you don't quite know where it comes from."[2]

The enterprising Kahnweiler was the force behind other prints by Picasso during these heady years of Cubism, which the dealer described as having "an atmosphere of euphoria, youth and enthusiasm."[3] Kahnweiler's sensitivity to the avant-garde was legendary. Born in Germany, he moved to Paris in 1902, ostensibly to follow the family tradition of banking; instead, he discovered his passion for art and opened a gallery in 1907. He began buying paintings by Picasso soon after, and helped develop a market for them. A canny businessman, he also fostered the idea of the exclusive contract, and eventually made agreements with Braque, as well as other Cubist painters, including André Derain, Juan Gris, Fernand Léger, and Maurice de Vlaminck. By late 1912, this impresario of Cubism finally persuaded Picasso, too, to sign a contract.

FIG. 12. Georges Braque. *Fox.* 1911.
Drypoint. Plate: 21 7/16 x 14 15/16" (54.5 x 38 cm).
Gift of Abby Aldrich Rockefeller, 1940

Kahnweiler managed his artists' careers shrewdly. For Picasso, this meant not showing in the annual salons or even having a solo show in the gallery. Kahnweiler's strategy was to disseminate Cubism prudently but widely, and he arranged for works to be included in exhibitions outside Paris, in other European capitals, and even in New York. Prints and illustrated books, which, as a collector, Kahnweiler loved, were a component of this overall strategy of dissemination, even though they never proved very successful financially. For his first book project, in 1909, Kahnweiler brought together Apollinaire and Derain for the landmark *L'enchanteur pourrissant* (The rotting magician). Next, he sought out Max Jacob, and again approached Derain for illustrations—but the painter declined to collaborate, finding Jacob's style incomprehensible. Picasso took up the challenge of creating prints to accompany Jacob's prose poem *Saint Matorel*, but barely referred to the plot in his illustrations.[4]

Jacob and Picasso had been close friends since 1901, even rooming together briefly during one of the artist's extended visits to Paris from Spain. When Picasso eventually settled in the city in 1904, Jacob was his neighbor. During those early years, the two friends spent almost all their free time together—"Max was marvelous," Picasso later recalled.[5] Jacob read poetry aloud to him, which helped Picasso's French, and introduced him to a range of literature.[6] When Jacob converted to Catholicism in 1915, Picasso stood as his godfather. All along, Picasso steadily encouraged Jacob's writing: the artist would thus surely not have been daunted by the inscrutability of *Saint Matorel*. Indeed, the book's disjunctive structure is thought to resemble the fragmentation of Cubist painting. It has been said of both avant-garde literary and visual works of the era that "Heterogeneous images and statements . . . seemingly disordered . . . together . . . build a coherent work."[7]

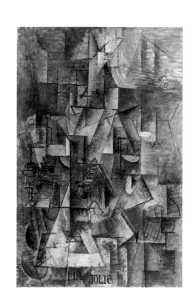

The principles of Cubism evolved in Picasso's prints as well as his paintings. And even before Kahnweiler began publishing his print editions, Picasso experimented with woodcut in the process of conceiving *Les Demoiselles d'Avignon*.[8] The etchings and drypoints Kahnweiler published in the seminal years of 1909–12 demonstrate how closely Picasso's printmaking was related to his painting (fig. 13).[9] Yet the medium of printmaking also offered Picasso possibilities inherent to its specific techniques. The tiny scratched lines of etching and drypoint lent themselves to a syncopated rhythm across the surface, through shading, and they easily contributed to fragmentation and to the breakdown of boundaries between objects and their enclosing spaces. The limitation of black ink on white paper was well suited to the analysis of forms, and echoed the limited color palette found at the height of Analytic Cubist painting. Finally, the intimate scale of Picasso's Cubist prints provides the opportunity to quietly contemplate this innovative pictorial language that so radically altered the development of modern art.

FIG. 13. *"Ma Jolie."* 1911–12.
Oil on canvas. 39 3/8 x 25 3/4" (100 x 64.5 cm).
Acquired through the Lillie P. Bliss Bequest, 1945

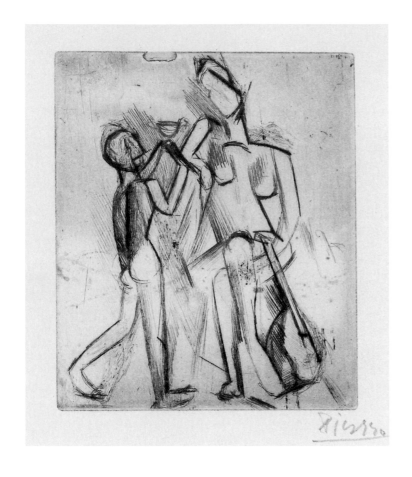

9. TWO NUDES. 1909.
Drypoint. Plate: 5 1/8 x 4 5/16" (13 x 11 cm).

10. HEAD OF A MAN WITH PIPE. 1912.
Etching. Plate: 5 1/8 x 4 5/16" (13 x 11 cm).

Dislocations, multiple perspectives, and interlocking spaces in the drypoint of 1909 reflect the early stages of Cubism and the influence of Cézanne. The mandolin[10] presages the role of musical instruments in Cubist iconography. The print from 1912 is among the last commissioned by Daniel-Henry Kahnweiler,[11] who, as a German, had to leave Paris at the onset of World War I.

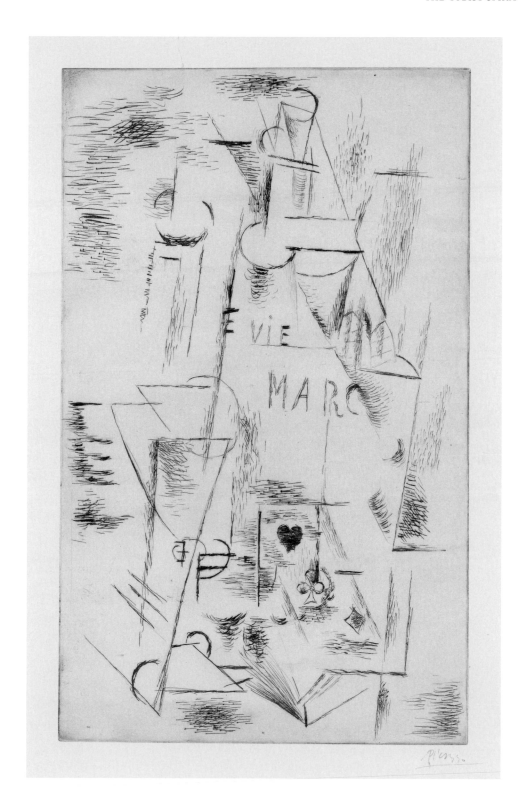

11. STILL LIFE WITH BOTTLE OF MARC. 1911.
Drypoint. Plate: 19 5/8 x 12"
(49.8 x 30.5 cm).

Picasso made this drypoint, his most important Cubist print, in 1911, when summering with Braque, who created a similar one at the same time. Lettering had recently entered the Cubist vocabulary in painting. Here, the word *marc* refers to a kind of brandy,[12] although the heart beneath it indicates that the word may also refer to Picasso's mistress Eva Gouel, whose real name was Marcelle.[13]

12. MADEMOISELLE LÉONIE. August 1910. From *Saint Matorel*, by Max Jacob, published 1911. Etching. Plate: 7 13/16 x 5 9/16" (19.8 x 14.2 cm).

Picasso's illustrations for Jacob's *Saint Matorel* are given no specific titles within the volume,[14] and the imagery does not refer to particular scenes. Instead, the etchings provide counterpoints to Jacob's whimsical and quasi-autobiographical prose poem about a character named Victor Matorel, who works in the Paris Métro and eventually retires to a monastery. Léonie is Matorel's love interest.

13. TABLE. August 1910. From *Saint Matorel*, by Max Jacob, published 1911. Etching. Plate: 7 7/8 x 5 9/16" (20 x 14.2 cm).

This abstracted still life may refer to a table at an inn where Jacob's hero, Matorel, stops for a meal. Picasso hints at the depth of a room by heavily shading the upper-right area. At the time,

it was unusual in book illustration to have such a vague connection between image and text, but Picasso would almost always use this approach in later book projects.

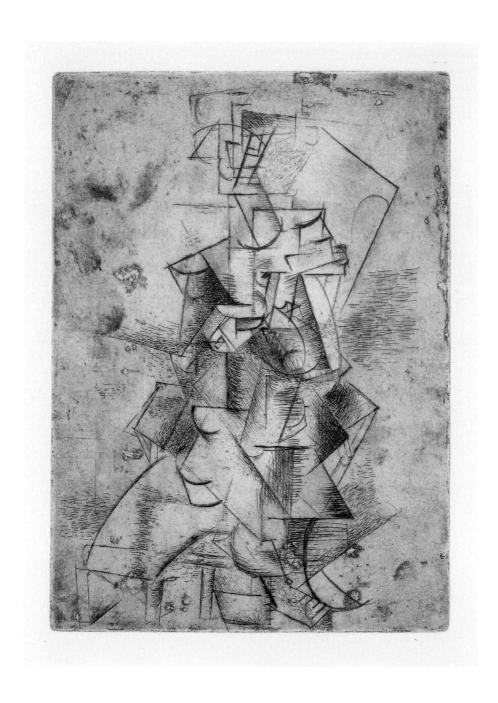

14. MADEMOISELLE LÉONIE IN A LOUNGE CHAIR. August 1910. From *Saint Matorel*, by Max Jacob, published 1911. Etching and drypoint. Plate: 7 3/4 x 5 9/16" (19.7 x 14.2 cm).

In the most complex composition in this book, Picasso positions Léonie sideways on a lounge chair. This image went through four progressive states.[15] Such experimentation may have been possible for Picasso since it seems he had access to a printing press in Cadaqués, north of Barcelona, where he spent the summer of 1910 and created the *Saint Matorel* etchings.[16]

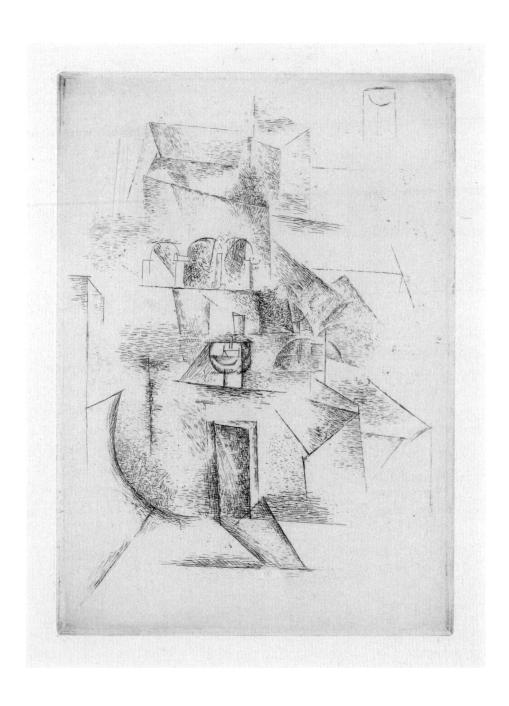

15. CONVENT. August 1910. From *Saint Matorel*, by Max Jacob, published 1911. Etching. Plate: 7 $^{13}/_{16}$ x 5 $^{9}/_{16}$" (19.9 x 14.2 cm).

This scene is based on an actual religious institution in Barcelona that Picasso knew well. In the text, it seems to refer to the monastery to which Jacob's hero, Matorel, retires. Picasso's light-filled composition gives the motif an appro-priately celestial cast. Jacob himself had a mystical vision in 1909, and then converted to Catholicism in 1915. Later, he became a lay brother at an abbey outside Paris.

3. Sculptor's Studio

In a burst of creative energy in the early 1930s, Picasso etched a series of more than forty prints on the subject of the sculptor in his studio. Comprised of simple, flowing lines, the prints of the Sculptor's Studio series are essentially naturalistic, in sharp contrast to those of Picasso's earlier Cubist phase. These later etchings should be seen in the context of changes in Picasso's work starting from the onset of World War I. At that point, Georges Braque, his partner in Cubism, had left Paris to serve in the military. Also, Cubism had spread to the work of a range of artists exhibiting in the annual salons. For Picasso, it was time for new inspiration. In 1914–15 he began to investigate a heightened naturalism and a mode of drawing that called to mind the work of nineteenth-century Neoclassical artist Jean-Auguste-Dominique Ingres.

After the death in December 1915 of Eva Gouel, who had been Picasso's lover since late 1911, he began to gravitate toward a new circle of friends. By 1917, he was involved in the ballet, designing costumes and stage sets. His first production was *Parade*, an avant-garde enterprise conceived by Jean Cocteau, with music by Erik Satie and performances by Sergey Diaghilev's Ballets Russes. Preparations included Picasso's first trip to Rome to meet with his collaborators. He remained in Italy for about two months, visiting Naples and Pompeii and gaining a new appreciation for classical art. In connection with *Parade*, he also met the Ballets Russes dancer Olga Khokhlova, whom he married in 1918.

Picasso's turn toward naturalism and classicism took place during a time when there was a broader focus on representation in art. This shift away from radical styles, such as Cubism and Futurism, occurred particularly in France and Italy from 1917 to 1925; it was seen as a "return to order"[1] after the devastation of war and the intense artistic experimentation of the previous years. By 1924 Surrealism had also emerged, and attentions shifted to unconscious thought as a wellspring of art. Although Picasso never fully joined the Surrealist movement, he was influenced by the art, poetry, and critical writing it engendered. As he had with classicism, Picasso made use of Surrealist subjects and devices as warranted by his subject matter.

In the late 1920s and into the 1930s Picasso's printmaking finally emerged as a major component of his art. Until this point, he had worked sporadically in the medium, experimenting on his own or responding to various commissions, including contributions to books by friends. Art-dealer Daniel-Henry Kahnweiler had published Picasso's prints during the Cubist years, but that stopped when war broke out, as Kahnweiler, a German, had to flee Paris. When he returned, the dealer occasionally commissioned prints from Picasso, but nothing constituted a major project for the artist until the legendary publisher Ambroise Vollard and the newcomer Albert Skira proposed book projects to the artist, in 1926 and 1928 respectively.

Skira's project, *Les métamorphoses* (*Metamorphoses*) by Ovid, appeared in 1931, at almost precisely the same time as Vollard's publication of *Le chef d'œuvre inconnu* (*The

Unknown Masterpiece) by Honoré de Balzac. It is the Balzac tale that relates most closely to Picasso's Sculptor's Studio series of prints, as the subject matter of both involves the artist in his studio. This theme had appeared in Picasso's painting in the mid-1920s and was one to which he would return often throughout his career. However, while the Balzac tale is allegorical—concerning an artist and his pursuit of absolute beauty—the Sculptor's Studio etchings seen here relate closely to Picasso's art and life at that time.

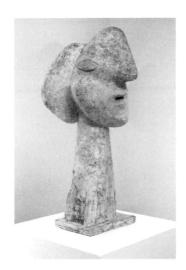

In 1931 Picasso set up a sculpture studio in a château he had recently purchased in Boisgeloup, on the outskirts of Paris. There he began to fashion the plaster heads (fig. 14) that appear in the etching series.[2] Their inspiration was Marie-Thérèse Walter, a young woman Picasso met in 1927, when she was seventeen years old. Although he was still married to Olga, Picasso and Walter began a torrid affair. Walter's distinctive face and profile inform the plaster heads, although they are also indebted to a mammoth African fertility mask, with jutting nose, that the artist owned and installed in the château.[3]

The Sculptor's Studio series was, in fact, part of a larger printmaking project Picasso undertook in the 1930s with Vollard, who always preferred the artist's naturalistic modes. The two men had been friends since Picasso's earliest years in Paris, and the series that became known as the Vollard Suite—one hundred prints, including the Sculptor's Studio series—was probably initiated by an amicable deal between the two: it seems Vollard owned two paintings that Picasso wished to purchase, and he promised the dealer the prints in exchange.[4]

Although created between 1930 and 1937, well beyond the period strictly considered Picasso's classical phase, the Sculptor's Studio prints are steeped in references to antiquity.[5] They show Zeus-like males and idealized nudes, as well as pedestals in the form of Greek columns, garlands, and laurel wreaths. The prints are even dated with Roman numerals. Also, in their pure linearity, the prints clearly reference Greek vase paintings and Etruscan mirror engravings.[6] Here, Picasso exploits the capability of the etched line to easily delineate bodily contours, strands of hair, and fabric patterns, clearly demonstrating his understanding of the effects of strictly linear compositions. As he said, "Line drawing has its own innate light, and does not imitate it."[7]

These Sculptor's Studio prints also provided the opportunity for Picasso to explore the theme of the artist's studio in idealized terms. The female character serves as model, muse, and lover, and the scenes often have undertones of the myth of Pygmalion and Galatea, in which a sculpture comes to life in response to the artist's love. The male protagonist is presented as a Greek god, appearing at different ages and in different moods. Yet, no matter what the scene, these allegorical compositions all evoke a sense of harmony and serenity, embodying the Apollonian side of classicism.

FIG. 14. *Head of a Woman*. 1932.
Plaster. 52 1/2 x 25 5/8 x 28" (133.4 x 65 x 71.1 cm).
Gift of Jacqueline Picasso in honor of the
Museum's continuous commitment to Pablo
Picasso's art, 1982

**16. SCULPTOR WITH HIS
MODEL**. March 23, 1933.
Etching. Plate: 10 ¹/₂ x 7 ⁵/₈"
(26.7 x 19.4 cm).

From 1931 to 1937, Picasso created one
hundred prints, now known as the
Vollard Suite, for publisher Ambroise
Vollard in exchange for paintings by
Cézanne and Renoir that were owned

by the dealer. [8] The series is made up of
various subjects; the Sculptor's Studio is
the most prominent, comprising forty-
six etchings. Picasso had no single nar-
rative in mind with the series overall.

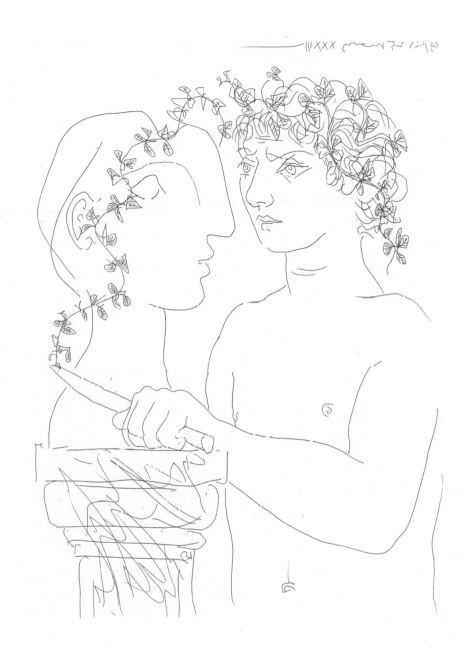

17. YOUNG SCULPTOR.
March 23, 1933. Etching.
Plate: 10 ¹/₂ x 7 ⁵/₈"
(26.7 x 19.4 cm).

This is a rare print in the Sculptor's Studio series depicting the artist as a young man. He carves a sculpture with features resembling those of Marie-Thérèse Walter, Picasso's lover at the time. Walter was nearly thirty years younger than the artist, although here, if the male figure is meant as a self-portrait, he seems far closer in age to the model. Symbolically, artist and muse confront each other on equal terms.

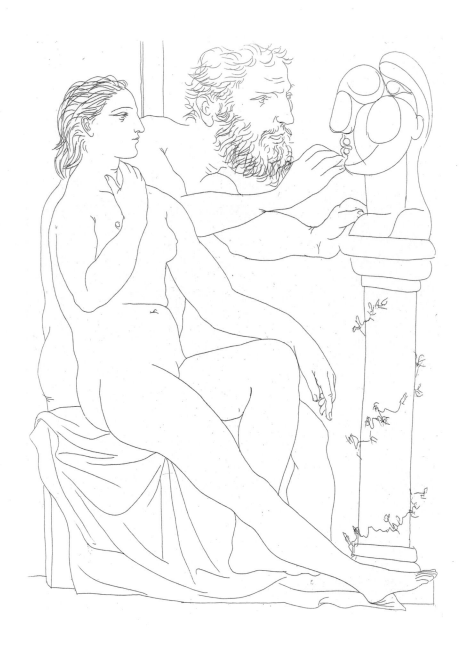

18. MODEL AND SCULPTOR.
March 17, 1933. Etching.
Plate: 10 ¹/₂ x 7 ⁵/₈" (26.7 x 19.3 cm).

Among the prints of the Sculptor's Studio series, this scene is perhaps the least idealized. The female seems more flesh-and-blood model than muse, and the setting appears to be the studio of a real working artist, not an imagined one. In contrast to other, more allegorical scenes, neither figure wears a laurel wreath. Cubist-inflected distortions are seen in the bodies, with limbs of varying sizes and multiple viewpoints.

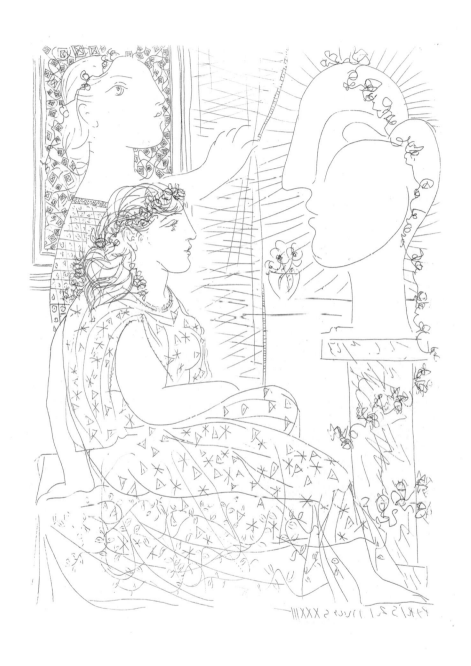

19. TWO WOMEN. March 21, 1933.
Etching. Plate: 10 1/2 x 7 5/8"
(26.7 x 19.3 cm).

Three characterizations of Marie-Thérèse Walter, with her distinctive profile, indicate this young woman's overwhelming presence in the artist's life and art. This scene is a joyous homage to her, as both mistress and muse. Using the fine point of an etching needle, Picasso creates a proliferation of varied patterns, along with cascading garlands, flowering wreaths, a small windowsill bouquet, and light emanating from the sculpture.

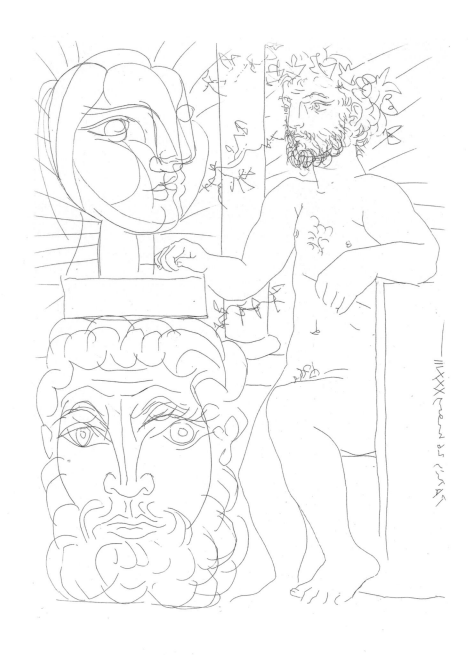

20. SCULPTOR. March 26, 1933.
Etching. Plate: 10 1/2 x 7 5/8"
(26.7 x 19.4 cm).

Classical sculptures, such as the head at
the lower left, make occasional appear-
ances in the Sculptor's Studio series. Here,
the arrangement is less logical than alle-
gorical, as a classical head becomes a ped-
estal for the artist's own sculpture. Their

proximity calls out for a direct compari-
son of the two works, as if Picasso is
setting up a challenge between his own
art and that of Greco-Roman tradition.

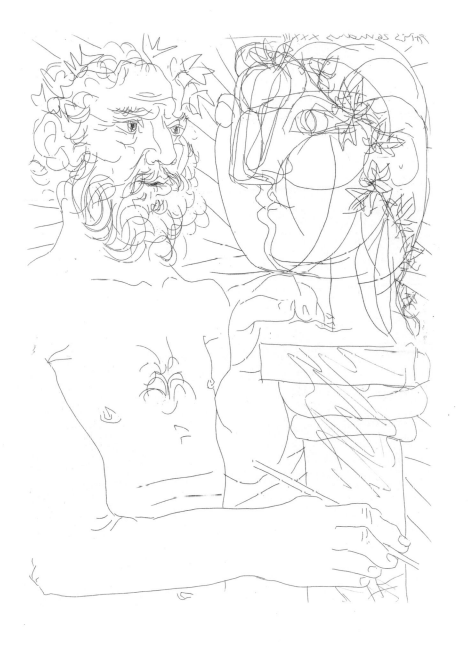

21. OLD SCULPTOR. March 26, 1933. Etching. Plate: 10 ¹/₂ x 7 ⁵/₈" (26.7 x 19.4 cm).

With deep wrinkles and sagging flesh, the artist here is decidedly elderly, and engrossed in his work. His sculpture, through overlapping lines, seems to be in the process of evolution. In this scene, and the one on the opposite page (made on the same day), Picasso makes use of his signature doubling device for faces, which began appearing in his work in the mid-1920s. The sculptures present profiles and frontal views simultaneously.

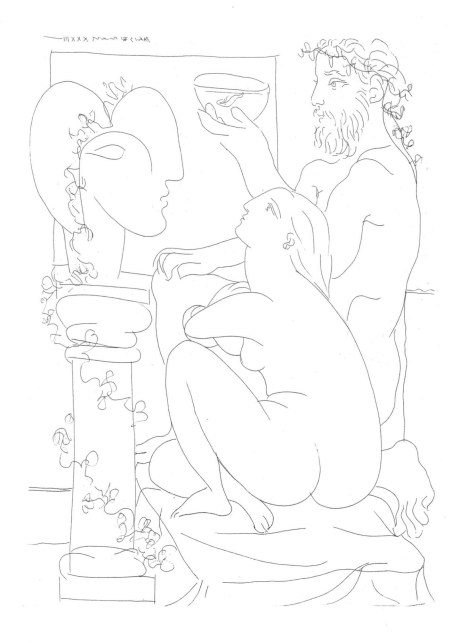

22. SCULPTOR AND MODEL.
March 21, 1933. Etching. Plate: 10 1/2 x 7 5/8" (26.7 x 19.4 cm).

Among the most harmonious and serene of the compositions in the Sculptor's Studio series, this etching demonstrates how Picasso manipulates the female body into an idealized shape by mis-aligning its parts. The model, and the sculpted head that resembles her, appear to occupy their own psychic realm, separate from the artist. She becomes the muse, seeming to breathe life into the plaster form.

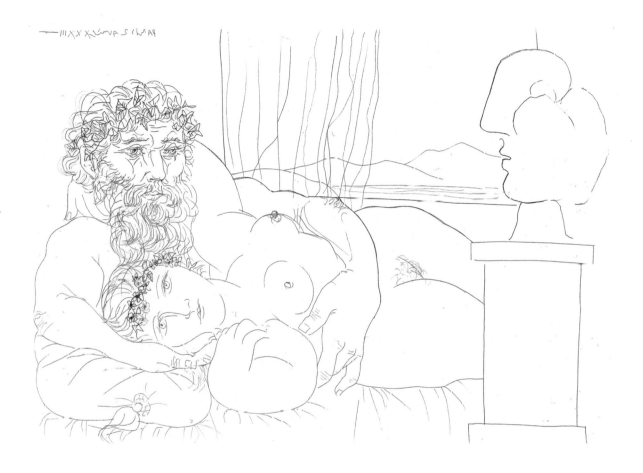

23. SCULPTOR AND MODEL.
April 2, 1933. Etching. Plate: 7 5/8 x 10 9/16"
(19.3 x 26.8 cm).

This is among the most erotic prints in the Sculptor's Studio series. There is no evidence here of a working artist, as found or implied in other examples. The couple, with entwined limbs, seems, indeed, detached from the work of art.

The much older man tenderly cradles the head of the childlike woman, while embracing her fulsome body. A gentle breeze seems to blow in from the window, contributing to the serene mood.

4. The Minotaur

Classicism was an abundant resource for Picasso's art, starting in the late 1910s and 1920s and coinciding with the art world's "return to order" after World War I. At that time, there was new attention to the ideals of harmony, serenity, and balance in Greco-Roman tradition. However, that tradition also encompassed ancient myths that articulated irrational aspects of human nature, and Picasso would make ample use of those as well. In the 1930s, he began to identify, in particular, with the Minotaur, the monstrous half-man, half-bull that symbolizes conflicted impulses in mankind.

Picasso introduced the Minotaur in 1928, in a tapestry design,[1] but focused on the subject in earnest after publisher Albert Skira requested that the artist create the cover for Skira's new magazine, *Minotaure*, first published in June 1933 (fig. 15). Picasso fashioned his own version of this legendary creature—the product of a liaison between Pasiphaë, the wife of King Minos of Crete, and a beautiful bull. According to the story, the Minotaur was hidden by the king in a labyrinth, where young men and women were periodically sent in ritual sacrifice, to be devoured by the monster.

Although representing contradictory urges and desires, the Minotaur is most closely associated with base instincts and forbidden thoughts of the unconscious. This was the realm mined by the Surrealists as a generative source of art. Picasso never officially joined forces with the Surrealist group—launched in 1924 with *Le manifeste du Surréalisme* (*The Surrealist Manifesto*)—nonetheless, he was influenced by the thinking of its members, particularly writers such as André Breton, Paul Éluard, and Michel Leiris, who became his longtime friends. In the mid-1930s, at a time of personal turmoil, Picasso himself began to write Surrealist stream-of-consciousness poetry, which was applauded and encouraged by Breton.[2]

The mythic Minotaur became Picasso's alter ego. As he later observed, "If all the ways I have been along were marked on a map and joined up with a line, it might represent a minotaur."[3] For his art and his life, it was liberating to acknowledge the forces of the unconscious. The persona of this creature gave him a vehicle for depicting sexuality and violence, and for expressing rage and guilt. At this point, he was embroiled in a deeply erotic affair with the young Marie-Thérèse Walter, while attempting to maintain his role as husband to Olga and father to Paulo. The betrayals inherent in this situation inevitably tainted the passion for his lover. The thorny situation grew still more complex when Walter became pregnant at the end of 1934, and Olga learned of the situation and moved out with their son. By mid-1935, Picasso had fallen into despair; he later called the period "the worst time of my life."[4] He had not anticipated this turn of events when first smitten with the beautiful seventeen-year-old Walter. Also, his ardor probably cooled as time passed, particularly with thoughts of his lover becoming

FIG. 15. Maquette for cover of journal *Minotaure*. 1933. Assemblage of corrugated cardboard, metal foil, ribbons, printed paper, paper doily, artificial plant, tacks, and pencil on paper mounted on wood with charcoal additions. 19 1/8 x 16 1/8" (48.5 x 41 cm). Gift of Mr. and Mrs. Alexandre P. Rosenberg, 1974

a mother. Later that year, in what would be a pattern of serial and overlapping relationships, Picasso met Surrealist photographer Dora Maar, who would soon supplant Walter in his affections.

Yet in late 1934, when such entanglements were complicating his personal life, Picasso took a new step in his growing involvement with printmaking. He began to work with master printer Roger Lacourière at his Paris print shop. Picasso's relationship with Lacourière was different from anything he had experienced with previous printers. Through the nature of his personality, Lacourière became an active collaborator, giving Picasso a new understanding of the intaglio processes (which involve the incising of metal plates). The result was a new level of ambition in Picasso's prints, as he began to grasp the full potential of the medium.

At Lacourière's shop, Picasso embarked on his most monumental print to date, one that is now considered a masterpiece of modern printmaking.[5] He gave the Minotaur a central role in this work's complex iconography. The title, *Minotauromachy*, was probably devised by someone other than Picasso, but its relevance remains in that it combines the word *Minotaur* with *tauromachy*, referring to the bullfighting spectacle that was so momentous for Picasso.[6]

Minotauromachy has been interpreted in countless ways.[7] The print not only situates the people from Picasso's life in an enigmatic drama, it also encompasses a range of ideas that were being debated at that time, including theories of the unconscious from Sigmund Freud, and conceptions of collective myth from Carl Jung. The print also references artistic epochs from Greco-Roman times to the Middle Ages to the Renaissance and Baroque periods. Ultimately, Picasso's multifaceted narrative, and his highly sophisticated use of the etching technique, provided him with the means to explore universal themes, such as good and evil, peace and violence, and man versus animal.

During these years, Picasso also placed his Minotaur in other visual contexts, more limited than *Minotauromachy*, but still potent for the overall allegorical framework of his art in the 1930s. The Minotaur is depicted in moments of calm, showing a tender side as the lover of a young woman whose features resemble those of Walter. Yet the Dionysian aspects of the creature's personality seem just below the surface. Unbridled instincts are expressed in scenes of the Minotaur as a debauched reveler and, more unsettlingly, as a violent marauder. At the same time that Picasso was inventing these Minotaur scenarios, he also created prints that bear a close resemblance to them but depict coupling men and women (fig. 16). These scenes have received mixed interpretations from scholars: they are given such titles as *The Battle of Love*, *The Rape*, and *The Embrace*, indicating a conflation of lovemaking, rage, and brutality. By contrast, Picasso also shows the Minotaur at the end of his life, sacrificed in an arena as if by his own guilt, as spectators look on.

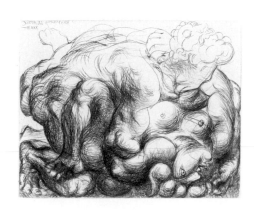

FIG. 16. *The Embrace, III.* 1933.
Drypoint. Plate: 11 5/8 x 14 3/8" (29.6 x 36.5 cm).
Abby Aldrich Rockefeller Fund, 1949

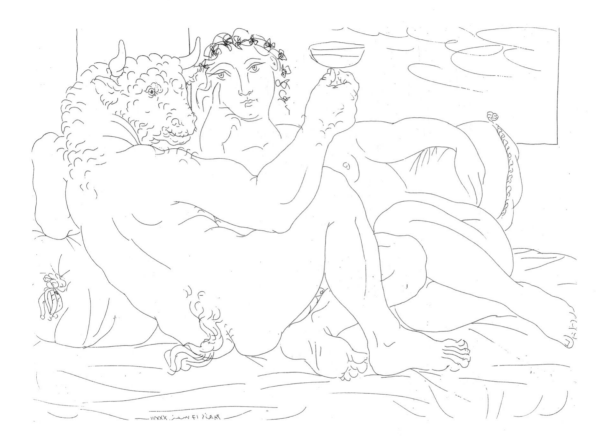

24. MINOTAUR'S REPOSE.
May 17, 1933. Etching. Plate: 7 5/8 x 10 9/16"
(19.3 x 26.9 cm).

This is the earliest of fifteen Minotaur subjects in Picasso's Vollard Suite. The suite comprises one hundred prints and was named for publisher Ambroise Vollard, who commissioned them in the 1930s in an exchange with the artist.[8]

Some of the Minotaur prints were probably meant to accompany a text by poet André Suarès titled *Minotaure*, or *Minos et Pasiphaë*, but Vollard's death in a car accident brought that project to a halt.[9]

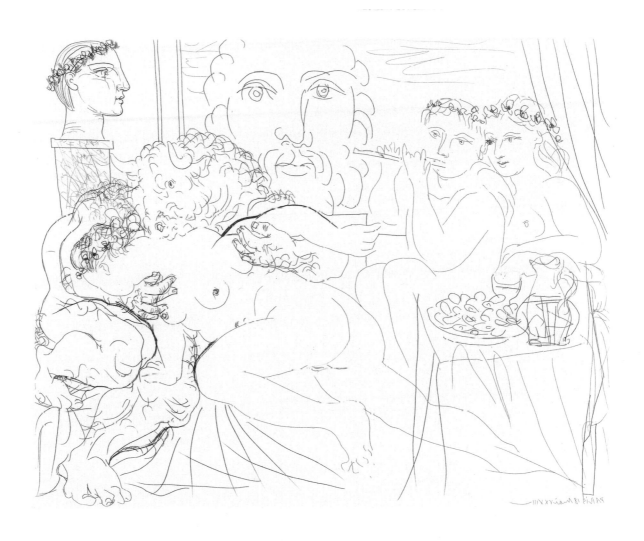

25. SELF-PORTRAIT IN THREE FORMS. May 18, 1933. Etching. Plate: 11 $^{11}/_{16}$ x 14 $^{1}/_{2}$" (29.7 x 36.8 cm).

The Minotaur became Picasso's alter ego in the 1930s, and is usually depicted with a woman representing his lover Marie-Thérèse Walter. Here, separate elements have been variously interpreted. The large, classically inspired sculpted head in the background and the small one on the pedestal have both been seen as references to the artist; yet the smaller sculpture more closely resembles Walter.[10]

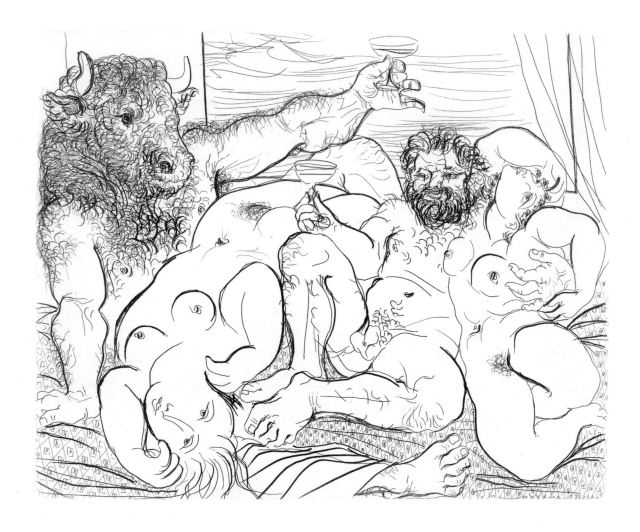

26. BACCHANAL WITH MINOTAUR.
May 18, 1933. Etching. Plate: 11 3/4 x 14 7/16"
(29.8 x 36.7 cm).

This middle-aged bearded male is recognized as a symbol of the artist, as seen also in prints from the Sculptor's Studio series (plates 16–23). Here, depicted without a classical laurel wreath, he relaxes with his models in a scene of lascivious revelry. His hairy head and body link him to the Minotaur. Note the compositional distortion of the Minotaur's right leg, extending into the bottom center.

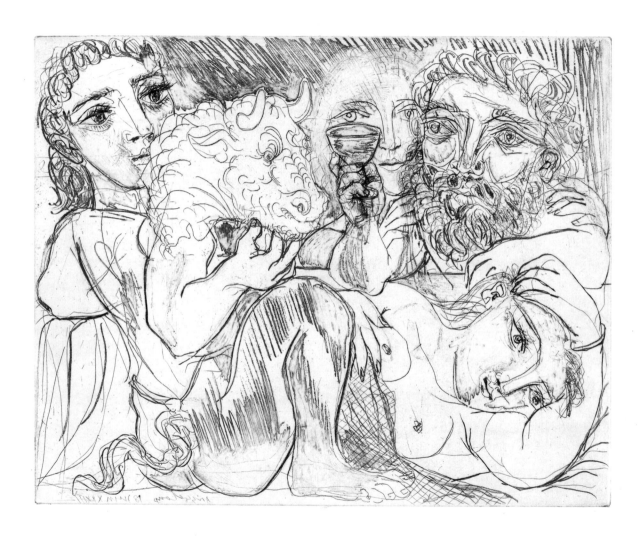

27. MARIE-THÉRÈSE DREAMING OF METAMORPHOSES. June 18, 1933. Drypoint, etching, and engraving. Plate: 11 ¹¹/₁₆ x 14 ³/₈" (29.7 x 36.5 cm).

This composition evolved through four states.[11] The first depicts a Minotaur and a bearded man toasting, with a reclining nude between them. The man and woman wear laurel wreaths. The scene grew in complexity as Picasso worked on it further, until this version with three females—all resembling Walter. The Minotaur has been replaced by only a mask and false tail around the left female's waist.

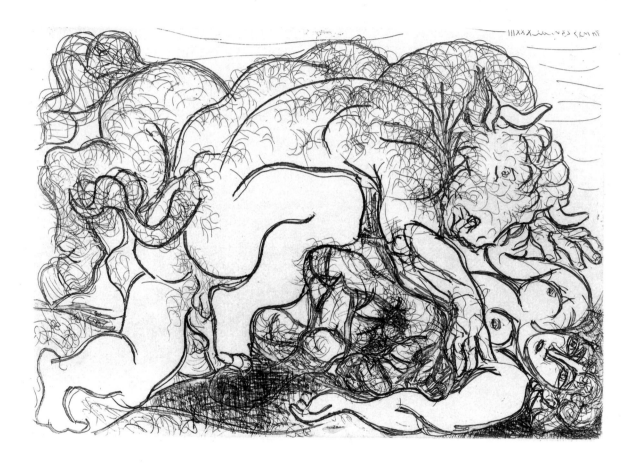

28. MINOTAUR RAVISHING A FEMALE CENTAUR. May 23, 1933. Etching. Plate: 7 9/16 x 10 9/16" (19.2 x 26.8 cm).

This scene seems to portray the Minotaur attacking a woman, but the hind legs of a horse, at upper left, reveal the female to be a centaur.[12] Early states of the print indicate not a centaur, but a horse as well as a woman, being crushed by the Minotaur. Such a scenario is familiar from Picasso's bullfight scenes that show a woman picador and her horse thrown by a bull.

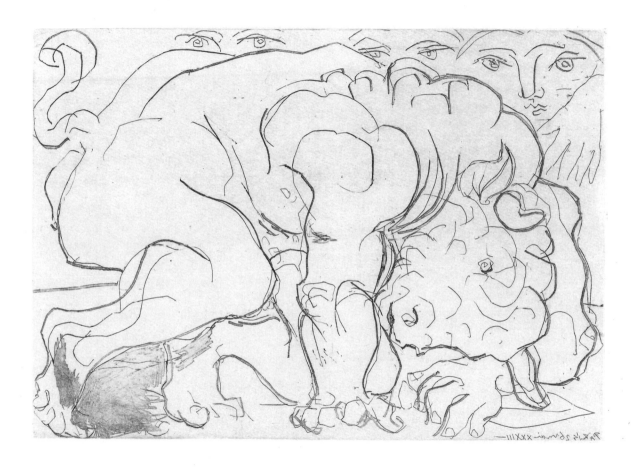

29. WOUNDED MINOTAUR.
May 26, 1933. Etching. Plate: 7 5/8 x 10 1/2"
(19.3 x 26.6 cm).

The Minotaur here assumes a posture similar to that of the attacker on the facing page. Now, however, he is wounded and contorted in pain, situated in an arena under watchful eyes that observe his suffering. A dagger is still in his hand, indicating a wound that was self-inflicted. In the bullring, a small dagger, or *puntilla*, is used to deliver the final blow to the bull's neck: the coup de grâce.

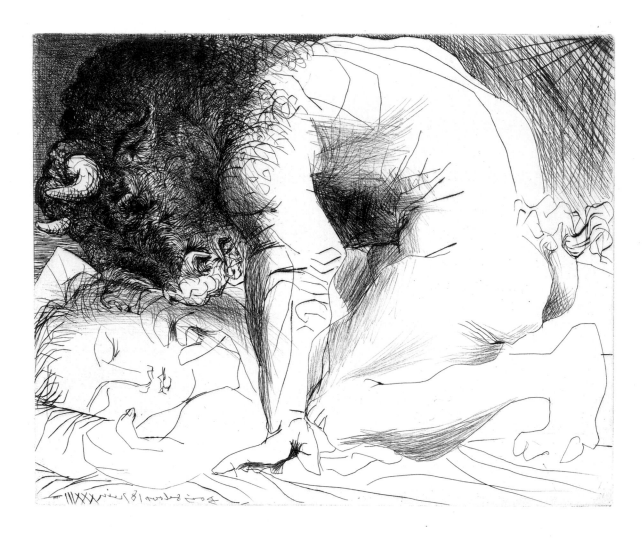

30. MINOTAUR CARESSING A SLEEPING GIRL. June 18, 1933. Drypoint. Plate: 11 $^5/_8$ x 14 $^7/_{16}$" (29.6 x 36.6 cm).

The watched sleeper is a persistent theme in Picasso's work: this is sometimes explained by the fact that the artist worked at night and had ample opportunity to observe his lovers as they slept.[13] Here, the Minotaur, seen reveling or aggressive in previous prints, has become a tender, adoring mate. The calm beauty of the sleeper and the beastly nature of the Minotaur are indicated through the use of spare and dense drypoint lines.

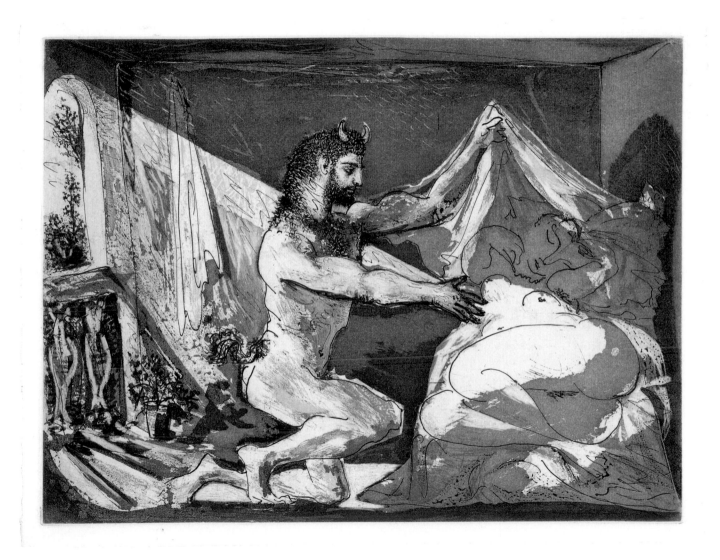

31. FAUN UNVEILING A SLEEPING GIRL.
June 12, 1936. Aquatint and engraving.
Plate: 12 $^7/_{16}$ x 16 $^7/_{16}$" (31.6 x 41.7 cm).

With its streaming light, this gently erotic image has been likened to a Christian Annunciation scene. Picasso's protagonist here has some traits of the faun, the mythic half-goat, half-man. For this print, the artist made use of tech-niques he learned in Roger Lacourière's Paris print shop. Lacourière's specialty was sugar-lift aquatint, which allowed Picasso to work with a brush and create tonal areas of gray.[14]

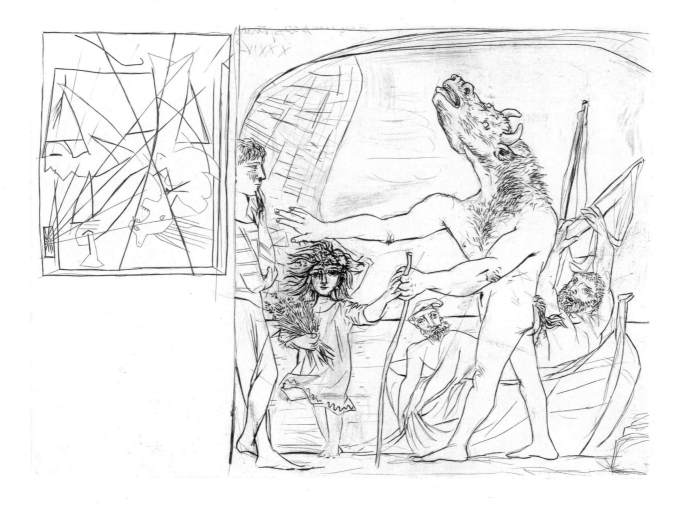

32. BLIND MINOTAUR. September 22, 1934. Drypoint and engraving. Plate: 9 ¹⁵/₁₆ x 13 ¹¹/₁₆" (25.2 x 34.7 cm).

Picasso's blind Minotaur has some characteristics of Oedipus, the mythic king who blinded himself out of remorse and was then led around by his faithful daughter, Antigone. The features of the little girl resemble those of Marie-

Thérèse Walter. At the upper left are the remains of an earlier print (now upside-down and canceled with a large X). After canceling that image on his copperplate, Picasso reused it and drew his new composition.

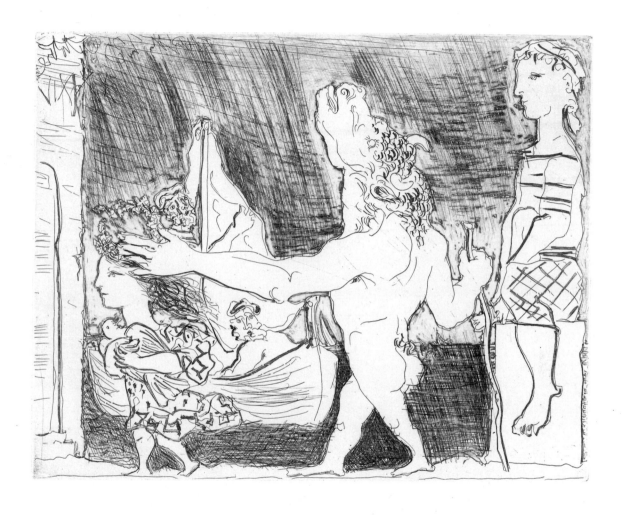

33. BLIND MINOTAUR. October 23, 1934. Etching. Plate: 9 ³/₈ x 11 ³/₄" (23.8 x 29.8 cm).

Here, Picasso changes the mood of his tale of the blind Minotaur. A sense of foreboding is evoked through the suggestion of a stormy night. Picasso created this effect by very strenuously scraping his plate with a tool usually deployed to gently burnish out unwanted areas. It is known that the printer Lacourière supplied Picasso with dozens of scrapers, and the surfaces of his copperplates were often torturously worked.[15]

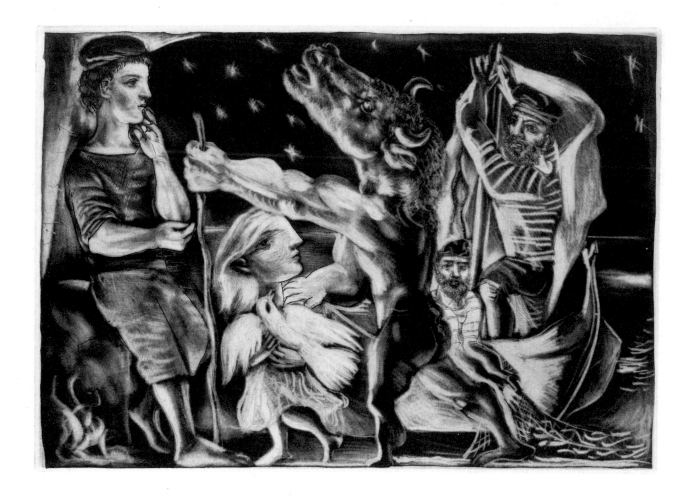

34. BLIND MINOTAUR. c. December 3, 1934, or c. January 1, 1935. Aquatint, drypoint, and engraving. Plate: 9 ³/₄ x 13 ¹¹/₁₆" (24.7 x 34.7 cm).

Here, black, velvety areas were produced with aquatint, a technique Picasso learned from the printer Lacourière. This scene of the blind Minotaur gives the middle-aged fishermen a prominent role. Their striped shirts recall those often worn by the artist. The girl's face is a distinct portrait of Walter, here seen holding a dove she kept as a pet.[16]

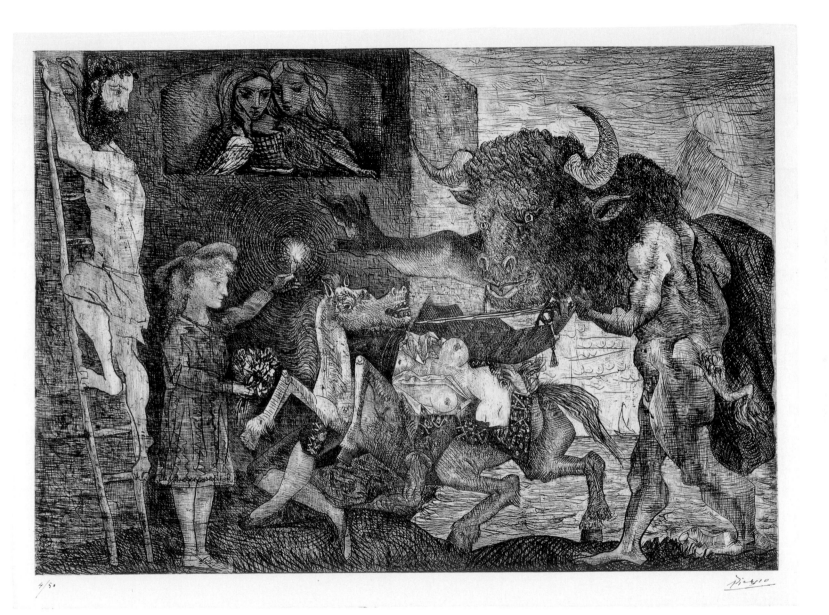

35. MINOTAUROMACHY. March 23, 1935. Etching and engraving. Plate: 19 1/2 x 27 3/8" (49.6 x 69.6 cm).

The Minotaur myth is combined here with the violence of the bullfight. This much-interpreted allegorical scene was created when Picasso's personal life was in turmoil. The cast of characters in the image includes his lover Walter in four guises: innocent child, devastated matador, and two observers on high. The wounded mare may represent Picasso's beleaguered wife Olga; the fleeing man, his father, or even the figure of Christ.

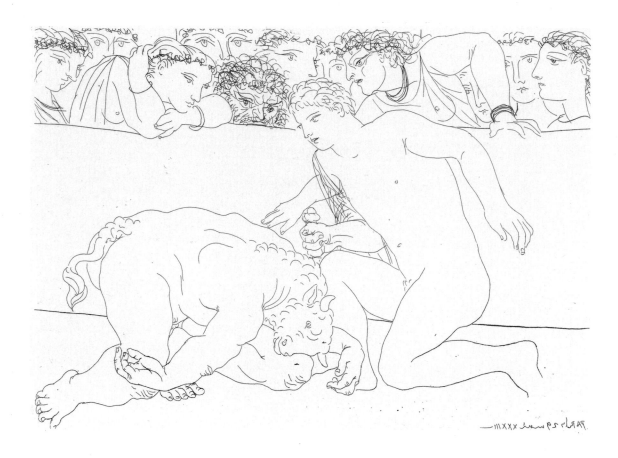

36. IN THE ARENA. May 29, 1933.
Etching. Plate: 7 5/8 x 10 5/8"
(19.3 x 27 cm).

The prints above and opposite were made on consecutive days and present an almost cinematic sequence. The first includes elements of classical Greece, as seen in the toga-clad, garland-wreathed observers and the idealized nude combatant. Both prints employ the simple line-drawing style of Attic vases. References to bullfighting are seen in the arena setting and in the final death-blow inflicted by dagger.

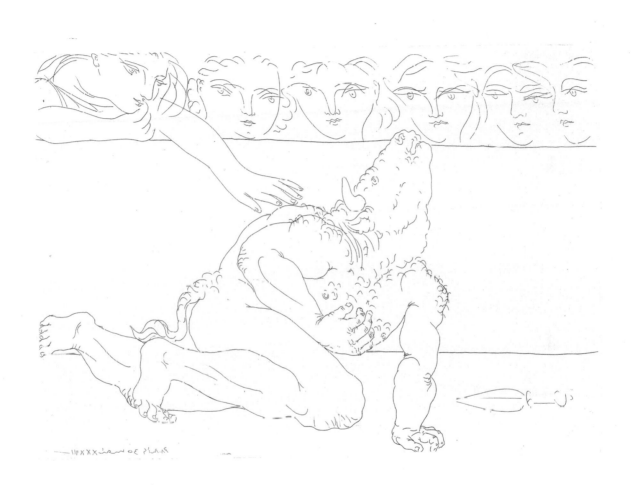

37. DYING MINOTAUR. May 30, 1933. Etching. Plate: 7 5/8 x 10 9/16" (19.3 x 26.8 cm).

In this scene, the Minotaur is left to die alone. He looks up, as if in remorse, to an arena in which the spectators have changed. The audience depicted in the print on the facing page is mixed, including an old man who may reference the artist and some women resembling Walter. Here, however, all the witnesses to the scene have become Walter, as if she were the ultimate reason for the Minotaur's guilt and final demise.

5. Reenacting the Bullfight

Picasso's Spanish heritage instilled in him a passion for bullfighting.[1] He began attending this national spectacle as a boy, accompanying his father. It has also been said that, when he was young, he drew bullfight scenes and sold them near the arena so he could earn money for tickets.[2] As an adult, after moving to France, he would always make time to attend the bullfights on visits home to Spain. Following the outbreak of the Spanish Civil War in 1936, Picasso, whose sympathies lay with the Republicans, never returned to his country. But when he was living in the South of France, he continued to gather friends and family for bullfights at arenas in that region.[3]

The bullfight is a recurring theme in Picasso's art. His very first print, created in 1899, shows a picador holding a lance. Many of his early paintings on this subject are colorful, picturesque renderings, and in later life, too, he would present the bullfight as a scene of decorative charm as well as action—as in the set of illustrations he made for the book *La tauromaquia* (Tauromachy; fig. 17), with a text by the eighteenth-century toreador José Delgado (also known as "Pepe Illo").[4] There, Picasso utilized the technique of sugar-lift aquatint, enabling him to brush his compositions directly onto the copperplate. With just a few strokes, he captured the drama, choreography, and beauty of the event.

The bullfight motif was, in effect, dormant throughout Picasso's Blue and Rose periods and into the Cubist years. But during the 1920s, in his so-called classical period, he returned to the subject. In that decade, he introduced the bull and the horse as primary protagonists, and their relationship to each other took on sexual dimensions. By the 1930s, the bullfight was again at center stage in the artist's work, but now layered with mythic overtones, its inherent violence stressed.

In the Vollard Suite etchings of that decade, commissioned by publisher Ambroise Vollard, the bullfight appears as a motif in late 1933, possibly inspired by a family trip to Spain in the preceding summer.[5] In the suite's sequence, the subject follows a series devoted to the Minotaur, thereby linking the two themes and imparting an aura of myth to the bullfight. But in an earlier etching, from 1930—*Death of Orpheus*, a study for Ovid's *Metamorphoses*—Picasso had already suggested that link (fig. 18).[6] Here, he focused on a relatively minor detail of the Orpheus story, involving a herd of oxen, to bestow connotations of bullfighting onto the scene. Ox heads figure prominently, mænads attack with weapons resembling the picador's lance, and the dying Orpheus resembles Picasso's depictions of picadors and matadors thrown across the backs of bulls.[7] The overall composition, contributing a sense of vivid fury, anticipates the structure and violence found in prints of bullfights that follow.

FIG. 17. *Lancing the Bull*. 1957. From *La tauromaquia* (Tauromachy), with a text by José Delgado ("Pepe Illo"), published 1959. Aquatint. Plate: 7 3/4 x 11 5/8" (19.7 x 29.5 cm). The Louis E. Stern Collection, 1964

Picasso's personal life had become increasingly untenable, as he juggled relationships with his lover Marie-Thérèse Walter, his wife Olga, and their son Paulo. His fiercest bullfight scenes were created during this time. He invariably set a bull in confrontation with a horse, which in turn is ridden by a female picador whose features resemble Walter's.[8] Her costume is revealingly torn and she seems to be either swooning in rapture or dying a painful death. The tormented horse in such portrayals suggests Picasso's suffering wife, while the raging bull symbolizes the artist himself, as savage and sexual elements commingle.

These bullfight images, set in a shallow frontal space, are close-up and confrontational, in contrast to picturesque renderings of the arena as a whole. They are also dramatically abstracted: instead of recording an event, they seem primarily intended to convey brutal confrontation. Their vehemently etched lines, filling the sheet, can be seen as allied to the "automatism" of Surrealist art, the object of which was to tap into the unconscious by allowing the artist's rendering hand to wander, uncontrolled by rational thought. Later, Picasso elucidated his approach to representation, no matter the pictorial syntax: "Whatever the source of the emotion that drives me to create, I want to give it a form which has some connection with the visible world, even if it is only to wage war on that world."[9]

Etching was a particularly effective technique for Picasso's bullfights of the 1930s. Its bristling, nervous line is well suited to conveying an intensely frenzied atmosphere, and allows for tiny, mesmerizing details—the embroidery on a costume, the hair of a horse's tail, the contorted face of a bull. In the late 1950s and early 1960s, when bullfights again appear in his prints, Picasso was after different effects, now using color linoleum cut. By this time, his personal life was stable and settled, without the conflicts and anxieties of previous times. He would soon marry Jacqueline Roque, with whom he lived for nearly twenty years, until his death in 1973.

But like the earlier etchings, the linoleum cuts present an abstracted version of the bullfight. Again the subject is deployed in a shallow space, but the compositions are now schematic and decorative, even while the action remains intense. The viewer is no longer face-to-face with violence, and has a wider view of the arena. The protagonist is still the horse-mounted picador, but tangential figures—such as a matador with flowing cape in the background, or spectators in the stands—seem to be included primarily for rhythmic effects. Here, rather than an outpouring of the unconscious, as in the black-and-white etchings of the Surrealist period, the linoleum-cut bullfights evoke a lush, almost vegetal world. Their forms even recall the late cutouts of Picasso's old friend and rival Henri Matisse, who died several years before they were completed.

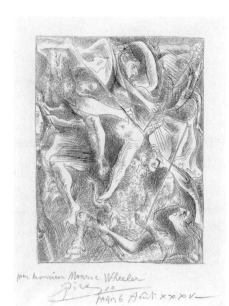

FIG. 18. *Death of Orpheus.* 1930.
Unpublished plate for *Les métamorphoses*
(*Metamorphoses*) by Ovid, published 1931.
Etching. Plate: 12 5/16 x 8 11/16" (31.2 x 22.1 cm).
Gift of Monroe Wheeler, 1967

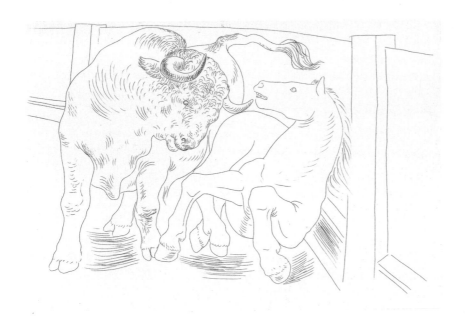

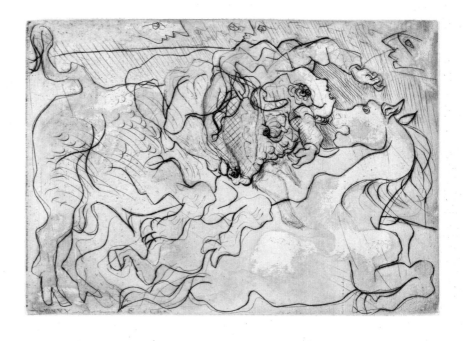

38. BULL AND HORSE. 1929. From *Le chef-d'œuvre inconnu* (*The Unknown Masterpiece*), by Honoré de Balzac, published 1931. Etching. Plate: 7 5/8 x 10 7/8" (19.4 x 27.7 cm).

39. WOUNDED FEMALE BULLFIGHTER. November 8, 1933. Etching and drypoint. Plate: 7 13/16 x 10 7/8" (19.8 x 27.7 cm).

In bullfighting, the picador, who lances the bull, is mounted on a horse. From the 1920s on, Picasso's depictions of the event include the horse in a primary role. The earlier print here is in the linear, naturalistic style of the artist's classical period.[10] The bull and horse seem to assume male and female roles. The frenzy of the later example is typical of Picasso's work in the 1930s, when his personal life was increasingly fraught.

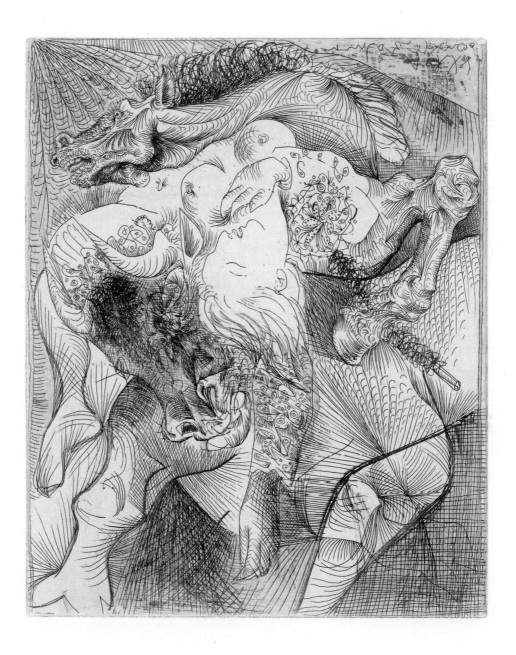

40. MARIE-THÉRÈSE AS BULLFIGHTER.
June 20, 1934. Etching. Plate: 11 ³/₄ x 9 ³/₈″
(29.8 x 23.8 cm).

Though rare, female bullfighters have practiced for centuries, more recently performing on horseback so as to be better protected.[11] Here, the thrown bullfighter has the features of Picasso's lover Marie-Thérèse Walter. If the charging bull symbolizes the artist, and the tortured horse represents his wife Olga, the painful triangle of Picasso's life at the time is fully portrayed.

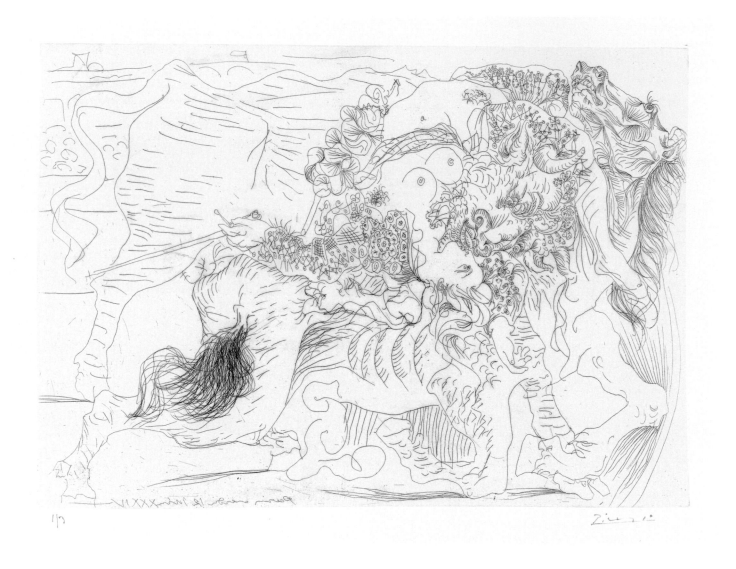

41. FEMALE BULLFIGHTER. June 12, 1934. Etching. Plate: 19 x 26 $^{11}/_{16}$" (48.3 x 67.8 cm).

Here, the gesture of the bull has been interpreted as a kiss being placed on the face of the female bullfighter—underscoring the idea of the two as Picasso and Walter.[12] The bullfighter's torn costume reinforces the sexual intimation.

This is one of three special examples of the composition made on vellum and signed and numbered in red. In this period, Picasso made similar special examples of the prints in the Vollard Suite.

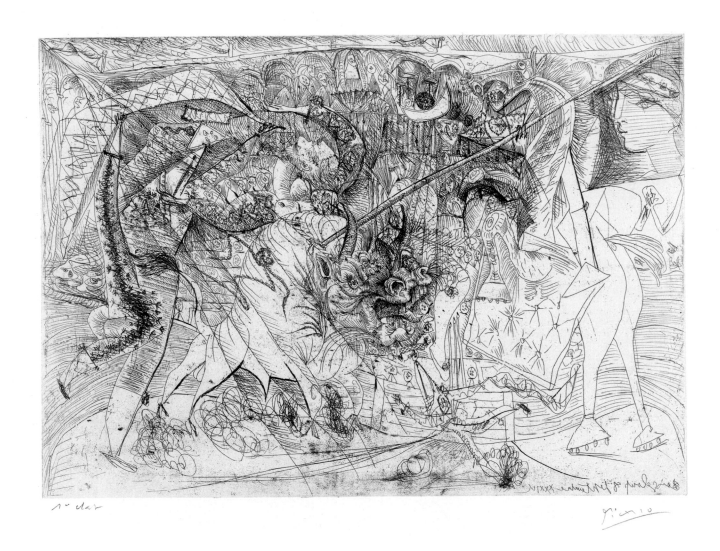

42. LARGE BULLFIGHT. September 8, 1934. Etching. Plate: 19 $^7/_{16}$ x 27 $^1/_{16}$" (49.4 x 68.7 cm).

A tour de force of etching, this print veers toward total abstraction in its rendering of the fury of the bullfight. The tangled composition calls to mind the practice of Surrealist automatism, with its spontaneous outpouring of the unconscious, while it also anticipates the allover skeins of Jackson Pollock's art. A charging bull emerges at center and a placid Walter observes from the stands at the upper right.

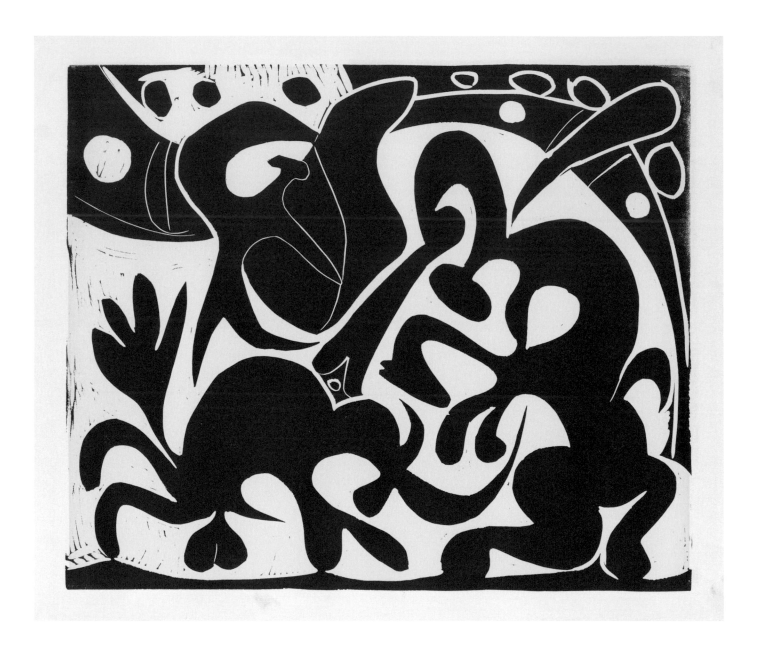

43. PICADOR. April 14, 1959. Linoleum cut. Composition: 20 $^{13}/_{16}$ x 25 $^{3}/_{16}$″ (52.9 x 64 cm).

While living in the South of France in the early 1950s, Picasso began to work with printer Hidalgo Arnéra, first utilizing the technique of linoleum cut for posters. The artist turned to it for more serious printmaking later in the decade, encouraged by his collaboration with Arnéra, whose workshop was in Vallauris. The two versions of a composition shown here demonstrate the possibilities for experimentation inherent in printmaking.

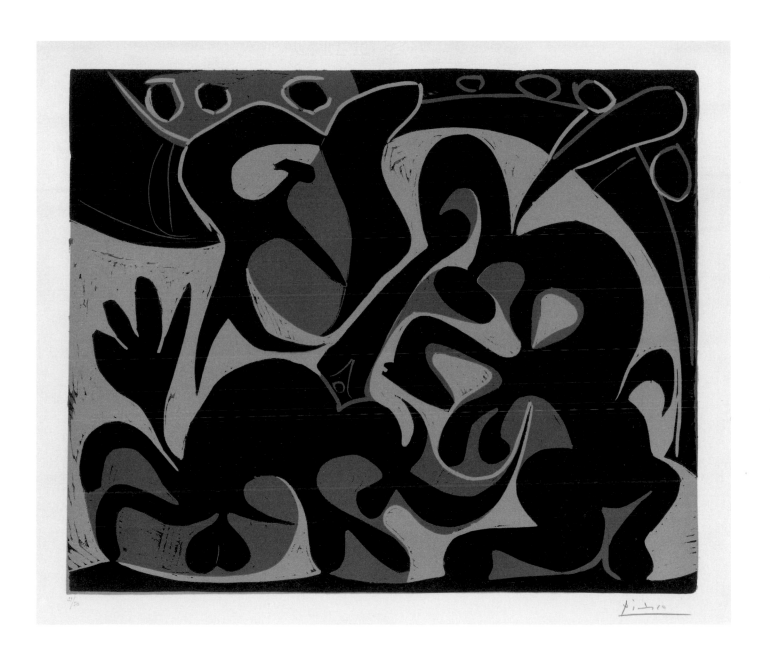

44. PICADOR. c. August 30, 1959.
Linoleum cut. Composition: 20 $^7/_8$ x 25 $^1/_4$"
(53.1 x 64.2 cm).

This print has a narrative reading, with suggestions of afternoon shadows. The version on the left is more abstract, but still conjures up blazing sun and bloody violence. (In fact, bullfight tickets are priced according to a seat's exposure to sun.) According to Arnéra, the printer, the composition in red and yellow—the Spanish national colors—celebrates the anniversary of the 1931 declaration of the Second Republic, which fell to Franco in 1939.[13]

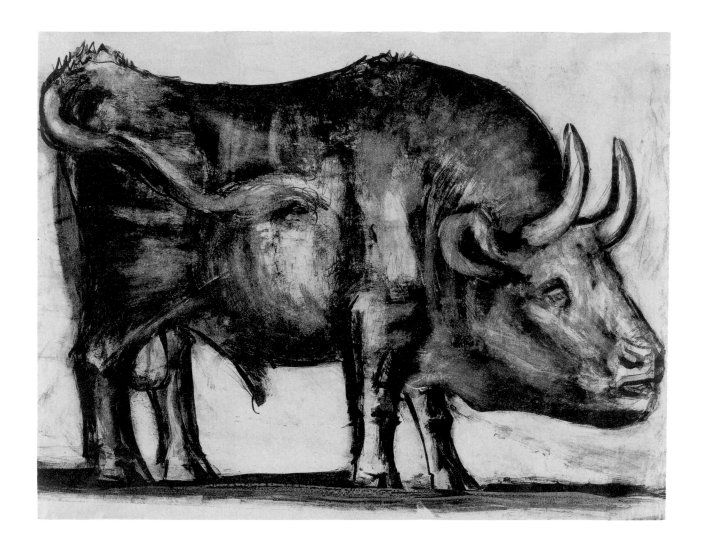

45. BULL, state III. December 12, 1945. Lithograph. Sheet: 13 1/16 x 17" (33.2 x 43.2 cm).

Picasso began to work at Mourlot's printshop in late 1945 and ultimately made about four hundred lithographs there. He collaborated with the printers, working side by side with them, and also operated from home, with proofs being sent back and forth between the shop and his studio. When Picasso moved to the South of France, Mourlot often brought materials to him so that the artist could continue making lithographs.

6. Abstracting the Bull

In the second half of the 1940s, Picasso delved into lithography. This technique is particularly useful for tracking the creative process, which was increasingly important to the artist. Drawn on a flat surface, a lithographic composition can be altered more easily than one in an intaglio technique such as etching or aquatint, both of which involve incising into a metal plate. Lithographs therefore allow for more developing stages (or states). These states are recorded by a run through the printing press, and are then preserved on paper.

Among the most vivid documentations of Picasso's creative thinking is the series of lithographic bulls he completed at the print workshop of Fernand Mourlot in Paris. Picasso came to the shop in November 1945, just after the end of World War II, on the recommendation of Georges Braque. There, he encountered a sizable printing business with a team of master craftsmen. He sparred amicably with the printers, and found that his imagination was fueled by their collaboration. In his first four months at Mourlot's, working side by side with these men, morning to night, he created several extended series, including the Bulls, which evolved from December 12, 1945, to January 17, 1946. (When the workshop closed for Christmas, Picasso continued experimenting at home.)

Picasso had tried lithography before—he made twenty or so examples in the 1920s—but had not been truly inspired by the technique. He lacked the sort of tutelage necessary to enrich his understanding of the medium—the kind of guidance he had received in intaglio techniques with printer Roger Lacourière in the early 1930s. With lithography, Picasso finally found that camaraderie and enthusiasm with Jean Célestin and "Père" Tutin at Mourlot's print shop.[1] Célestin would later say of Picasso, "There was no stopping him. As lithographers we were astounded by him."[2]

The bull, an iconic emblem of Spain, was a favorite motif of the artist. Like the mythic Minotaur, it served as one of the artist's alter egos, manifesting itself in countless bullfight scenes over the years. In his 1937 painting *Guernica*, a bull, standing somberly aside, serves as a complex, multifaceted symbol. But Picasso also presented the bull in whimsical terms, as in his 1943 sculpture made from a bicycle seat and handlebars. Something of that sculpture's schematic characterization is found in the final print of the lithographic Bulls series. But before Picasso arrived at that point, he had thoroughly analyzed his subject, treating the bull less as a symbol than as a specimen. A similar kind of analysis and fragmentation manifests itself in a plywood sculpture he made around 1958—but in that case, we cannot trace Picasso's artistic steps (fig. 19).[3] The lithographic series, on the other hand, is a primer on Picasso's process and his approach to abstraction.[4] Such analysis—showing the solid beast to have a linear, almost hieroglyphic equivalent—reveals the artist's wit, as well as his profound skill at caricature.[5]

FIG. 19. *Bull.* c. 1958.
Plywood, tree branch, nails, and screws.
46 1/8 x 56 3/4 x 4 1/8" (117.2 x 144.1 x 10.5 cm).
Gift of Jacqueline Picasso in honor of the
Museum's continuous commitment to Pablo
Picasso's art, 1983

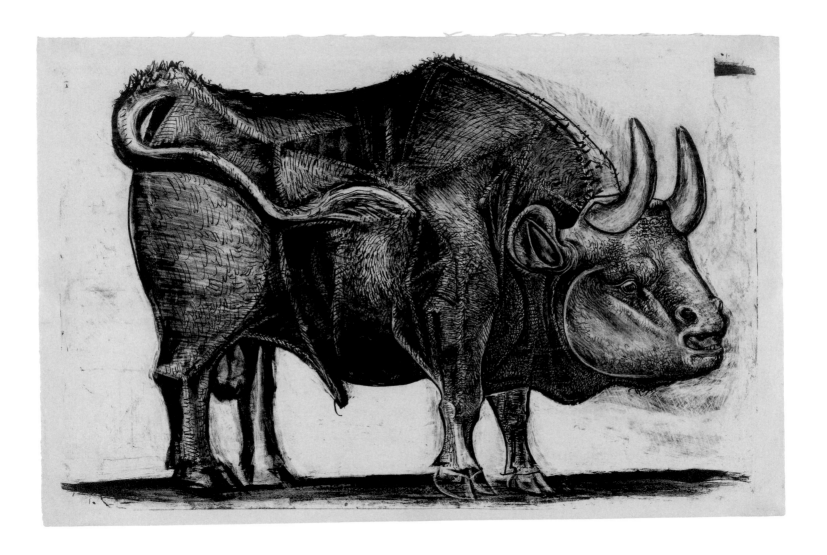

46. BULL, state IV. December 18, 1945. Lithograph. Sheet: 13 ⁵/₁₆ x 20 ⁵/₁₆" (33.8 x 51.6 cm).

The Mourlot printers demonstrated the lithographic technique for Picasso, but the rules only challenged him to go in other directions. Using a scraping tool to delete areas of his compositions, and sometimes making pen additions, he was often in danger of ruining the carefully prepared surface of the lithographic stone. But, as Mourlot noted, "He looked, he listened, he did the opposite of what he had learnt—and it worked."[6]

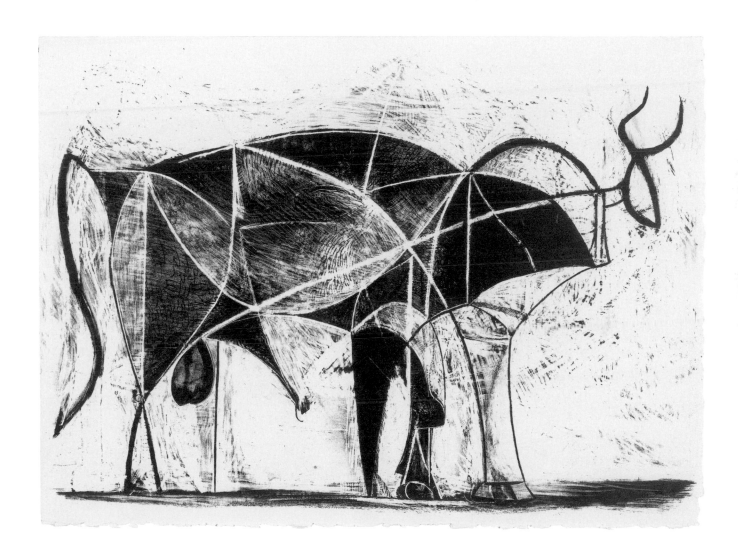

47. BULL, state VII.
December 26, 1945. Lithograph.
Sheet: 12 ¹⁵/₁₆ x 17 ¹/₂" (32.8 x 44.4 cm).

This print shows evidence of Picasso's furious attack on the lithographic stone as he defined his composition. Mourlot's printers were dismayed at his relentless scraping and changing. "After this sort of treatment," they said, "the design generally becomes indecipherable and is destroyed. But, with him! Each time it would turn out very well. Why? That's a mystery."[7]

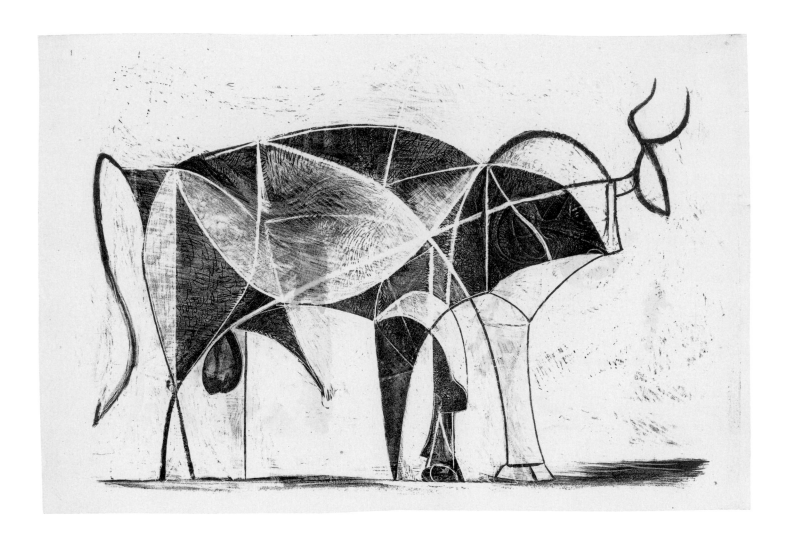

48. BULL, state VII, variant.
December 26, 1945. Lithograph.
Sheet: 13 $\frac{1}{16}$ x 19 $\frac{7}{16}$" (33.2 x 49.3 cm).

This image, seemingly reduced in form, actually represents the same stage of the composition seen in the previous example.[8] There, more ink was applied to the stone, so all markings were revealed in the printing. Here, yellow imagery on the verso shows through. Randomly printed sheets of paper like this were available in the shop for trial runs.

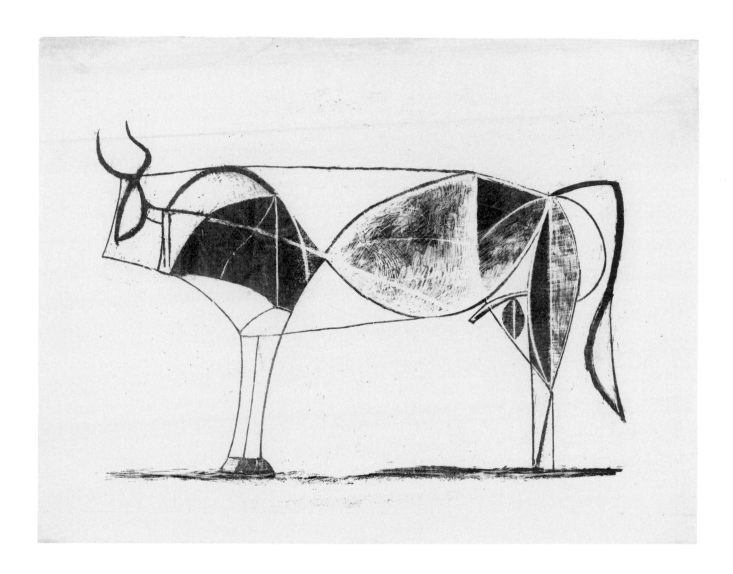

49. BULL, state X, counterproof.
December 28, 1945. Lithograph.
Sheet: 15 ¹¹/₁₆ x 20 ⁹/₁₆" (39.9 x 52.2 cm).

According to Mourlot's documentation of the Bulls series, Picasso's composition went through eleven states.[9] Later scholars raised that number to sixteen, including two counterproofs.[10] This image in reverse is one of the counterproofs, made by laying a piece of paper on a freshly printed example, still wet with ink. It is not known why Picasso wished to see the image in this orientation.

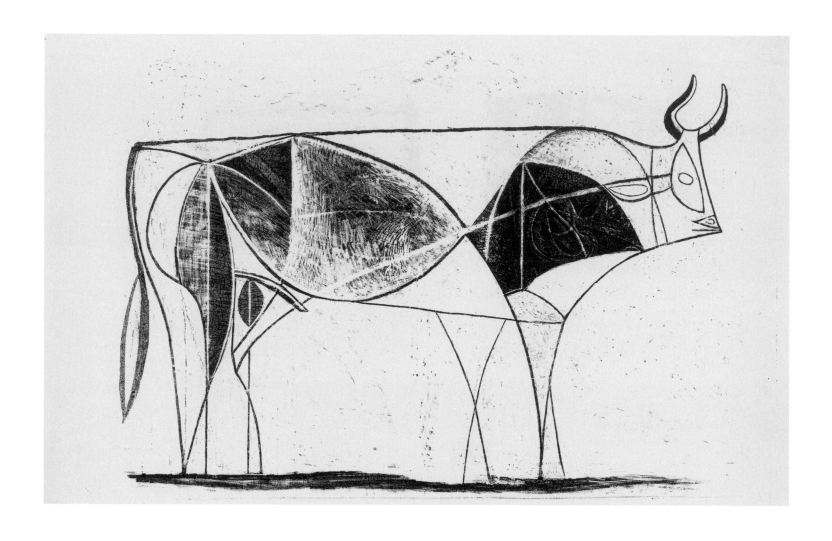

50. BULL, state XI. January 2, 1946. Lithograph. Composition: 12 $^{7}/_{16}$ x 19 $^{3}/_{16}$" (31.6 x 48.8 cm).

As Picasso continued to segment and distill the image of the bull, it began to resemble the diagrammatic charts that sometimes hang in butchers' shops. The printers were shocked to see how the bull was evolving, but Picasso joked with them about it, amused by the allusion to cuts of beef. "Look," he said, "we ought to give this bit to the butcher. The housewife could say: I want that piece, or this one. . . ."[11]

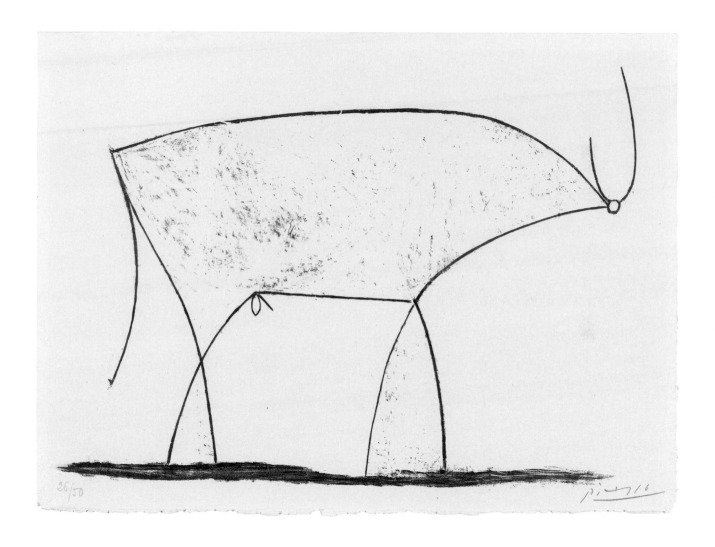

51. BULL, state XIV. January 17, 1946. Lithograph. Sheet: 13 ¹/₁₆ x 17 ¹/₂" (33.2 x 44.4 cm).

It is noteworthy that even in this schematic rendering, the bull's genitals are still partly visible. That sign of potency had been prominent in Picasso's earlier renderings. It was only at this abstracted stage of the *Bull* that Picasso decided to make an edition of prints. He was satisfied, but his printers were baffled: "That Picasso! He finished where, *normally*, he ought to have started."[12]

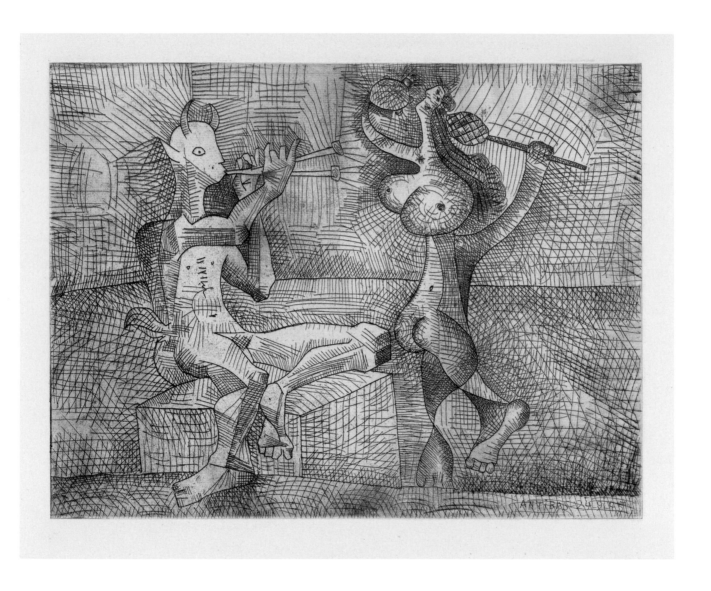

52. FAUN AND DANCER.
September 24, 1945. Etching.
Plate: 10 $^7/_{16}$ x 13 $^{11}/_{16}$" (26.5 x 34.7 cm).

Printer Louis Fort, retired in the South of France, worked on this etching with Picasso. The two were good friends and Picasso stayed at Fort's house with his new lover, Françoise Gilot. Here, the female figure, with her full breasts and long hair, signals Gilot.[1] But her tambourine recalls a print of Dora Maar (plate 99), with whom Picasso had recently parted ways.

7. Fauns and Satyrs

Ancient myths and deities appeared as motifs in Picasso's art starting with his classical period in the late 1910s and 1920s. Among the early touchstones is his 1923 painting *Pipes of Pan*, a study in serenity and balanced monumentality. Yet myths take many forms. Pan, a faun—half-man, half-goat—is sometimes seen as a gentle woodlands creature, but also can be a reveling satyr dancing with frenzied mænads. His pipes, too, have different shapes. In prints, Picasso favored a version with two long reeds joined at an acute angle, known as an *aulos*—an instrument often associated with debauchery.[2] As ever, Picasso made use of whatever aspect of classical myth suited his art and its current narratives.

Fauns and satyrs appear with considerable frequency in Picasso's work of the mid- to late 1940s, when the artist was spending more time away from Paris, on the Côte d'Azur. The locale of southern France, so steeped in ancient history, provoked an outpouring of such imagery. ("It is strange," he once remarked, "in Paris I never draw fauns, centaurs, or mythical heroes . . . they always seem to live in these parts.")[3] But it seems also that mythic revelers materialized when Picasso was in a happy frame of mind. In 1945 the war was ended and he had found a new love, the beautiful young Françoise Gilot; by 1946, they were expecting their first child.

But these themes had been foreshadowed a few years earlier, with a project in Paris. During the Occupation, Picasso had the idea of commemorating the poetry of his late friend Ramón Reventós, whom he had known during his early days in Barcelona.[4] Picasso trekked to the Bibliothèque Nationale to copy Reventós's *Dos contes* (Two tales), stories that happen to feature a faun and a centaur. He eventually made illustrations for two editions of the Reventós book, one in Catalan and the other in French (fig. 20).[5]

Ancient themes emerge again in linoleum cuts of the late 1950s, when Picasso was in a loving and stable relationship with Jacqueline Roque, who would become his second wife in 1961. The linoleum-cut process fosters curving lines and flat areas of color, as the material is soft and easy to gouge, and the printing surface is uniform. Working with printer Hidalgo Arnéra in Vallauris, Picasso took advantage of those qualities in a series of daytime pastoral scenes and depictions of nighttime revelries. Later, possibly inspired by his renewed efforts in etching and aquatint with the printers Piero and Aldo Crommelynck, who had set up a workshop nearby, Picasso returned to some of his linoleum cuts and gave them a new sense of nuance and tone. Still working with Arnéra, he concocted a rinsing technique that involved the bathroom shower.[6] By manipulating black ink, he gave his mythic characters an eerie cast. Going still further, he occasionally added watercolor, allowing for even more elaborate changes of mood.

FIG. 20. *Faun Flutist*, II. 1948. From *Deux contes/ Dos contes* (Two tales) by Ramón Reventós, published 1948. Drypoint. Page: 13 x 10 1/8" (33 x 25.7 cm). The Louis E. Stern Collection, 1964

53. PIPES, state I. c. August–September 1946. Etching and drypoint. Plate: 10 9/16 x 13 15/16" (26.8 x 35.4 cm).

Picasso's creative process is evident in the two prints on these facing pages. Here, the artist starts out with a heavily gouged angular line that gives structure and definition to his allover composition. The reference to Gilot, as the

dancing mænad at the center, is clear. The tambourine she holds is barely noticeable, becoming just another geometric form balancing the composition.

54. PIPES, state VI. c. August–September 1946. Etching and drypoint.
Plate: 10 ¹¹/₁₆ x 13 ¹⁵/₁₆" (27.2 x 35.4 cm).

Around this time, Picasso began to depict Gilot in his paintings as a flower woman. That symbolism is evident here with shapes that resemble petals, stems, and leaves. The green ink adds to a sense of verdant lushness. The mænad's role as music maker has diminished, as her tambourine blends into the overall composition. Yet the lustful satyr remains close by, explicitly aroused.

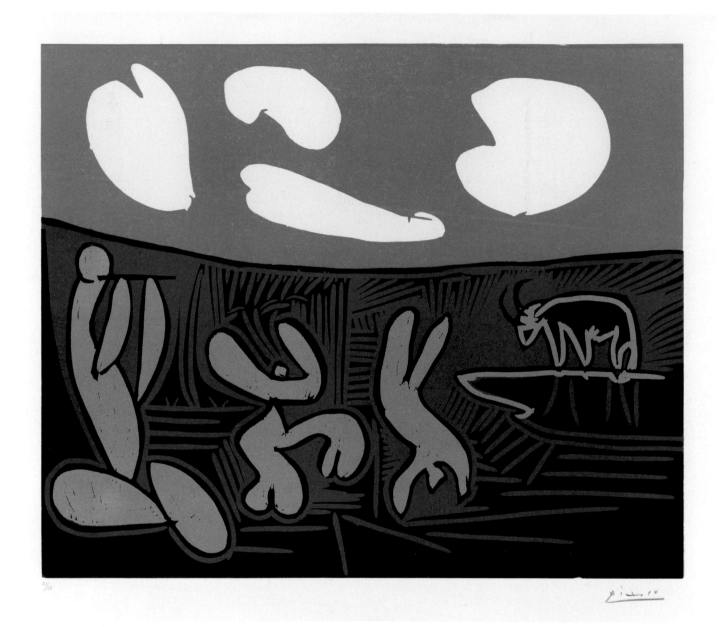

55. BACCHANAL WITH ACROBAT.
November 1959. Linoleum cut.
Composition: 20 ¹¹/₁₆ x 25″ (52.5 x 63.5 cm).

This decorative pastoral scene recalls the cutouts of Henri Matisse. But Picasso's vocabulary of myths remains. As in the previous etchings, a pipe-playing creature appears at left, a dancing mænad in the middle, and a somersaulting faun at right. A goat suggests Pan's herding duties. Here, Picasso worked on separate linoleum blocks for the sky and for the landscape, fitting the blocks together like a puzzle.[7]

56. NOCTURNAL DANCE WITH OWL.
November 18, 1959. Linoleum cut.
Composition: 20 9/16 x 25 1/4"
(52.3 x 64.2 cm).

The figure at the right, with goat's hooves, takes on the identity of Marsyas, the mythic deity whose music accompanied Dionysian revelries. This nighttime bacchanal in linoleum cut was created in two steps. The sheet was first printed entirely in black from an uncut piece of linoleum. The composition was then gouged out and the surface of the linoleum was inked in brown and printed over the black.

57. NOCTURNAL DANCE WITH OWL.
November 18, 1959. Linoleum cut,
rinsed 1963–64. Composition and sheet:
24 x 29 ¼" (61 x 74.3 cm).

In the early 1960s, with an experimental technique, Picasso revisited the block for the composition on the previous page. What he did baffles even conservators studying these works under microscopes: it involved a combination of printing, hand-inking, and rinsing under a bathroom shower. His wife Jacqueline helped with this unconventional process. Its tonal effects heighten the sense of crazed emotion in this scene.

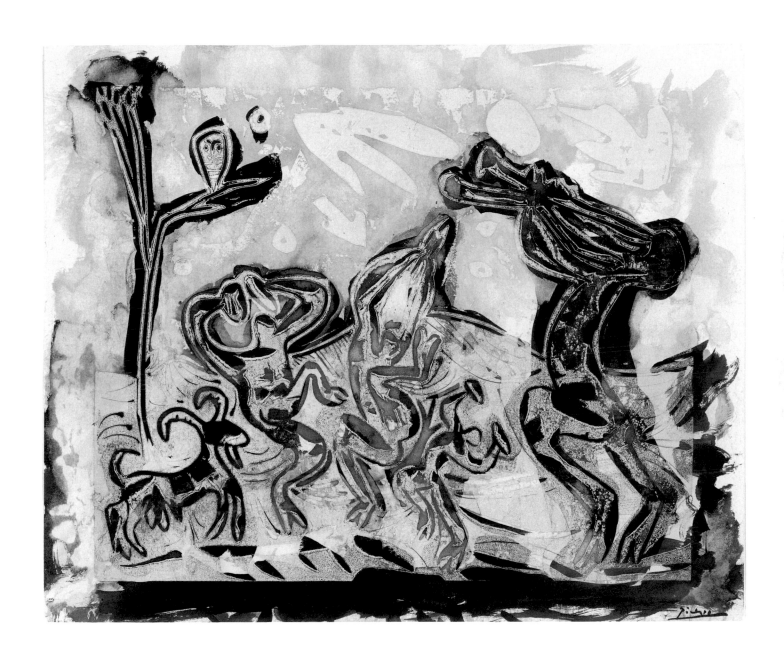

58. NOCTURNAL DANCE WITH OWL. November 18, 1959. Linoleum cut, rinsed 1963–64. Composition and sheet: 24 $^7/_{16}$ x 29 $^7/_{16}$" (62 x 74.8 cm).

Here, Picasso takes advantage of one of printmaking's distinct attributes—the ability to experiment continuously with the same composition. He turns the bacchanal on the facing page into a joyous scene suggesting a celebration of spring. After using his novel rinsing technique, Picasso made additions by hand in watercolor, especially evident in the margins at bottom left and right, where the corners of the printing block are visible.

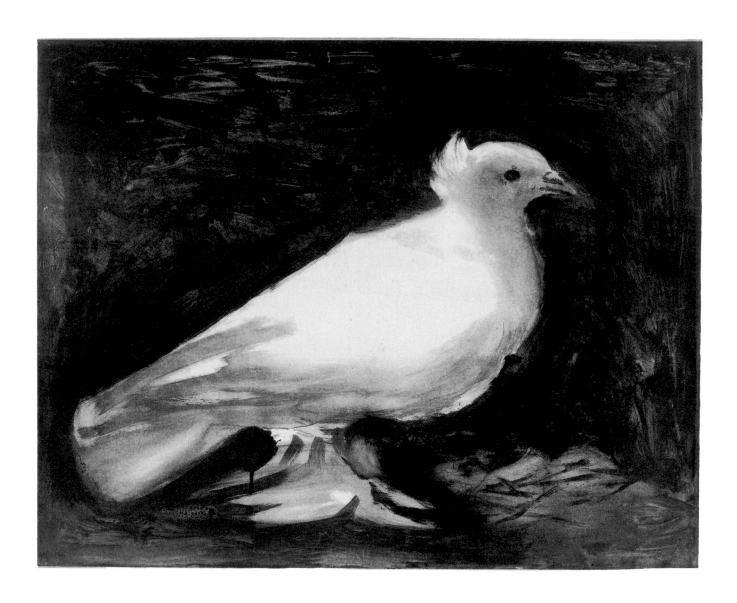

59. DOVE. January 9, 1949. Lithograph. Composition and sheet: 21 ⁵/₈ x 27 ³/₁₆" (55 x 69.1 cm).

Considered a lithographic feat, with its subtle gray washes, this print was chosen by Picasso's friend Louis Aragon, a Surrealist poet and political activist, as the image for a poster announcing a 1949 Communist peace conference in Paris.

It would be followed by many more Picasso doves adorning further peace posters. This bird is actually a pigeon given to Picasso by Matisse. (Ironically, pigeons are known as mean birds.)

8. Animals Real and Imagined

Picasso was a great animal lover and always surrounded himself with pets. When he was young, his father, an artist himself, kept pigeons and painted them as a specialty. Picasso also kept pigeons, as well as canaries and turtledoves, and was even known to have tamed an owl that sat on his finger.[1] This sympathetic connection to animals served him well in his art. He could capture an animal's most distinctive features and movements, and was adept at depicting fur, hides, feathers, claws, and hooves.

Animals also served as vehicles for a range of emotions in Picasso's art.[2] Gentle monkeys and serene horses are found in his Rose period.[3] Bulls, so linked to his Spanish heritage, began to appear even earlier, and are a primary subject again in the 1920s and 1930s. During the Surrealist years, animals assumed a role in Picasso's evolving personal mythology: the raging bull and the fearsome Minotaur—half-man, half-bull—functioned as his symbolic alter egos. In the late 1930s, during the Spanish Civil War and on the brink of World War II, animals in his art expressed the terror and ferocity of the times, whether in monumental works such as *Guernica* of 1937, or in smaller, easel-size paintings that show screaming cocks, or vicious cats tearing apart birds. Later, in yet more somber terms, the goat's head became a still-life object, in works that fall within the tradition of *vanitas* paintings, representing life's transience.

But many of Picasso's animals are free of such dark and complex interpretations. For a new version of an eighteenth-century natural history by Georges-Louis Leclerc, Comte de Buffon, Picasso depicted thirty-one animals, with apparent ease and pleasure. There is great charm in these beasts: among them is a comical ostrich speeding by, a friendly monkey holding out a paw, a ram posing with great daintiness, and a cat that seems almost to purr. Picasso made the Buffon compendium in 1936, soon after his daughter Maya was born; perhaps he planned to teach the new baby all about the animal kingdom through these delightful creatures. Playful animals also appear in Picasso's work after his children Claude and Paloma are born: consider the winsome 1950 sculpture *She-Goat*, the body of which is made up of old jugs, baskets, and other detritus, all cast in bronze (fig. 21).

Elsewhere, Picasso presents the animal as a universal symbol. His "peace dove" has been visible worldwide, adorning countless posters for Communist party peace congresses, and adapted to other purposes as well.[4] Picasso was a party member from 1944 on, and his doves not only appeared on posters, but also found their way onto postage stamps, buttons, and other paraphernalia.[5] However, the first of the posters, from 1949, had particular significance: it announced a congress held at the time of the birth of his daughter, Paloma, whose name derives from the Spanish *paloma de la paz*—dove of peace.

FIG. 21. *She-Goat.* 1950.
Bronze. 46 3/8 x 56 3/8 x 28 1/8" (117.7 x 143.1 x 71.4 cm). Mrs. Simon Guggenheim Fund, 1959

60. OSTRICH. 1936. From *Histoire naturelle* (*Natural History*), by Buffon, published 1942. Aquatint and drypoint. Page: 14 ³/₁₆ x 11 ¹/₄" (36 x 28.5 cm).

This print and those that follow appear in a book with excerpts from *Histoire naturelle* (*Natural History*), by Georges-Louis Leclerc, Comte de Buffon, a well-known eighteenth-century naturalist. Buffon's study, systematically presenting all kinds of animals, ran to forty-four volumes and was widely read and respected. Picasso probably did not refer to Buffon's text in drawing his animals, as he had his own ideas about how they should look.

61. HORSE. 1936. From *Histoire naturelle* (*Natural History*) by Buffon, published 1942. Aquatint and drypoint. Page: 14 3/16 x 11 1/4" (36 x 28.5 cm).

Picasso's *Histoire naturelle* was commissioned in 1931 by dealer and publisher Ambroise Vollard. Picasso created thirty-one illustrations for it in the early months of 1936. The production of the book was delayed; when Vollard died after an automobile accident in 1939, the project was still unpublished. It was finally taken over by Vollard's associate Martin Fabiani, who issued the volume in 1942.[6]

62. MONKEY. February 9, 1936. From *Histoire naturelle* (*Natural History*), by Buffon, published 1942. Aquatint and drypoint. Page: 14 ³/₁₆ x 11 ¹/₄" (36 x 28.5 cm).

Picasso's illustrations for Buffon's *Histoire naturelle* were created with the sugar-lift aquatint technique, which Picasso learned from Roger Lacourière at his print shop in Paris. The technique allows for ease and flexibility in rendering, as a brush can be used to paint compositions onto copperplates. These prints were made rapidly, sometimes in a single day. The spontaneity of Picasso's conception is evident.

63. RAM. 1936. From *Histoire naturelle* (*Natural History*), by Buffon, published 1942. Aquatint and drypoint. Page: 14 ³/₁₆ x 11 ¹/₄" (36 x 28.5 cm).

With the sugar-lift aquatint technique, Picasso was able to use his fingertips to create the tufted coat of this ram. Working with a brush and other tools, he added a range of textures in the grasses, tree, and clouds. His delineation of a frame in casual strokes reinforces the sense of effortless charm found in these compostions, while his anthropomorphic renderings create a kind of portraiture.

64. CAT. 1936. From *Histoire naturelle* (*Natural History*), by Buffon, published 1942. Aquatint, drypoint, and engraving. Page: 14 ³/₁₆ x 11 ¹/₄" (36 x 28.5 cm).

It is said that Picasso played a joke on the publisher Vollard by not including a cat among his initial illustrations for the *Histoire naturelle*.[7] Vollard was a great cat lover and, of course, insisted that one be represented. Picasso responded with this beguiling pet.

65. PIGEON. February 7, 1936. From *Histoire naturelle (Natural History)*, by Buffon, published 1942. Aquatint and drypoint. Page: 14 3/16 x 11 1/4" (36 x 28.5 cm).

Picasso's father, José Ruiz y Blasco (1858–1913), was an academic painter who encouraged his son's skills. He earned his living from various teaching posts in art schools, and painted pigeons as a specialty. Picasso's many depictions of pigeons and doves can be linked to the early training he received, and to his relationship with his father.

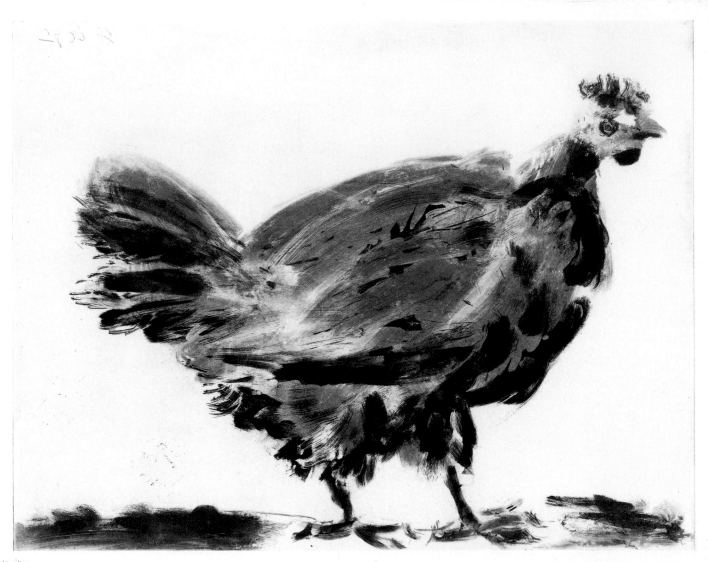

66. HEN, state II. June 23 and 25, 1952. Aquatint and drypoint. Plate: 20 5/16 x 26 1/4" (51.6 x 66.7 cm).

The prints on these facing pages represent two states in the development of the composition. In working with the aquatint technique, which produces tone rather than line, Picasso first sketched out his hen on the surface of a copperplate, probably with a rag.[8] He then differentiated certain areas on the hen's body with darker passages that were bitten more deeply with acid.

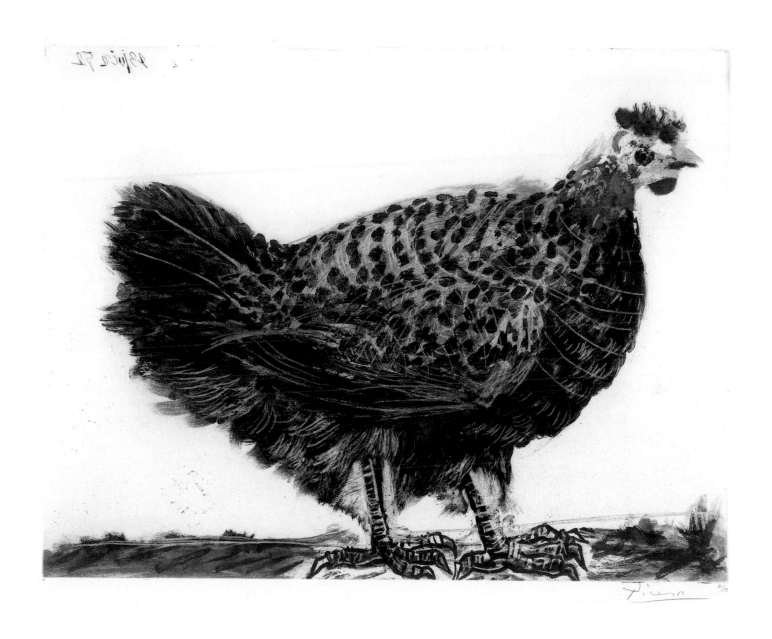

67. HEN, state VI. June 23 and 25, 1952. Aquatint and drypoint. Plate: 20 1/4 x 26 3/16" (51.5 x 66.5 cm).

This is the last of six stages of development for this image of a hen. In some areas, Picasso used his fingertips to create spots on the hen's feathers. In others, he employed a scraper to add defining lines. Clearly, the artist scrutinized the hen that served as his model closely, as the image has the detailed appearance of a specimen. Even so, with the aquatint technique, Picasso captures the downy softness of feathers.

O CHEVAUX !

CHEVAUX DE MINUIT...

MAIS !

QUAND C'EST UN CAVALIER !

LA SOLITUDE S'ÉVASE

SURNATUREL EFFET D'UN MONDE

QUI SE LIVRE INSONDABLE ET MENAÇANT

TOUFFU

FORMEL

SE HÉRISSANT D'ACTUALITÉS

PROJECTION PERPÉTUELLE !

ET SANS PLAN

ET SANS SOUCI

ET SANS RÊVE

ET SANS MERCI

AUSSI BIEN DEVANT UNE MONTAGNE

QUE DEVANT UN RAVIN

DEVANT UNE AME EN FLAMMES

QUE DEVANT UN COQUIN

LA SOLITUDE UNIVERSELLE DES CHOSES

QUI NE SE MONTRENT QU'A UN SEUL

ET DÉTESTENT LA COMPAGNIE !

LE CAVALIER ET SON CHEVAL

QUI NE FONT QU'UN SEUL

19

ÊTRE PLANTUREUX ET FRINGANT

MÊME DANS LA PLUS TERRIBLE TRAGÉDIE...

CENTAURE CATHOLIQUE ET ROMAIN

68. UNTITLED. c. April 1955. From *Chevaux de minuit* (Horses of midnight), by Roch Grey, published 1956. Engraving and drypoint. Page: 12 x 8 1/4" (30 x 21 cm).

This volume was published and designed by Georgian poet and playwright Iliazd, who changed his name from Ilia Zdanevich in 1919 and came to Paris in 1921.[9] Iliazd's highly original publications utilize reductive fonts, unconventional typographical designs, varying page sizes, and unusual folds. Here Picasso chose engraving, a technique that creates a crisp, assertive line, in keeping with Iliazd's distinctive, spare vision.

69 and 70. UNTITLED. c. April 6–30, 1956. From *Chevaux de minuit* (Horses of midnight), by Roch Grey, published 1956. Engraving. Plate: 9 1/8 x 6 1/16" (23.2 x 15.4 cm).

Iliazd commissioned this book soon after the death of its author, the Russian poet, novelist, painter, and patron Baroness Hélène d'Oettingen, here writing under the name Roch Grey. Though d'Oettingen's artistic efforts were not highly regarded, she had played a significant role in Picasso's social circle in Paris in the 1910s. She also tutored him in Russian when he was courting Olga Khokhlova, whom he married in 1918.[10]

71. FUNERAL SONNET. February 6, 1948. From *Vingt poèmes* (Twenty poems), by Luis de Góngora y Argote, published 1948. Drypoint. Page: 14 x 9 ¹⁵/₁₆" (35.6 x 25.2 cm).

When Picasso was coming of age as an artist in Barcelona, the paintings of El Greco and the poetry of Luis de Góngora y Argote, both of the Spanish Baroque period, were undergoing revivals. Góngora, whose work is dreamlike and rich in metaphor, came to be associated with everything "dark and difficult and unfathomable."[1] Later, Góngora would be much admired by Picasso's friend the Surrealist poet Robert Desnos.[2]

9. Text and Image

Letters and words have symbolic roles in some of Picasso's Cubist paintings, but it is in the artist's many illustrated books that text takes center stage.[3] As early as 1905, he contributed an etching to a collection of poems by André Salmon. It was Picasso's first such collaboration, and many more would follow with poet friends. He might provide a portrait of the author, or illustrations, even if the imagery had no connection to the text. Picasso enjoyed these collaborations and, as his reputation grew, his participation enhanced a book's stature in the eyes of the publisher.

Picasso was also sought after for deluxe illustrated books, designed for bibliophiles. Those elaborate volumes sometimes had texts by long-dead authors, and Picasso's illustrations usually took the form of separate, page-size prints inserted throughout, as well as other embellishments. But there are several examples, conceived in the 1940s, in which text and image are more fully integrated. In these instances, the texts are printed in manuscript form and the volumes have an improvisational look, sometimes recalling personal letters with drawings that Picasso wrote to friends and family.[4] That vibrant combination of text and image is also found in certain posters he designed, such as the linoleum cuts announcing events in Vallauris in the 1950s and 1960s (fig. 22).[5]

Le chant des morts (The song of the dead) is a compilation of poems written during World War II by Picasso's old friend Pierre Reverdy. This sumptuous volume was issued in 1948 by Tériade (Efstratios Eleftheriades), a publisher Picasso knew well from his ties to such periodicals as *Cahiers d'art*, *Minotaure*, and *Verve*. Tériade admired illuminated manuscripts and a number of his publications with handwritten texts seem inspired by them.[6] In *Le chant des morts*, the poems are presented in Reverdy's hand, and Picasso embraces the words with calligraphic signs: the pages become a kind of duet between artist and poet. Tériade himself felt it was as if the two men were talking.[7]

The Reverdy project may have prompted Picasso when he set out, at about the same time, to illustrate a volume of sonnets by the Spanish Baroque poet Luis de Góngora y Argote. In that volume, titled *Vingt poèmes* (Twenty poems), the artist's fragmented but naturalistic drypoints fill the margins, sparring with the Spanish text written out in Picasso's own distinctive cursive style.[8] The combination of handwriting and drawing gives the pages the spontaneous feel of a sketchbook.

In the late 1940s, Picasso decided to illustrate some of his own vivid Surrealist-oriented poetry, written during the Occupation of Paris in 1941.[9] For *Poèmes et lithographies* (Poems and lithographs) he created a distinctive checkerboard layout that brings together text and imagery on large sheets. In writing his poems, Picasso used block lettering, with sizes and spacing that vary, seemingly reflecting his changing moods. Such variations, as well as cross-outs and corrections, give the texts a sense of nervous, almost obsessive rambling. The illustrations serve to moderate that intensity.

FIG. 22. *Bulls in Vallauris.* 1960.
Linoleum cut. 29 1/2 x 24 1/2" (74.9 x 62.2 cm).
Gift of Mr. and Mrs. Leo Farland, 1967

72. SONNET III. February 6, 1948. From *Vingt poèmes* (Twenty poems), by Luis de Góngora y Argote, published 1948. Drypoint. Page: 14 ⅛ x 10 ¹/₁₆" (35.8 x 25.5 cm).

Embellished sonnets like this one, all written in Picasso's hand, make up a sumptuous volume of Góngora's poetry that was published by an association of bibliophiles. Interspersed throughout the pages are also twenty-six aquatint portraits of beautiful women. As was often the case with Picasso's illustrated books, these additional aquatints add lushness to the volume, but do not actually relate to the texts.

73. SONNET XVII. June 25, 1947.
From *Vingt poèmes* (Twenty poems),
by Luis de Góngora y Argote, published
1948. Drypoint. Page: 13 ¹/₂ x 9 ¹/₂"
(34.3 x 24.2 cm).

Picasso created his volume of Góngora's poetry in the late 1940s, when his relationship with Françoise Gilot had intensified. In this example of one of the handwritten sonnets, the marginalia references Gilot, with her luxurious hair and full breasts. Of the twenty sonnets included, eight are love poems.[10] While Picasso's illustrations do not always relate closely to the texts, in this one, Góngora refers to a "fair-haired Cloris."[11]

Miracles du sommeil
Les mains liées dans
les ornières
Les pieds au ciel

74 and 75. PAGES 20 and 21. 1945–48. From *Le chant des morts* (The song of the dead), by Pierre Reverdy, published 1948. Lithograph. Page: 16 $^9/_{16}$ x 12 $^5/_8$" (42 x 32 cm).

Pierre Reverdy had been a friend of Picasso since the Cubist years. In 1922 the artist contributed to a book of Reverdy's poems, adding a portrait frontispiece and several prints. Also around

that time, the author published a short text on Picasso. These poems, written during World War II, have been characterized as "mourning stanzas."[12]

From 1943 to 1971, the celebrated publisher Tériade issued twenty-six illustrated books, including this one. He was known for including printed manuscript texts, and sometimes encouraged artists to illustrate their own writings, as was the case with Henri Matisse's 1947 volume *Jazz*. Here, however, Picasso's friend Reverdy has written out his own poems, and Picasso serves as illuminator.

À la lueur de la guerre

Au refus des condamnés

Toutes les prisons de verre

L'Amour les a refermées

76 and 77. PAGES 28 and 29. 1945–48.
From *Le chant des morts* (The song of the
dead), by Pierre Reverdy, published 1948.
Lithograph. Page: 16 $^9/_{16}$ x 12 $^5/_8$"
(42 x 32 cm).

Picasso decided on this unusual form
of illustration when he saw Reverdy's
handwritten poems and responded to
them as works of visual art. With this
kind of embellishment, Picasso said,
"the illustration will be organic and

the unity of the book that much more
complete."[13] He began his designs in late
1945, completing them—123 in all—in
an intensive period of about two weeks
in 1948.[14]

Vierge et fière sur
la bande animée
Elle tamise l'argent
des branches
Elle sèche les roseaux
qui chantent
Sous les voûtes des
ponts tournants

Reverdy's poems and Picasso's configurations form two sparring communication systems, one verbal, the other nonverbal. The artist's choice of red here is particularly dramatic. Françoise Gilot, his lover in this period, has suggested that he was influenced by medieval manuscripts with black Gothic lettering and red ornamental initials. Picasso had acquired a volume of such manuscripts around that time.[15]

78. UNTITLED. May 14–16, 1949. Sheet 6 from *Poèmes et lithographies* (Poems and lithographs), by Pablo Picasso, published 1954. Lithograph. Sheet: 25 7/8 x 19 13/16" (65.8 x 50.4 cm).

From 1935 to 1959, Picasso wrote some 340 poems and two plays.[16] He began in a period of personal crisis, when his mistress Marie-Thérèse Walter was pregnant, his wife Olga had moved out, and he stopped painting. His stream-of-consciousness poetry is in the vein of Surrealist automatist writing. The poems seen here were written in 1941, during the Occupation of Paris.[17]

79. UNTITLED. May 24–26, 1949. Sheet 12 from *Poèmes et lithographies* (Poems and lithographs), by Pablo Picasso, published 1954. Lithograph. Sheet: 26 x 19 ¹³/₁₆" (66 x 50.3 cm).

Picasso's writing is filled with vivid images and outrageous juxtapositions. Poet Tristan Tzara called it "a verbal tide in which his torrential imagination latches on to experienced sensations."[18] Picasso himself said of his poems:

"When I began to write them I wanted to prepare myself a palette of words, as if I were dealing with colors."[19] While these poems are from 1941, the illustrations were done in 1949 and the volume was issued in 1954.

80. VOLLARD. I. March 4, 1937.
Aquatint and engraving.
Plate: 13 ⁵/₈ x 9 ³/₄" (34.6 x 24.8 cm).

Ambroise Vollard (1866–1939) was born on the French-governed island of Réunion, off the southeast coast of Africa. He went to France to study law, but soon gave in to his passion for art and opened a gallery in Paris in 1893. He began to publish prints and was instrumental in creating a new perception of the medium as no longer the exclusive realm of professional printmakers, but also a vehicle for painters.[1]

10. Portraits: VOLLARD, KAHNWEILER, BALZAC

Much of Picasso's art focuses on the human figure, and invariably his figures derive from people in his life. Often they are transformed into symbolic presences reflecting the artist's thoughts and feelings, portrayed in whatever pictorial mode absorbed him at that moment.[2] Sometimes, Picasso worked more traditionally, focusing on capturing his sitter's personality and likeness. That was the case when he was asked to contribute the frontispieces for books by friends, including his portraits of André Breton, in an imperious pose, and of Pierre Reverdy, slightly disheveled and lost in his own world (figs. 23 and 24).

Other people with whom Picasso was in close contact were art dealers. Early on, he courted these businessmen; later, it was of course they who hoped to stay in favor with him. When he was starting out, he ingratiated himself by making portraits; among these are paintings of dealers Pedro Mañach (1901) and Clovis Sagot (1909). By 1910 Picasso was steadily gaining recognition, but still had no firm agreement; he painted Cubist portraits of Wilhelm Uhde, Ambroise Vollard, and Daniel-Henry Kahnweiler. In

1912, he signed a contract with Kahnweiler, but would also maintain a close relationship with Vollard over the years.[3] In spite of the commercial aspects of such associations, and occasional wrangling over prices and payments, Picasso and these dealers formed deep bonds.

Picasso was fifteen years younger than the legendary Vollard, whose exhibitions of the 1890s had featured pioneers of modern art, including Paul Cézanne, Vincent van Gogh, and Paul Gauguin. The young Picasso would have been honored to work with Vollard on a steady basis, but the businessman showed a certain reluctance initially, perhaps based on differences concerning new directions in art. Even so, Vollard enjoyed a profitable relationship with Picasso, and the two were friends until the dealer's death, as the result of a car accident, in 1939.[4] Kahnweiler, on the other hand, was a close contemporary of the artist. He was enthralled with artistic developments of his own time—particularly Cubism. His connection to Picasso would endure over many decades, until the artist's death in 1973.[5]

Picasso also made portraits of historical figures, particularly later in his career, as he began to see himself within a line of celebrated masters. He once said that he was haunted by images of Rembrandt and Balzac.[6] He "collaborated," in effect, with the latter in the late 1920s, when Vollard commissioned him to illustrate a deluxe edition of Balzac's *Le chef d'œuvre inconnu* (*The Unknown Masterpiece*). Later, in the 1950s, Picasso was asked for a likeness of the author to serve as a frontispiece for a new edition of Balzac's 1835 novel *Le Père Goriot*. He responded enthusiastically, with a series of eleven portraits.

TOP: **FIG. 23.** *André Breton*. 1923.
Frontispiece for Breton's *Clair de terre* (Earth light), published 1923. Drypoint. Plate: 5 7/8 x 3 15/16" (15 x 10 cm). Gift of Victor S. Riesenfeld, 1948

BOTTOM: **FIG. 24.** *Pierre Reverdy*. 1921.
Frontispiece for Reverdy's *Cravates de chanvre* (Hangman's nooses), published 1922. Etching. Plate: 4 5/8 x 3 1/2" (11.8 x 8.9 cm). Abby Aldrich Rockefeller Fund, 1951

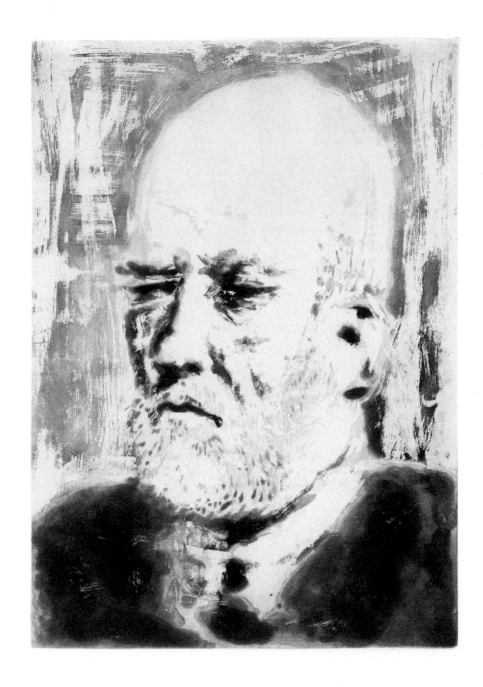

81. VOLLARD. II. March 4, 1937. Aquatint.
Plate: 13 ¹¹/₁₆ x 9 ³/₄" (34.8 x 24.7 cm).

Although Vollard dealt primarily in paintings, his love of illustrated books led, in 1900, to his first publication: *Parallèlement* (In parallel), with text by Paul Verlaine and illustrations by Pierre Bonnard. It became a milestone in the history of illustrated books. His projects with Picasso are also celebrated, including his 1931 volume of Balzac's *Le chef d'œuvre inconnu* (*The Unknown Masterpiece*).

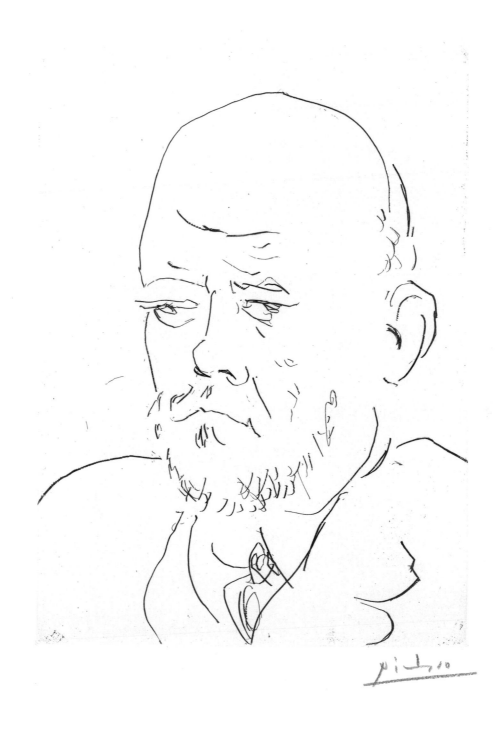

82. VOLLARD. III. March 4, 1937. Etching. Plate: 13 ⁵/₈ x 9 ³/₄" (34.6 x 24.8 cm).

The first three Vollard portraits here served to complete the series of one hundred prints, later known as the Vollard Suite.[7] But Picasso actually created four portraits in a single day, demonstrating his relish for the intaglio techniques and his ability to capture subtle shifts in the dealer's mood. He also catches him feigning sleep (which Vollard reportedly often did in front of clients).

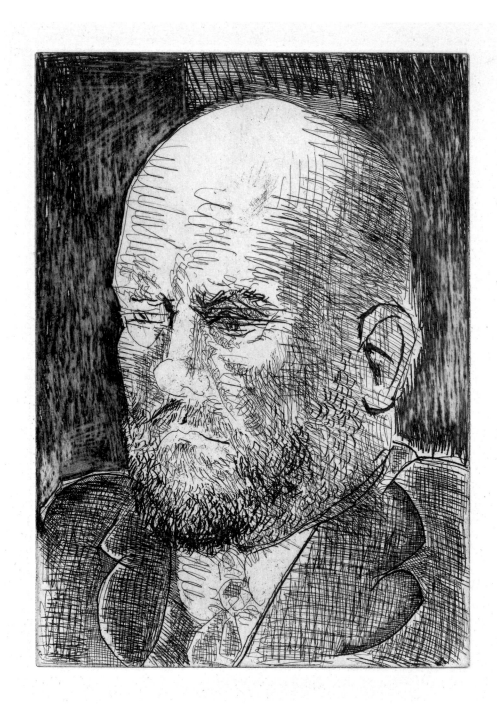

83. VOLLARD. IV. March 4, 1937.
Aquatint and etching. Plate: 13 $^9/_{16}$ x 9 $^{11}/_{16}$"
(34.5 x 24.6 cm).

This portrait was not included in the Vollard Suite, as just three were needed to round out the series's number to one hundred. It is thought that Picasso intended to eventually create a print portfolio devoted entirely to Vollard's likeness, but that never came to pass.[8] This portrait is the most starkly realist of the group, depicting Vollard with a particularly gruff demeanor.

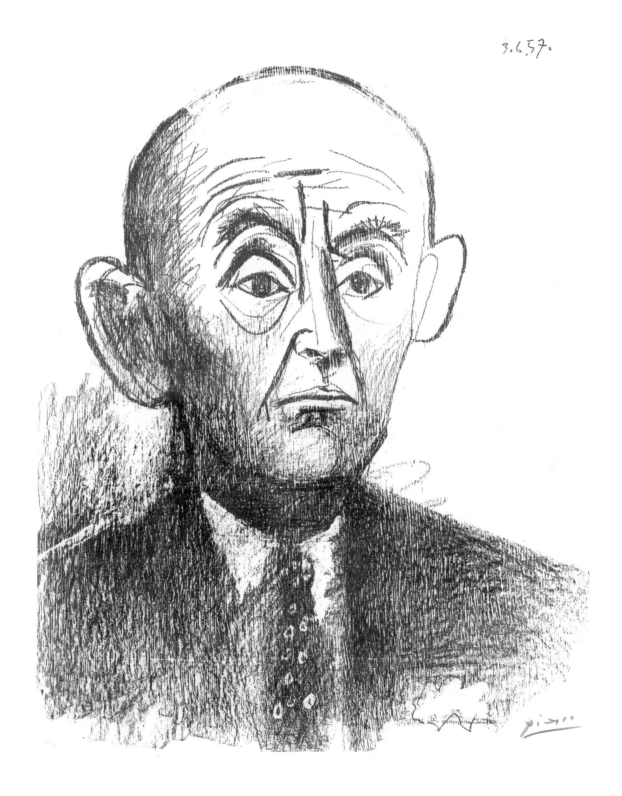

3.6.57.

84. D. H. KAHNWEILER I. June 3, 1957. Lithograph. Sheet. 25 $^9/_{16}$ x 19 $^{15}/_{16}$" (65 x 50.6 cm).

Born in 1884, art-dealer Daniel-Henry Kahnweiler was only three years younger than Picasso; he died in 1979, surviving the long-lived artist. The two were friends for nearly seven decades; at the time of these portraits, they had known one another for fifty years. It was a tumultuous friendship, partly due to historical circumstances, including two wars that drove the German-Jewish Kahnweiler from France, drastically disrupting his life and business.

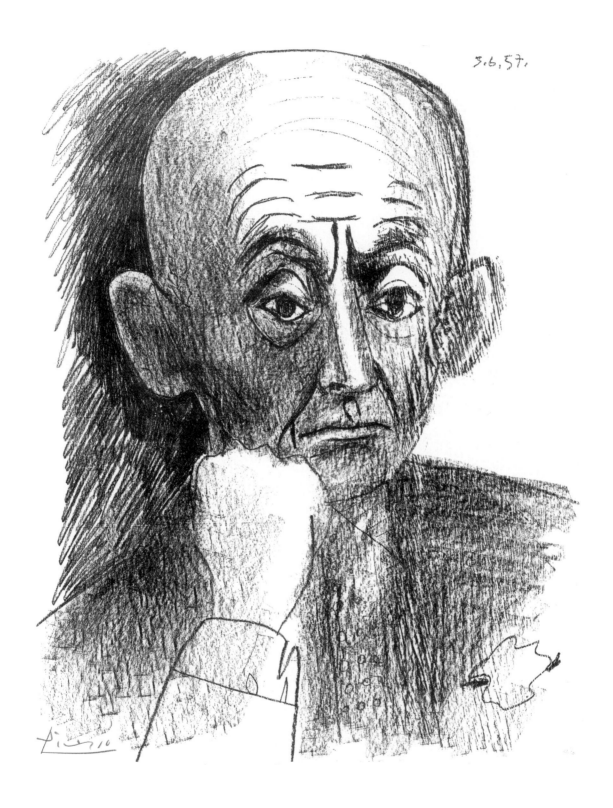

3.6.57.

85. D. H. KAHNWEILER II. June 3, 1957. Lithograph. Sheet: 25 7/8 x 19 15/16" (65.8 x 50.7 cm).

The political situation in Europe affected the name of the Galerie Kahnweiler. In 1920, after World War I, it became the Galerie Simon, after Kahnweiler's partner, André Simon. During World War II, it became Galerie Louise Leiris, named for Kahnweiler's stepdaughter, who had assisted him since the 1920s. These changes also affected the dealer's publishing imprint, under which prints and illustrated books were issued.

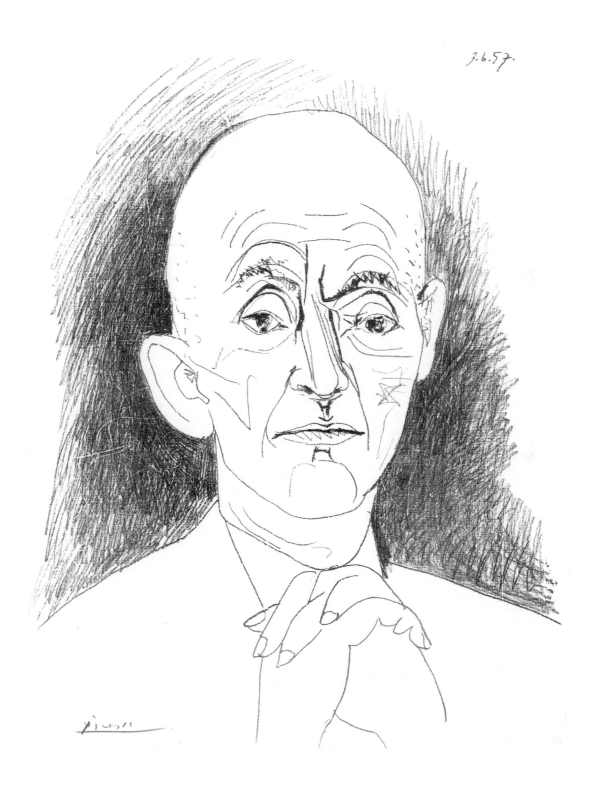

3.6.57.

86. D. H. KAHNWEILER III. June 3, 1957. Lithograph. Sheet: 25 ¹¹/₁₆ x 19 ¹⁵/₁₆" (65.3 x 50.6 cm).

Picasso's first portrait of Kahnweiler is a Cubist painting from 1910. There, his full head of dark hair is discernable even amid the Cubist distortions. That feature is noticeably gone here. In this series,

Picasso captures Kahnweiler as an astute businessman, a pensive and literate figure, and clearly a good friend, no matter what the complications of their relationship were over the years.

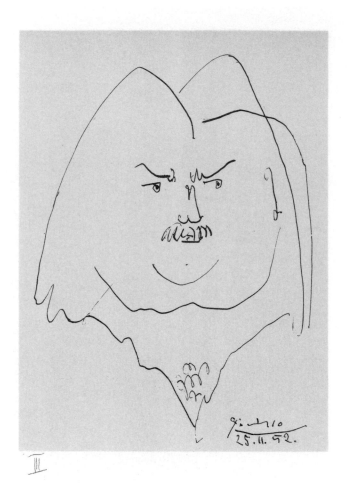

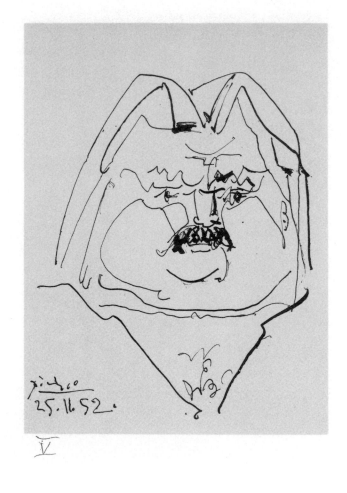

87 and 88. BALZAC. November 25, 1952. From *balzacs en bas de casse et picassos sans majuscule* (balzacs in lowercase and picassos without capitals), by Michel Leiris, published 1957. Lithograph. Composition: 8 7/8 x 6 9/16" (22.6 x 16.7 cm).

Picasso admired Balzac as one of the great figures of French literature; it is not known, however, if he ever actually read the author's novels.[9] These portraits appear in a portfolio with text by Picasso's friend the Surrealist poet and anthropologist Michel Leiris.[10] Leiris seems to have chosen lowercase letters for the title in order to claim the artist and poet as everyday figures.[11]

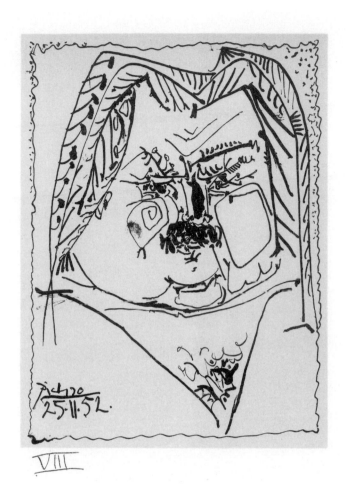

VIII

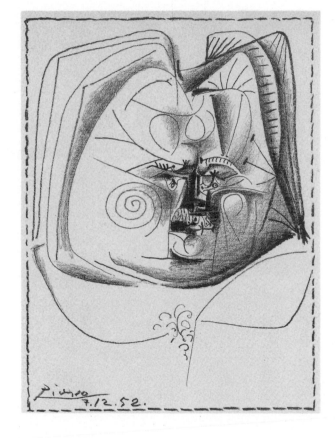

89 and 90. BALZAC. November 25 and December 7, 1952. From *balzacs en bas de casse et picassos sans majuscule* (balzacs in lowercase and picassos without capitals), by Michel Leiris, published 1957. Lithograph. Composition: 8 7/8 x 6 9/16" (22.6 x 16.7 cm).

In this series, Picasso appears to delight in the challenge of capturing Balzac's likeness and maintaining it, while also experimenting with abstraction. As a portrait, these renderings look like Balzac as seen in a photograph of c. 1842, which shows the author with hair similarly arranged and an open shirt.[12] Schematic patterning in the faces on this page is a device Picasso began to use in portraiture in the latter part of the 1940s.

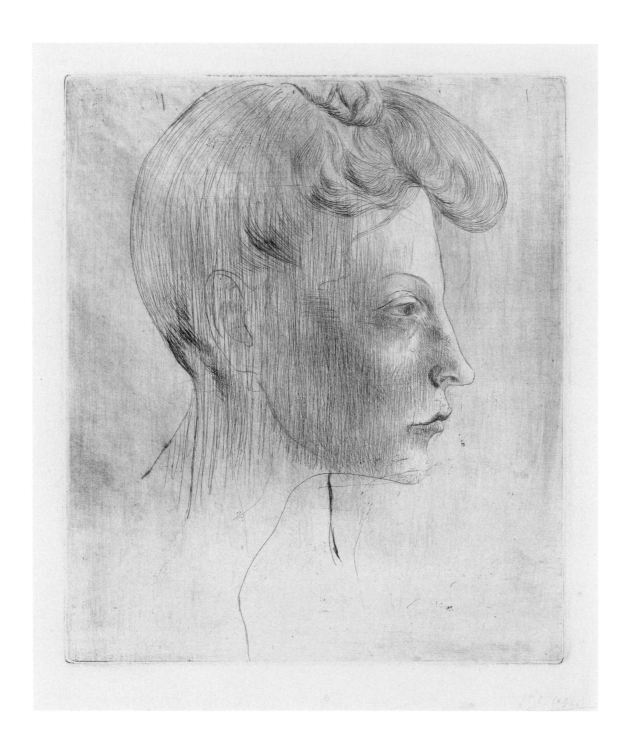

91. HEAD OF WOMAN. c. February 1905. Drypoint. Plate: 11 ⁷/₁₆ x 9 ¹³/₁₆" (29.1 x 25 cm).

This delicately rendered image portrays a woman who is known only as Madeleine. While it is an intimate portrait of Picasso's lover, this print also encompasses the broader concerns of his Rose period: dreamlike imagery and allegory. Madeleine became pregnant, but did not carry to full term; she probably inspired the figure of the mother in the Saltimbanques series (plates 5 and 6).

11. Portraits: LOVERS AND WIVES

It is widely acknowledged that the women who were Picasso's lovers had an enormous influence on both his life and his art. While he had many brief encounters, there were eight women in particular who had significant impact in terms of his work's subject matter. Yet for the most part, they did not pose for him in the traditional sense. Their physical characteristics were so familiar that, on canvas, on paper, and in sculpture, they became symbolic rather than literal subjects.

There were certainly occasions when Picasso paid homage to his lovers with tender likenesses, fulfilling a more conventional function of portraiture. But more often he focused on his own feelings, transforming them into what have been characterized as "autobiographical" portraits.[1] At other times, his instinctual knowledge allowed these women to be points of departure for various pictorial investigations. Sometimes their faces are abstracted almost beyond recognition, and only telltale signs remain.

Early on, portraits of Picasso's lovers found their way into very few examples of printmaking, since he worked just occasionally in the medium. But in the 1930s, when prints began to occupy more and more of his time, portraits of the women who shared his life appear frequently in etchings, lithographs, or linoleum cuts, depending on the technique capturing his attention at the moment.

Yet some printed portraits from earlier years stand out for the role they played in his developing art. In 1905, during the Rose period, Picasso created a striking drypoint of a woman known simply by the name Madeleine (plate 91).[2] She was probably an artist's model and became involved with Picasso in early 1904, after he settled in Paris. It may be Madeleine's lean, boyish frame and delicate features that appear in the emaciated and forlorn figures of Picasso's late Blue period. For example, she has been identified as the possible female model for the celebrated etching *Frugal Repast* (plate 1), but that figure's face lacks some of the refinement distinguishing the subject of the drypoint portrait. There, Picasso's ethereal, almost dreamlike depiction demonstrates his move away from the downtrodden as subject matter, and toward more allegorical renderings.

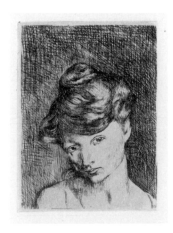

Madeleine would be replaced in Picasso's affections by Fernande Olivier. It seems that Olivier played the coquette for a time, and she and Madeleine overlapped in the artist's life. A small etching of 1905 (fig. 25) has long been considered a depiction of Madeleine, with her piled-up hair and delicate features. Some, however, have seen in it instead the sensual, rounded face of Olivier.[3] In later years, it would be a common practice for Picasso to merge characteristics of various lovers, reflecting the fact that he remained engaged with each, at least psychologically.

But it is unquestionably Olivier represented in a major woodcut Picasso made in 1906 (plate 92). This print came at a pivotal time, as the artist was

FIG 25. *Head of a Woman.* 1905.
Etching. Plate: 4 ¹¹/₁₆ x 3 ⁷/₁₆" (11.9 x 8.7 cm).
Gift of Abby Aldrich Rockefeller, 1940

assimilating a variety of influences and developing toward a Cubist aesthetic. Here, artistic preoccupations seem to overpower any desire to truly represent Olivier's likeness.[4] Instead, Picasso creates a kind of mask, making use of the potential of woodcut to communicate a sense of raw immediacy through rough, reductive forms and surface textures.

This expressionist approach to woodcut had been initiated by Paul Gauguin in the 1890s, and Picasso surely knew his prints.[5] Gauguin's art would have been available to him through a variety of sources; for example, a Spanish friend, sculptor Paco Durrio, owned work by the artist, and Picasso is known also to have visited another Gauguin collector at the time.[6] Furthermore, a retrospective of Gauguin's work at the Salon d'Automne in 1906 was an important event, which Picasso would likely have attended.

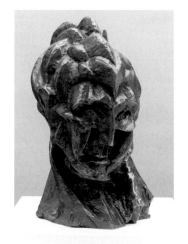

Picasso's adoption of woodcut, rarely seen in his printmaking, may have been influenced by other factors as well. Henri Matisse had recently taken up the technique (also through Gauguin's example), and Picasso knew this.[7] In addition, he learned that Matisse and fellow Fauvists Maurice de Vlaminck and André Derain had become interested in Oceanic and African wood sculpture, which bears relation to the woodcut technique as Picasso interpreted it.[8] Finally, a new installation at the Louvre of ancient Iberian stone sculpture, with simplified and abstracted forms, contributed to Picasso's evolving vision. Clearly, Olivier's features in the portrait woodcut were a springboard for experimentation, as they would be often as his work developed and changed (fig. 26).

By 1911, however, Picasso and Olivier were at odds, and he began seeing Eva Gouel, who would move in with him in early 1912. Gouel's time with Picasso coincided with the least representational phase of his work, and either her features are buried in his Analytic Cubist and Synthetic Cubist compositions, or she is referenced simply through words and letters that became part of his pictorial vocabulary. However, a rare likeness exists in a 1916 print (fig. 27). Gouel died in December 1915; this tiny rendering is a touching reflection of her, made after her death. Picasso uses a tool called a roulette to create evocative shadows and gives his representation a sense of memory more than reality.

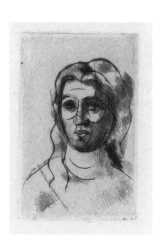

In 1918 Picasso married Olga Khokhlova, and went on to create a series of elegant portraits of her in his classical style. Later, as their relationship deteriorated, her likeness took on frightening attributes, associated with a Surrealist vocabulary. But Picasso made relatively few prints of Olga, as he had not yet fully embraced the medium. That would come later, after his affair with Marie-Thérèse Walter began. Walter is the subject of countless prints, as are the women who followed in Picasso's life: Dora Maar, Françoise Gilot, and Jacqueline Roque.

TOP: **FIG. 26.** *Woman's Head (Fernande)*. 1909. Bronze. 16 ¼ x 9 ¾ x 10 ½" (41.3 x 24.7 x 26.6 cm). Purchase, 1940

BOTTOM: **FIG. 27.** *Head of a Woman*. 1916. Engraving with roulette. Plate: 3 ⅛ x 2" (8 x 5.1 cm). Mrs. Bertram Smith Fund, 1969

92. BUST OF YOUNG WOMAN. 1906. Woodcut. Composition and sheet: 20 ³/₁₆ x 13 ¹/₂" (51.3 x 34.3 cm).

Paul Gauguin's expressionist woodcuts were an influence on this portrait of Fernande Olivier, who took Madeleine's place as Picasso's mistress. The face barely represents Olivier, as her features were only a starting point for Picasso's experimentation. They would serve this function repeatedly in the years leading up to Cubism.

93. FACE OF MARIE-THÉRÈSE.
c. October 1928. Lithograph.
Composition: 8 x 5 9/16" (20.3 x 14.1 cm).

The classic features here belong to Marie-Thérèse Walter, whom Picasso met on a street in Paris in 1927. She was nearly thirty years his junior; he was married with a child. Nonetheless, a passionate affair developed almost immediately, which Picasso kept secret from even his closest friends. Such secrecy is captured by this mysterious view, which also succeeds in expressing the mesmerizing effect Walter had on the artist.[1]

11a. MARIE-THÉRÈSE WALTER

On January 8, 1927, Picasso saw Marie-Thérèse Walter on a street in Paris and was immediately smitten. She was seventeen and he would soon turn forty-six. Within a week they were lovers; her likeness would be a dominating presence in his art for the following decade. Their relationship was kept from Picasso's wife Olga, but with Walter's pregnancy and the birth of their daughter, Maya, in September 1935, the secrecy ended. Picasso's wife and son moved out of the family apartment, and he entered a period of deep despair.

There have been debates about the date of Picasso's first encounter with Walter. A woman with features very much like hers appears in his art before their purported 1927 meeting,[2] leading to speculation that they might actually have met as early as 1925.[3] While further research has confirmed the 1927 meeting date, these earlier depictions of someone who looks very much like Walter raise certain issues regarding Picasso's portraiture. It has been surmised that, on occasion, he may have conceived of a face artistically and then found the model to match it.[4] Picasso suggested this possibility himself in a conversation with his lover Françoise Gilot. Struck by the likeness between Gilot and a figure from a print made long before he met her, he said, "I've always been haunted by a certain few faces and yours is one of them."[5]

By the 1930s, Walter appears in countless works by Picasso, including some of his best known (fig. 28).[6] In prints, she serves as model and muse in the Sculptor's Studio etchings. Also, a young woman resembling Walter is found in scenes with a Minotaur, some of them highly erotic, others strikingly tender. In his Bullfights series, Walter is featured in the role of ravaged picador. The violence in some of these works suggests the growing turmoil in Picasso's life.

Walter was a blond, classic beauty: her facial features were distinctive and her body was athletic. Picasso incorporated her physical attributes in various figurations, drawing upon artistic lexicons ranging from the Neoclassical to the Surrealist. The young woman's personality was exceedingly docile and undemanding; Picasso himself said about Walter: "She was sweet and gentle and did whatever I wanted her to."[7] She must have provided a dramatic contrast to his increasingly jealous and haranguing wife, Olga. But this quiet and amenable young woman was not an intellectual and took little interest in art or in the kinds of people Picasso liked best. This became a problem when the initial ardor of their affair cooled. Soon after Walter gave birth to Maya, Picasso took up with the vivacious and stimulating Dora Maar, an accomplished photographer and an active participant in Surrealist circles. Picasso later said, "It wasn't at all that I was so greatly attracted by Dora . . . I just felt that finally, here was somebody I could carry on a conversation with."[8]

FIG. 28. *Girl Before a Mirror*. 1932.
Oil on canvas. 64 x 51 1/4" (162.3 x 130.2 cm).
Gift of Mrs. Simon Guggenheim, 1937

94. PAINTER WITH TWO MODELS. 1927.
From *Le chef-d'œuvre inconnu* (*The Unknown
Masterpiece*), by Honoré de Balzac, pub-
lished 1931. Etching. Plate: 7 ⁵/₈ x 10 ⁷/₈"
(19.3 x 27.7 cm).

Picasso was commissioned by Ambroise
Vollard to illustrate Balzac's tale of an
artist's quest for ideal beauty. The theme
of the artist in the studio would pre-
occupy him throughout his career. Here,
in allegorical terms, the artist looms as

a spiritual presence, joined by his model
and a toga-clad muse. The features
of the model are those of Walter, whom
Picasso met just weeks before he made
this etching.

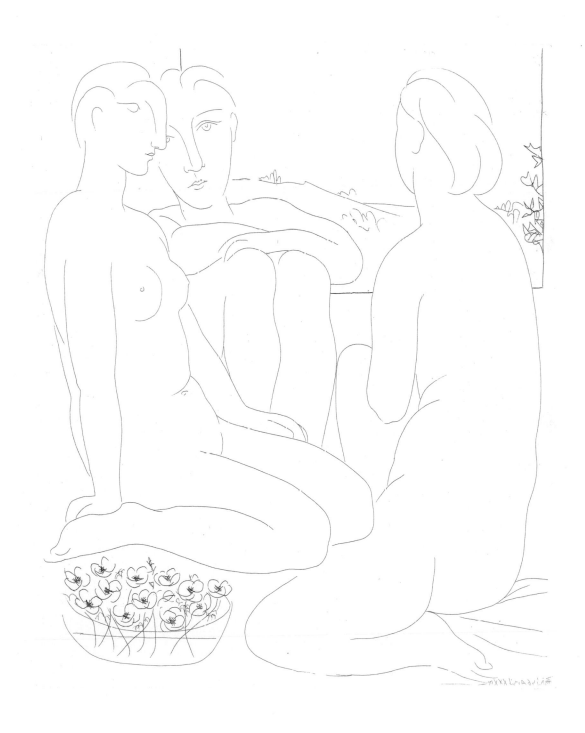

95. THREE NUDE WOMEN. April 6, 1933. Etching. Plate: 14 $^1/_2$ x 11 $^3/_4$″ (36.8 x 29.8 cm).

The subject of this etching, and its serene Neoclassical style, evoke the myth of the Three Graces. Yet all the women resemble Walter, with one revealing the distinctive profile Picasso had devised for her in his work. This scene indicates Walter's intoxicating presence in Picasso's life at that time. In many prints containing her likeness, flowers are placed somewhere close by.

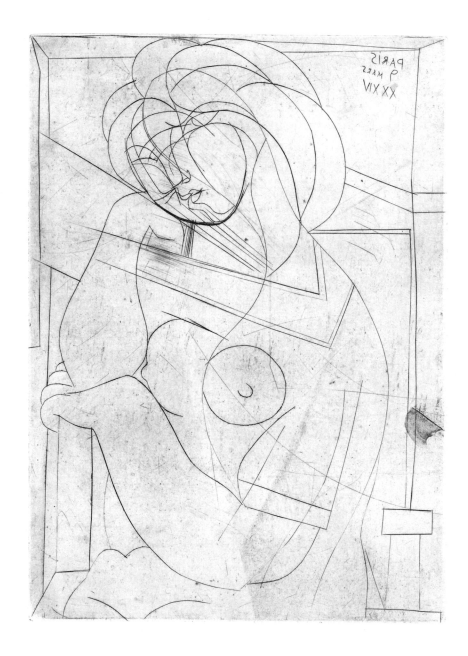

96. DREAMING WOMAN IN ARMCHAIR. March 9, 1934. Etching. Plate: 10¹⁵/₁₆ x 7¹³/₁₆" (27.8 x 19.8 cm).

Picasso often depicted Walter relaxing in a pensive mood, or asleep. Here, her head incorporates his device of the "double-face," showing both profile and full-face. The duality conjures up realms of the conscious and unconscious, central preoccupations of Surrealists at this time. Picasso also shows the contradiction of Walter's youth and her erotic appeal: her prim schoolgirl's blouse is open, revealing her breasts.

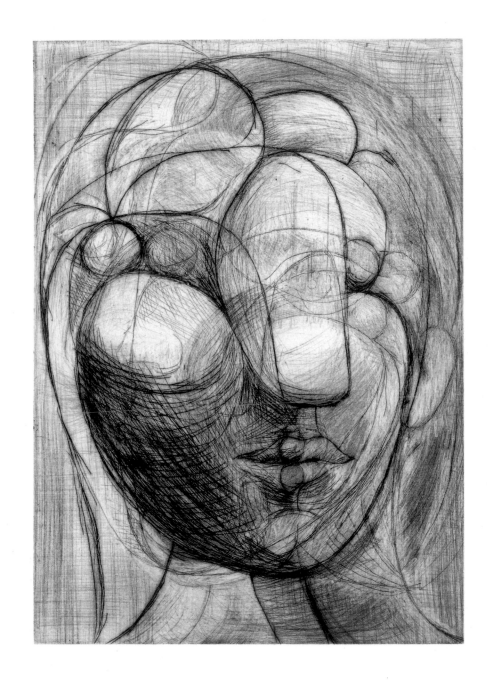

97. SCULPTURE. HEAD OF MARIE-THÉRÈSE. February 18, 1933. Drypoint. Plate: 12 ¹/₂ x 9″ (31.8 x 22.8 cm).

This drypoint went through twenty stages (states), and traces of the process are evident. The image is based on a plaster sculpture of Walter, and the many changes in the print evoke the act of shaping and modeling. Here, Walter's features serve primarily as a departure point for artistic exploration. Representation and abstraction collide as Picasso challenges himself to create a two-dimensional image from a three-dimensional source.

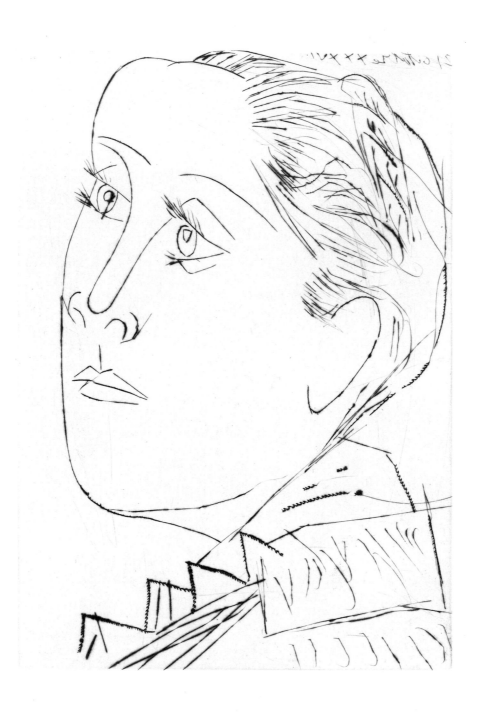

98. PORTRAIT OF DORA MAAR WITH CHIGNON. October 21, 1936. Drypoint and engraving. Plate: 13 1/2 x 9 1/2 (34.3 x 24.2 cm).

Photographer Dora Maar was in her late twenties when she met Picasso, who was nearly thirty years her elder. During the period of their affair, Picasso continued to see Marie-Thérèse Walter and their baby daughter, causing inevitable jealousy. This early portrait of Maar captures her luminous beauty and thoughtful intelligence, mixed with a touching vulnerability.

11b. DORA MAAR

Picasso first encountered photographer Dora Maar at Paris's Café Deux Magots, in the winter of 1935–36. Legend has it that he was intrigued by the dangerous game she was playing: with her hand on a table, she jabbed a knife between her fingers, occasionally drawing blood.[1] Though they had not yet met, Picasso and Maar had already exhibited together in a group show, and also had friends in common among the Surrealists.

By then, Picasso's passion for Marie-Thérèse Walter had begun to fade. Yet even after he took up with Maar, he maintained a relationship with Walter—he even seemed to enjoy the inevitable jealousies between the two.[2] While Maar's image dominated his work in this period, Walter by no means disappeared from it. In fact, in a single day in 1939 Picasso painted each of them in the same pose, on the same size canvas: Walter is rounded and voluptuous and Maar is a complex mass of agitated shapes and angles.[3]

Although born in France, Maar spoke fluent Spanish, having grown up in Argentina, where her father worked as an architect. She began studying art in Paris in 1926, choosing photography as her preferred medium and eventually traveling in the circles of such figures as Henri Cartier-Bresson, Brassaï, and Man Ray. It was surely her skill and talent that led Picasso to experiment in photography at that time. However, Maar herself turned to painting, probably encouraged by Picasso, who considered it a more serious art form. Her paintings, however, never reached the quality of her finest photographs, which are highly regarded examples of the Surrealist idiom.[4]

Maar was active in left-wing political causes, providing yet another bond with Picasso during a period of great social upheaval. The Spanish Civil War broke out soon after their affair began. In 1937, she was with Picasso as he created *Guernica*, a rare and momentous example of political intent in his work, responding to the bombing of a small Basque town. The stages of *Guernica*'s evolution are documented through Maar's photographs.

In the period that followed, the world situation only worsened, with Germany making incursions into Austria, Czechoslovakia, and Poland, and finally occupying Paris in June 1940. The trauma of those events is reflected in Picasso's works, which sometimes took a distorted and tormented likeness of Maar as a starting point (fig. 29). He called her "the weeping woman," referring to her volatile emotionality, but the anguish in his depictions goes beyond her temperament and encompasses widespread fears and anxieties the artist shared at that time. Maar, speaking generally of his portraits of her, said, "They're all Picassos, not one is Dora Maar."[5]

It was only later that Maar suffered her greatest distress, as Picasso's attraction to her waned. In his last significant portrait of her, from late 1942, she looks lonely and forlorn. In 1945, Maar experienced a psychological breakdown, requiring hospitalization. By the following year, her relationship with Picasso was over.

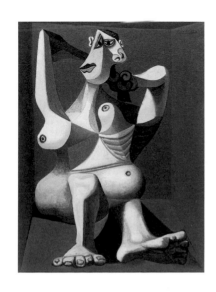

FIG. 29. *Woman Dressing Her Hair*. 1940.
Oil on canvas. 51 ¹/₄ x 38 ¹/₄" (130.1 x 97.1 cm).
Louise Reinhardt Smith Bequest, 1995

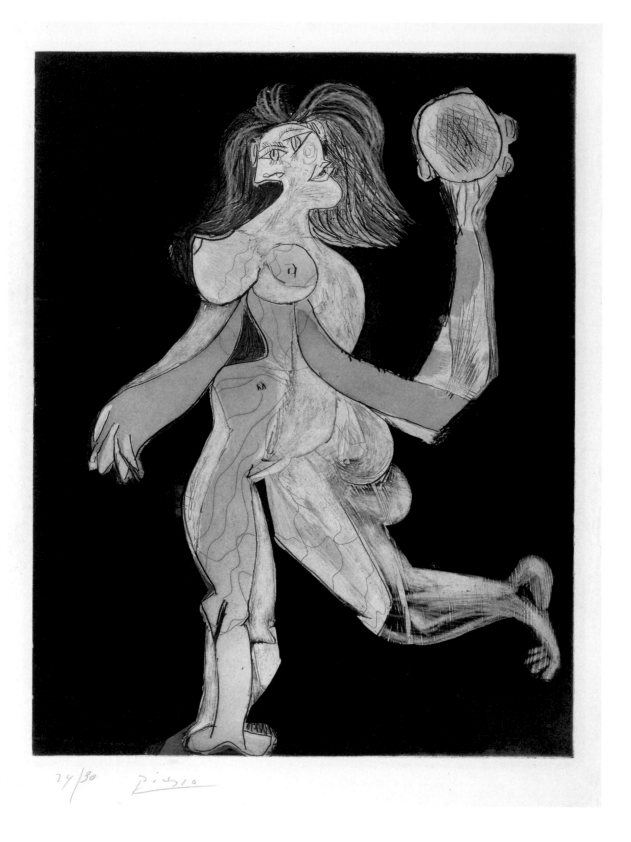

24/30 Picasso

99. WOMAN WITH TAMBOURINE. 1939.
Aquatint and etching. Plate: 26 1/4 x 20 3/16"
(66.7 x 51.2 cm).

Many of Picasso's depictions of Maar
show her in distress; this is usually
ascribed to her volatile temperament.
However, the sense of anxiety here
may also be rooted in heightened ten-
sions in Europe, where the Spanish

Civil War was raging and World War II
was imminent.[6] The ominous setting of
stark blackness, created through aqua-
tint, contributes to the sense of terror
embodied in the contorted forms.

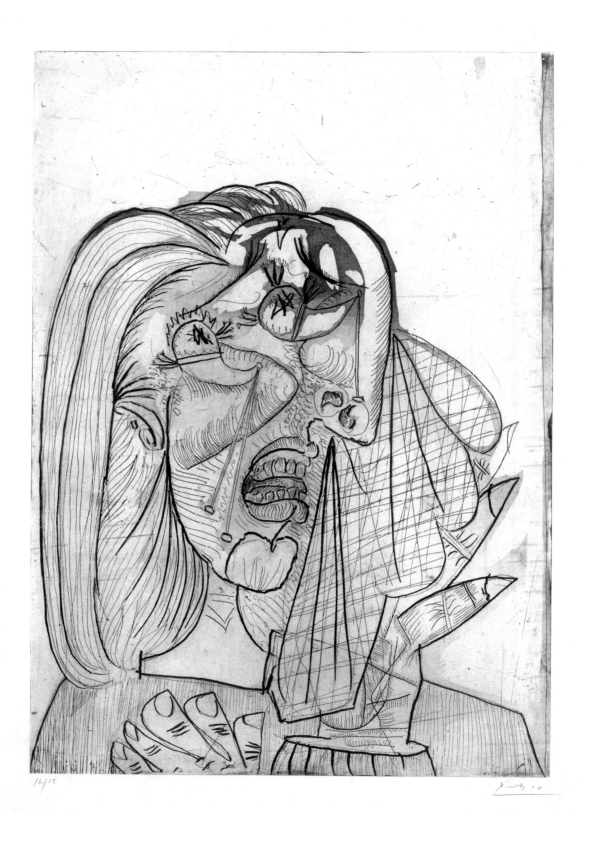

12/15

100. WEEPING WOMAN. July 1, 1937.
Etching, aquatint, and drypoint.
Plate: 27 1/8 x 19 1/2" (68.9 x 49.5 cm).

This figure is usually identified with Maar, whom Picasso called "the weeping woman."[7] But there are also hints of Marie-Thérèse Walter: the bitten fingernails on one hand and the distinctive profile. Picasso's long-suffering wife Olga is suggested in the fearsome mouth. Entwining the personal and political, this image, conceived at the time of *Guernica*, expresses Picasso's profound anguish over the Spanish Civil War.

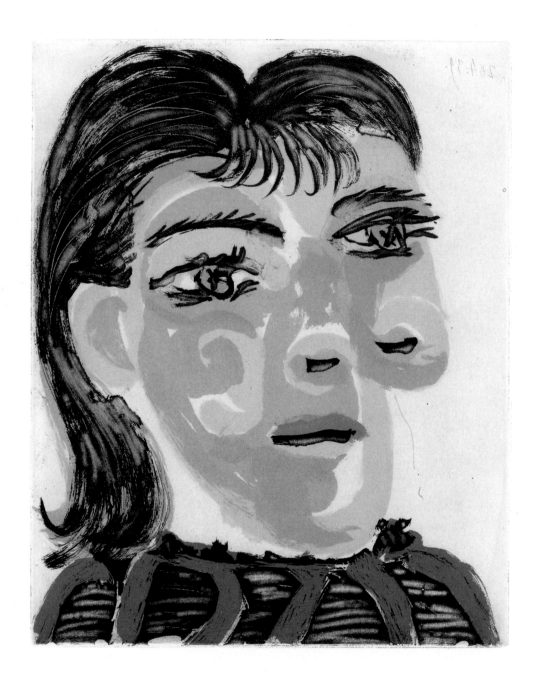

101. HEAD OF A WOMAN NO. 2. DORA MAAR. March–April 1939. Aquatint and drypoint. Plate: 11 3/4 x 9 5/16" (29.8 x 23.7 cm).

This is one of a series of seven portraits of Maar intended as illustrations for a book project published by Ambroise Vollard.[8] But with Vollard's death, as the result of a car accident in 1939, the book never appeared. The text was to be the manuscript version of Picasso's Surrealist-oriented poetry, with corrections and deletions left in place. The artist had begun writing poetry in 1935.

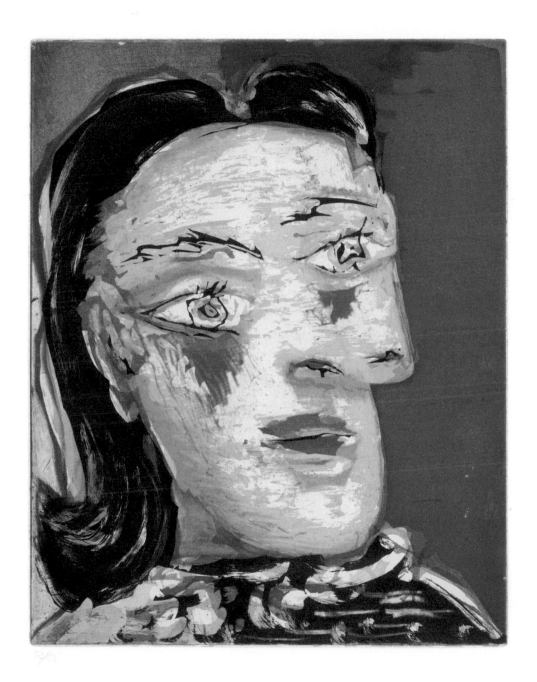

102. HEAD OF A WOMAN NO. 4. DORA MAAR. April–May 1939. Aquatint. Plate: 11 13/16 x 9 5/16" (30 x 23.7 cm).

Along with his series of portraits of Maar, Picasso created several small prints of bathers who have her features; these were probably conceived as marginalia to surround the text of his planned book of poetry.[9] If completed, this volume would have been an homage to Maar, a committed Surrealist herself, who must have appreciated his stream-of-consciousness poetry, with its irrational juxtapositions of imagery.

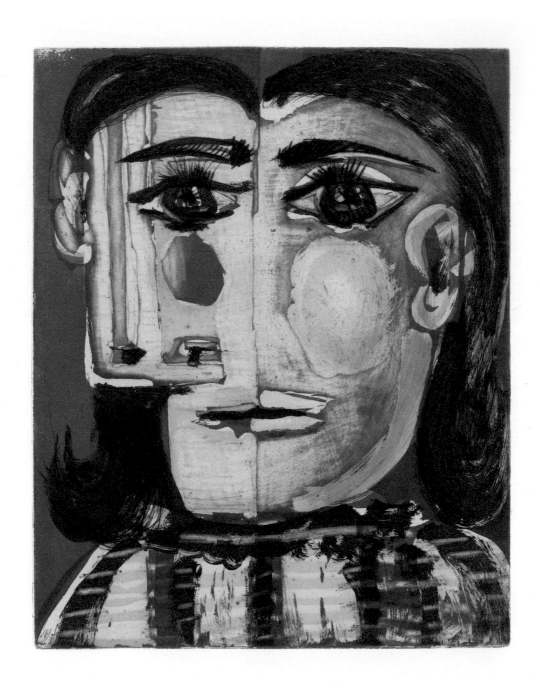

103. HEAD OF A WOMAN NO. 5. DORA MAAR. January–June, 1939. Aquatint and drypoint. Plate: 11 ³/₄ x 9 ³/₈" (29.8 x 23.8 cm).

While Picasso often presents Maar's likeness in distorted forms that personify torment, this series captures the kind of changing moods that would be familiar in any intimate relationship. But it also includes distinctive aspects of Maar's features, such as her relatively low brow and full jaw. The "double-face" motif here is a variation on a device that first appeared in Picasso's work in the 1920s.

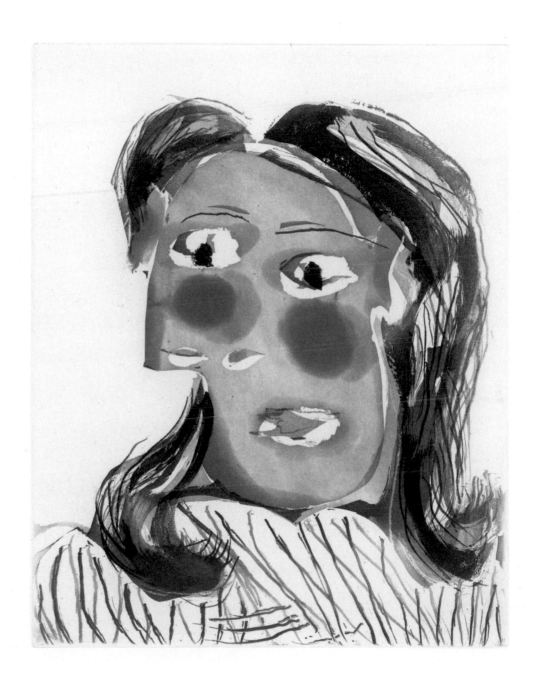

104. HEAD OF A WOMAN NO. 6. DORA MAAR. January–June, 1939. Aquatint. Plate: 11 3/4 x 9 5/16" (29.8 x 23.6 cm).

This series represents Picasso's first sustained foray into color printing. Although guided by printer Roger Lacourière, the artist was probably frustrated by the painstaking demands of the process, which requires a separate plate for each color.[10] He may have been tempted to try it after seeing prints by Georges Rouault at Lacourière's workshop.[11]

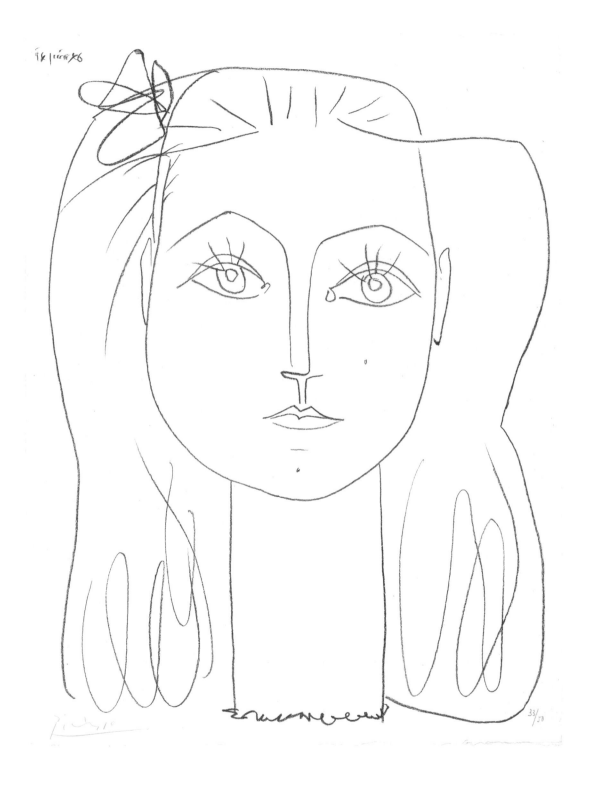

105. FRANÇOISE WITH A BOW IN HER HAIR. June 14, 1946. Lithograph. Sheet: 26 x 19 ⁵/₈" (66 x 49.8 cm).

In this depiction of Françoise Gilot as a dewy-eyed youth, Picasso employs some of Henri Matisse's signature devices, in a composition made simply of lines and bold, seemingly flat shapes. The two masters renewed their friendship in these years, as Picasso was spending more time in the South of France, where Matisse lived. Gilot and Matisse were fond of each other, and had an active correspondence.[1]

11C. FRANÇOISE GILOT

Picasso met the twenty-one-year-old aspiring artist Françoise Gilot in May 1943. Then sixty-two, he was not blind to her fresh beauty and immediately invited her to pay him a visit. A flirtation began that would continue over several years. After Picasso had definitively broken with Dora Maar, in 1945, he and Gilot became closer; she finally moved in with him in April 1946.[2]

The Occupation was now over and, to Picasso, Gilot may have represented the sense of new beginning that was in the air in postwar France. Together they began to spend more time in the South. Among the most famous photographs of the couple is Robert Capa's 1948 image showing Picasso playfully holding a beach umbrella over a resplendent Gilot as she strolls on the beach. It is this sense of idyll that permeates Picasso's depictions of Gilot in their first years together. She is shown as a "flower woman," in some works, and her likeness occupies the center of his 1946 mural-sized painting *The Joy of Life*.[3] Also, the couple's two children, Claude and Paloma, were born in 1947 and 1949, providing a happy family life (fig. 30).

It was likely at Gilot's instigation that Picasso rekindled his friendship with Henri Matisse, who was living in the South of France, too. She and Matisse liked each other, and this may have provided a new spark between the two masters.[4] In certain works depicting Gilot, Picasso even borrows some of Matisse's rhythmic simplification, fluid lines, and evocation of light. Other notable aspects of Picasso's art during this period with Gilot were a reengagement with the technique of lithography, and the adoption of a new medium: ceramics.

In November 1945 Picasso began frequenting the Mourlot lithography workshop in Paris, where he became engrossed in the process, working closely with the studio's master printers. Some of the earliest lithographs he made there were portraits of Gilot. Her presence also permeates several lithographic series of the next few years, as he went back and forth from Paris to the South of France. By then, he had discovered the pottery kilns of Vallauris, and was once again inspired by new collaborations.

These were, in addition, Picasso's most active years with the Communist party; he attended peace conferences and designed posters announcing events. Gilot has noted that it was after one of those conferences, in Poland in 1948, that she first sensed a distance between them.[5] Picasso began to travel to Paris more frequently alone, and was generally less communicative. She grew increasingly unhappy over the next years, leading up to September 1953, when she finally moved out with the children. It was as if the bright and hopeful light represented by the youthful Gilot, in a time of newfound freedom, could not glow forever. However, this self-assured and determined woman kept her bearings, continuing with her own art, and living a full and active life in the years that followed.

FIG. 30. *Mother and Children*. 1953. Lithograph. Composition: 19 $^1/_8$ x 29 $^3/_{16}$" (48.5 x 74.2 cm). Stephen C. Clark Fund, 1956

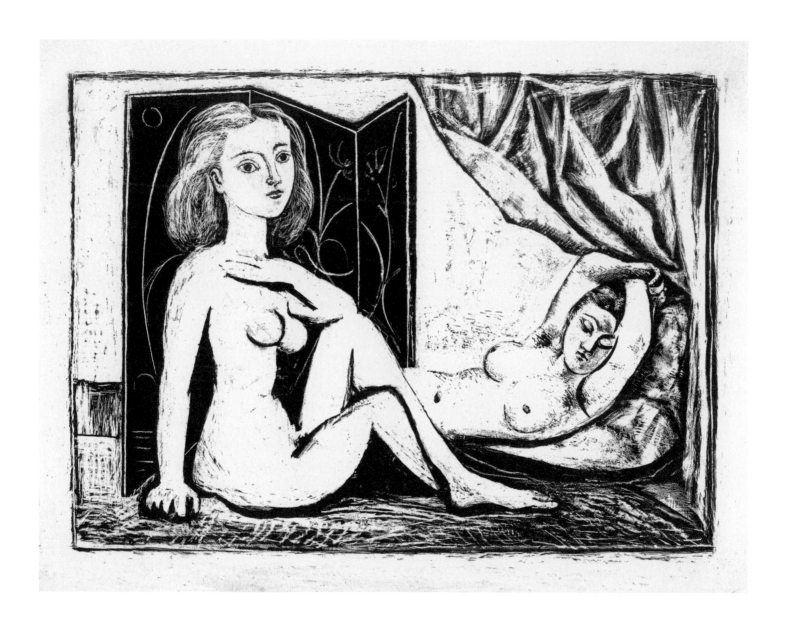

106. TWO NUDE WOMEN, state IX. January 10, 1946. Lithograph. Composition: 10 ⁵/₈ x 14 ¹/₄" (27 x 36.2 cm).

The theme of the watched sleeper goes back to Picasso's Blue period, and is seen in hundreds of works over the course of his career.[6] This motif can include two women, as seen here, or a man and a woman. This seated woman clearly resembles Gilot, and Picasso identified the sleeping figure as Dora Maar.[7] At this point, his relationship with Maar had ended, but Gilot had not yet moved in with him.

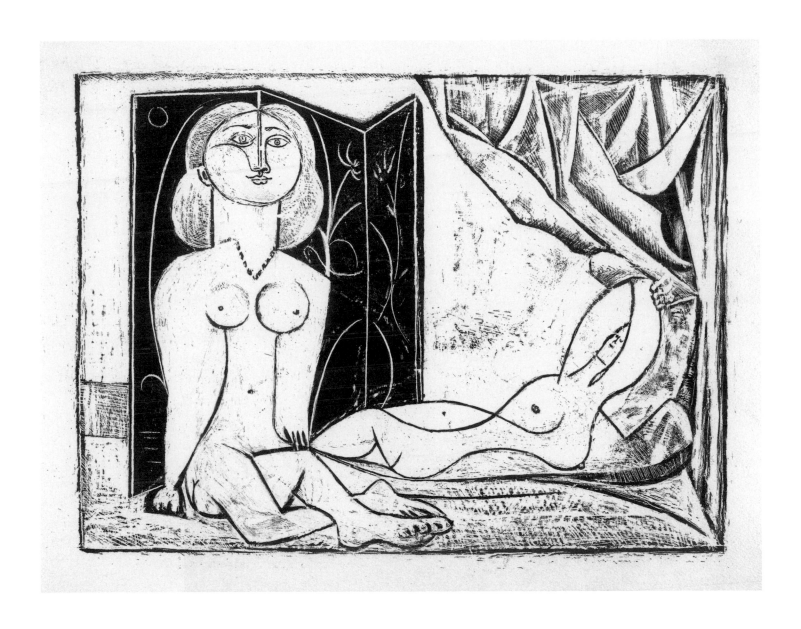

107. TWO NUDE WOMEN, state XI.
January 21, 1946. Lithograph.
Composition: 10 ⁵/₈ x 14 ³/₈" (27 x 36.5 cm).

Picasso took a renewed interest in lithography in late 1945, when he began to collaborate with the printers at the Mourlot workshop in Paris. Lithography allows for changes and corrections more readily than etching, and Picasso took advantage of the process to work on extended series. This composition occupied him for a three-month period, evolving through some twenty-five states and variations.[8]

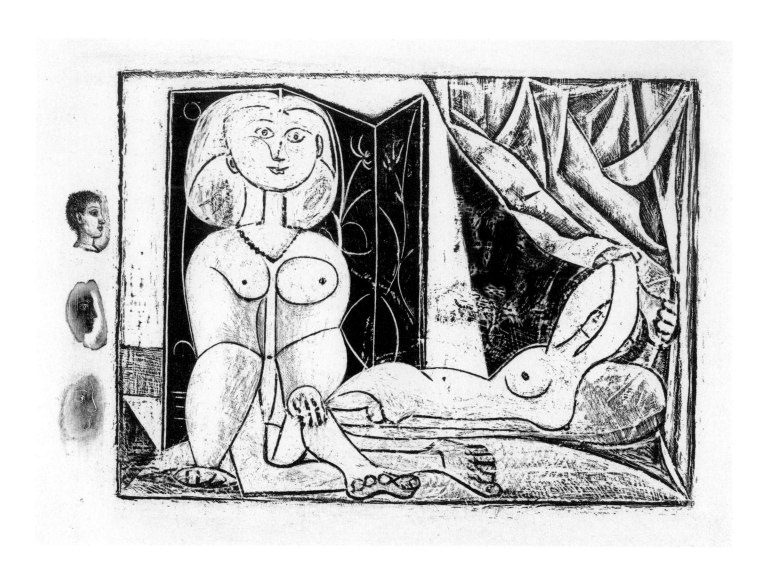

108. TWO NUDE WOMEN, state XVI.
February 6, 1946. Lithograph.
Composition: 10 ¹³/₁₆ x 15 ¹/₂"
(27.5 x 39.4 cm).

The sequence of development of this composition is almost cinematic in its effects, particularly the posture of the seated figure. Over the course of its stages, her arm is lowered from a raised position, her body turns to the front, and her legs are raised, lowered, and raised again. In this version, a dark, vaguely triangular shape appears behind the torso of the recumbent figure, accentuating her presence in a kind of sleeping nook.

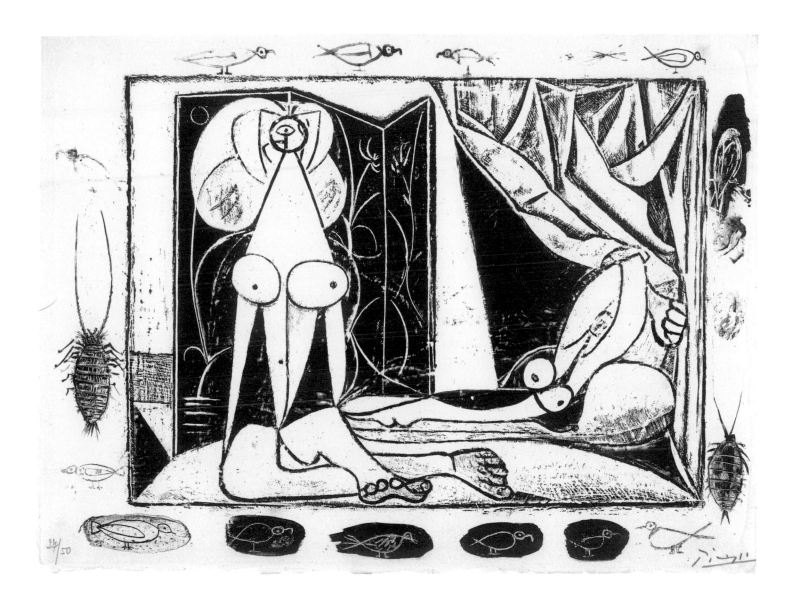

109. TWO NUDE WOMEN, state XVIII.
February 12, 1946. Lithograph. Sheet:
13 1/16 x 17 1/2" (33.2 x 44.4 cm).

Here, the figures are frightening hiero-
glyphs that can be variously interpreted.
However, two days before devising
this version, Picasso did a large group
of drawings studying just the compo-
sitional aspects of the scene, in terms
of diagonals, verticals, and balancing
shapes.[9] According to Gilot, he identi-
fied the subjects—herself and Maar—
only later.[10]

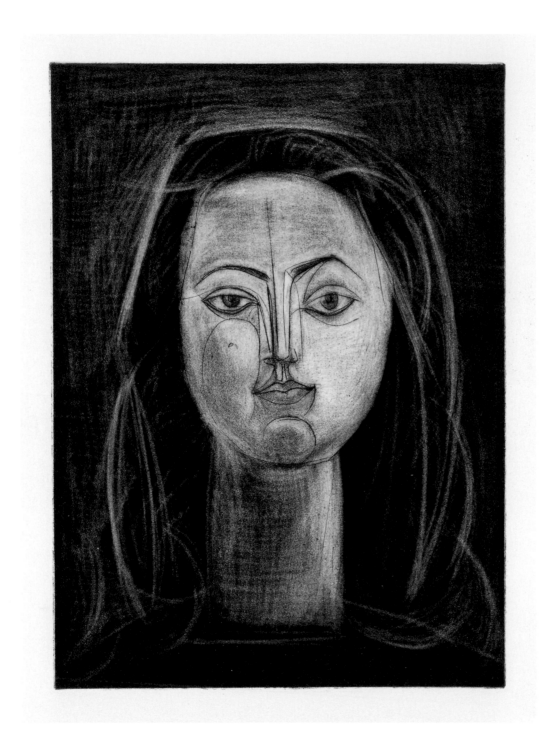

110. FRANÇOISE WITH LONG NECK. I, state II. 1946. Aquatint and engraving. Plate: 13 1/2 x 9 3/4" (34.5 x 24.8 cm).

This series of aquatints with engraving was probably made after Gilot had finally moved in with Picasso, following a three-year period of intermittent dalliance (she had been the reluctant one, but finally succumbed). Picasso surely felt victorious and also reinvigorated by the prospect of a new life to be shared with this beautiful, vivacious, and creative young woman.

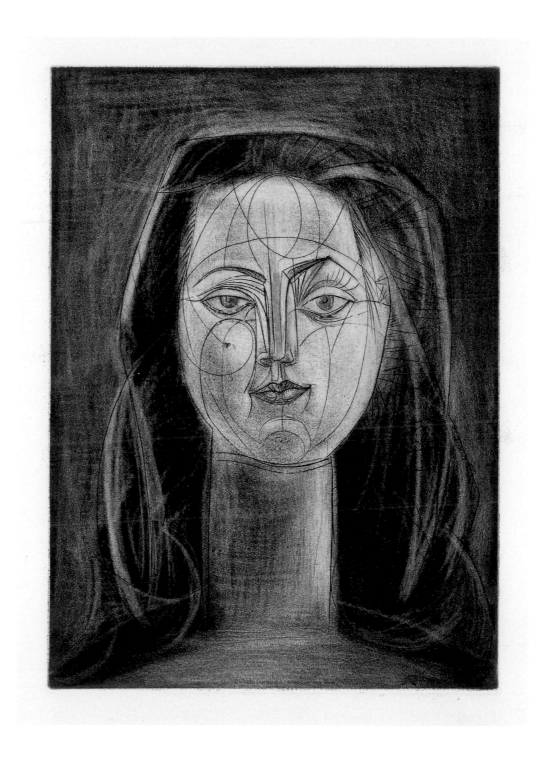

111. FRANÇOISE WITH LONG NECK. I, state III. 1946. Aquatint and engraving. Plate: 13 9/16 x 9 3/4" (34.5 x 24.8 cm).

Picasso began this series depicting a woman naturalistically, and then superimposed a study in abstraction. Still, this is clearly a likeness of Gilot, including a mole on her cheek (reversed due to the printing process), and his signature reference for her: long, luxuriant hair. Later, as tensions grew between the couple, she is often shown with her hair pulled back in a bun.

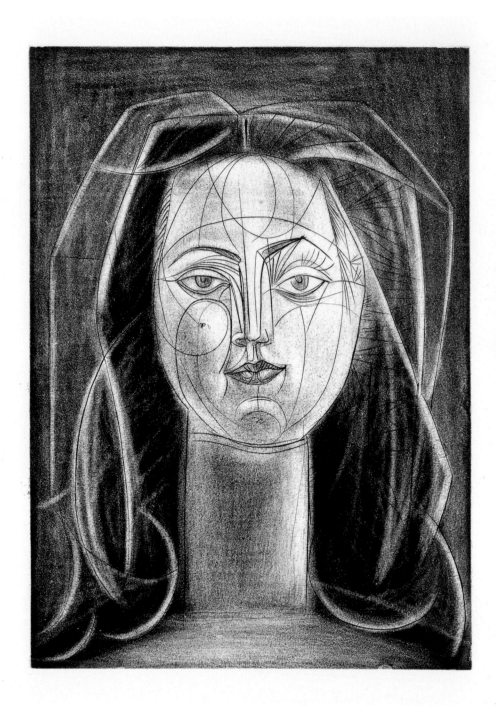

112. FRANÇOISE WITH LONG NECK. I, state IV. 1946. Aquatint and engraving. Plate: 13 9/16 x 9 5/8" (34.5 x 24.8 cm).

The first three prints in this series were made in a process that went from dark to light. Starting with black aquatint across the surface, Picasso burnished away areas that he wanted to lighten.

This process creates a glowing effect, very appropriate for what appears to be a celebration of Gilot finally settling into his life. In this state, the soft burnished lines in her hair suggest a bridal veil.

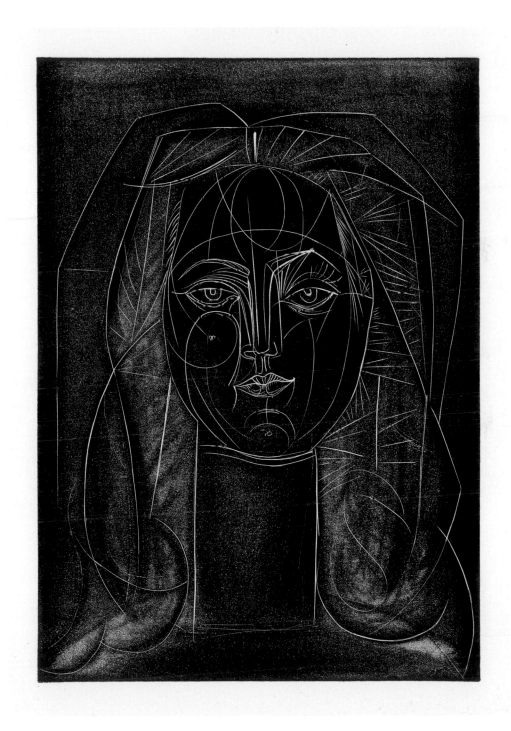

113. FRANÇOISE WITH LONG NECK. I, state IV. 1946. Aquatint and engraving, printed in relief. Plate: 13 $^{11}/_{16}$ x 9 $^{3}/_{4}$" (34.8 x 24.8 cm).

This print may represent a step toward turning the aquatint and engraving into a lithograph, like others in white lines of around this time.[11] Ink was spread across the surface of the plate, rather than pushed into the incised lines, so they printed as white. Also, ink was wiped selectively for areas of modulation. Here, Picasso takes a further step away from naturalistic portraiture and toward abstraction.

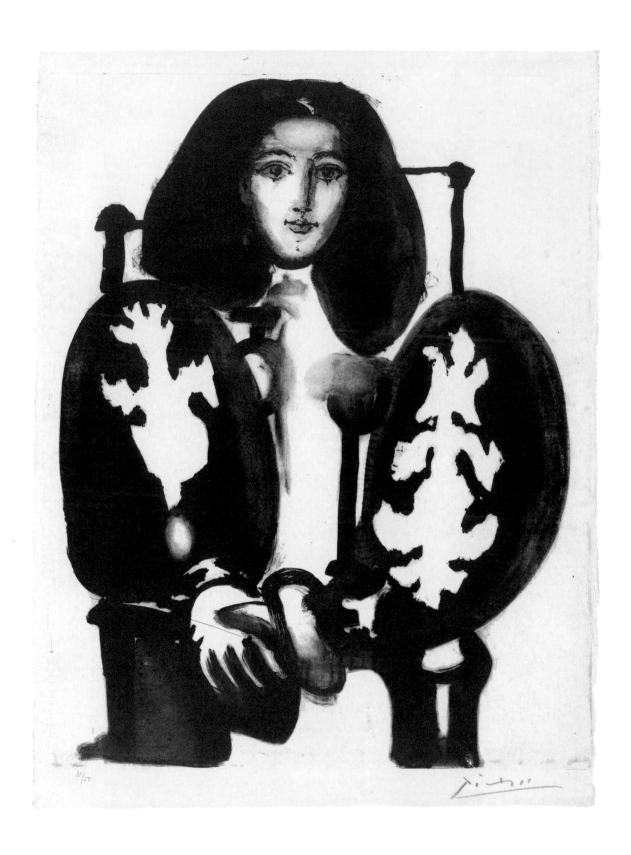

114. ARMCHAIR WOMAN NO. 1.
December 30, 1948. Lithograph. Sheet:
29 $^{15}/_{16}$ x 22 $^{7}/_{16}$" (76 x 57 cm).

Picasso's lithographs from the second half of the 1940s, when he was working at the Mourlot workshop, represent a high point in his printmaking. There are many lithographic representations of Gilot from this period. Between

December 1948 and May 1949, he made no fewer than twenty-eight variations of this composition, showing her wearing an embroidered jacket that he had brought back from Poland.

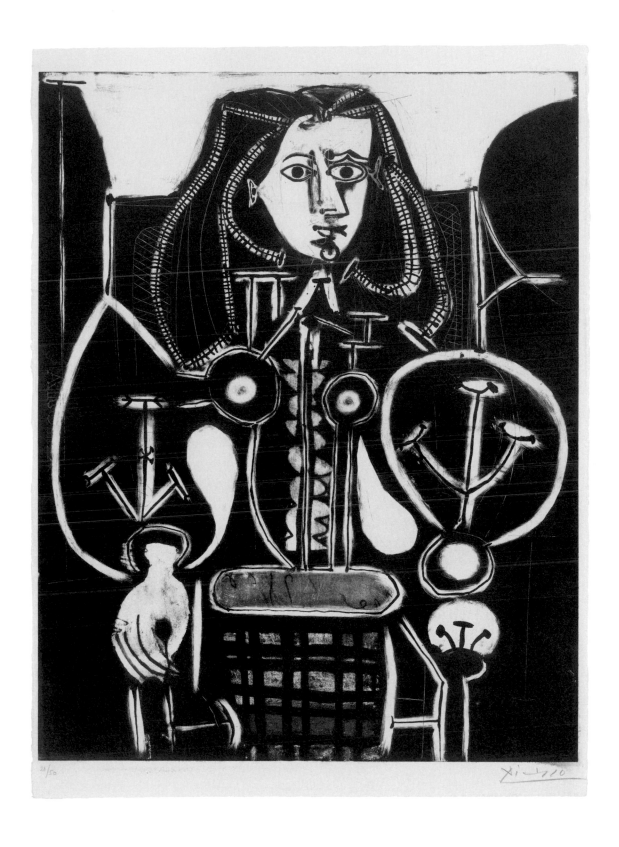

115. ARMCHAIR WOMAN NO. 4.
January 3, 1949. Lithograph. Sheet:
30 x 22 ¼" (76 x 56.5 cm).

Picasso went through an unusual process to arrive at these prints: he began with a lithograph in five colors (using five plates), perhaps inspired by Gilot's colorful jacket. Not satisfied, he developed the compositional fragments on each of the plates. With those as his starting points, he depicted Gilot both naturalistically and abstracted, and printed only in black.

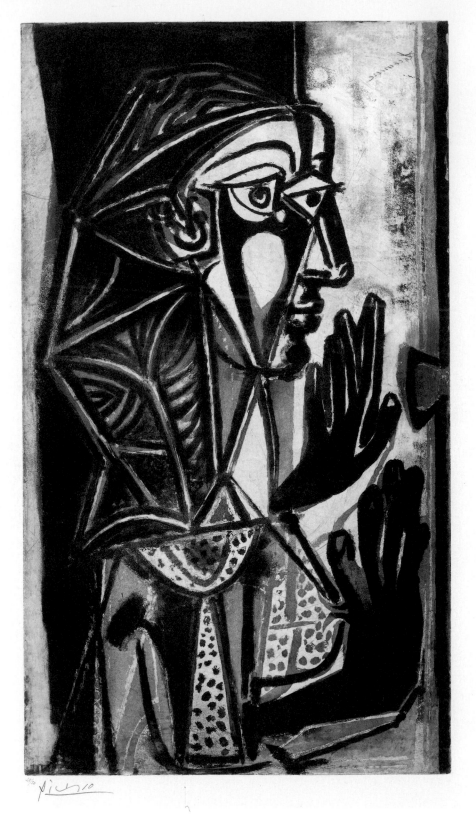

116. WOMAN AT WINDOW. May 17, 1952.
Aquatint. Plate: 34 ¹³/₁₆ x 18 ⁵/₈"
(88.4 x 47.3 cm).

Gilot was increasingly unhappy as she discovered Picasso's affairs with other women; nonetheless, she tried to maintain their family life. He was often critical, sometimes even commenting on her looks declining. She describes one day when she could not stop crying.[12] Picasso took advantage of the moment to create a lithographic portrait of her. Here, in aquatint, he captures an apparently equally saddened Gilot.

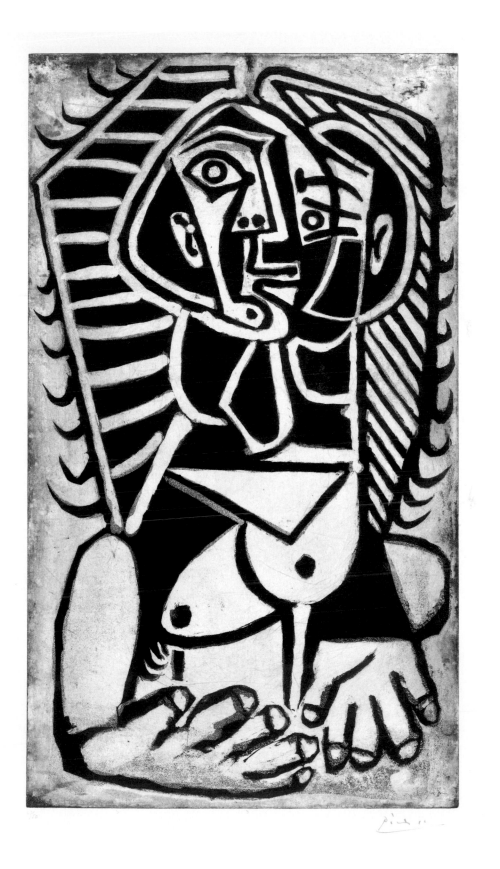

117. EGYPTIAN. May 11, 1953.
Aquatint. Plate: 32 ¹¹/₁₆ x 18 ⁹/₁₆"
(83.1 x 47.1 cm).

In March 1953 Gilot went to Paris to
work on sets for a ballet. She returned
in the summer, but Picasso was furious
with her. His anger is reflected in this
fierce portrait, in which Gilot's features
are distorted, and her flowing hair is
hardened into an aggressive helmetlike
shape. (The work's title was a nickname
given by the printers.)[13] Gilot left Picasso
for good in September 1953.

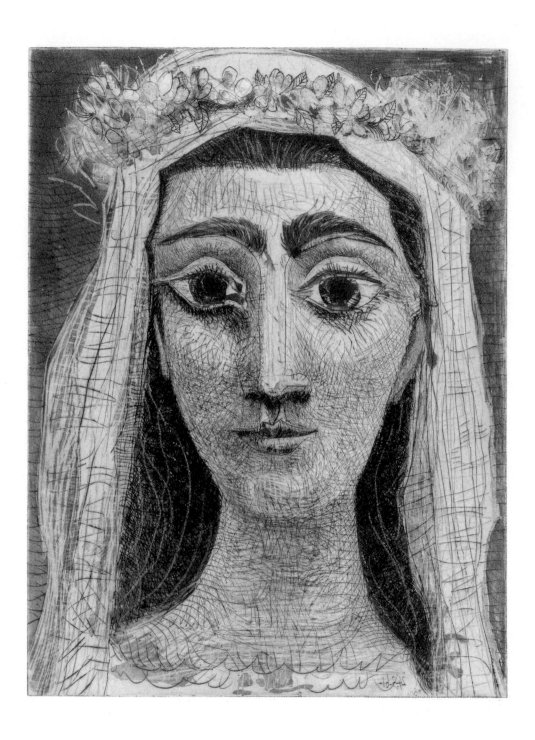

118. JACQUELINE AS A BRIDE. March 24, 1961. Aquatint, drypoint, and engraving. Plate: 15 ¹¹/₁₆ x 11 ⁵/₈" (39.8 x 29.6 cm).

Picasso met Jacqueline Roque when she was working in a sales position for the Madoura pottery studio, where he made ceramics. She moved in with him in 1954 and they remained together until his death, in 1973. Picasso began this print soon after their marriage, in March 1961. He was assisted by printer Jacques Frélaut, who sometimes traveled from Paris to the South of France to work with him.[1]

11d. JACQUELINE ROQUE

Picasso's second wife, Jacqueline (née Roque), was with him for nearly twenty years—thus occupying an unusual place among the women in his life for her longevity alone. Picasso was seventy-two when they met in 1953; she was just twenty-seven and working in a sales position for the pottery studio where he made ceramics. While she was further from him in age than even Françoise Gilot, Jacqueline had had a certain amount of life experience before they met: she had been married and divorced, had lived in French colonial West Africa, and had a young child of her own. She was strikingly good looking, and possessed a temperament that matched Picasso's needs in the last two decades of his life.

After so many tumultuous relationships with women, Picasso was perhaps now ready for a muse who was utterly steadfast. Jacqueline was loving, submissive, committed to his art, and efficient at administering the details of his life—keeping visitors at bay, helping to organize his papers, providing documentation, and facilitating his many exhibitions. While she was certainly not immune to the effects of his changing moods and constant demands, she never wavered.

Jacqueline's likeness would appear in countless works by Picasso, not only in portraits, but also in narrative and allegorical scenes (fig. 31).[2] She is sometimes shown with an intense and impenetrable gaze; at other times, she appears with eyes downcast, seeming both vulnerable and melancholy. In still other depictions, her features are abstracted almost beyond recognition and her presence serves simply as a departure point for new pictorial investigations.

Jacqueline and Picasso were based in the South of France: they settled first near Cannes, then bought a château at the foot of Mont Sainte-Victoire near Aix-en-Provence, and finally moved to a house in Mougins. In these later years, many of Picasso's oldest friends passed away—including Henri Matisse, Georges Braque, and Jean Cocteau. In his final decade, Picasso seemed to be racing against time, as he painted, drew, and made prints furiously, producing an enormous quantity of powerful work.

The "Jacqueline Epoch," as it has been called, represents a significant period within Picasso's œuvre, and one that is steadily gaining recognition.[3] It was during those years that he created an extended series of variations on the old masters, and also continuously explored the theme of artist and model, in both painting and drawing. In addition, he brought a new focus to his sculpture, and his printmaking flourished. He continued for some time to work with the Paris printers Fernand Mourlot, and Jacques Frélaut of the Lacourière workshop; they traveled back and forth to the South of France with materials. He also collaborated closely with master-printer Hidalgo Arnéra, based in Vallauris, for linoleum cuts.[4] Finally, he entered into an extended relationship with the printers Aldo and Piero Crommelynck, who set up an etching shop in Mougins so they could be near Picasso and on constant call.

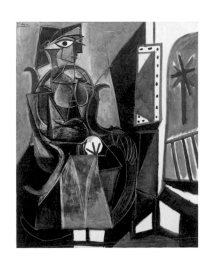

FIG. 31. *Woman by a Window*. 1956.
Oil on canvas. 63 3/4 x 51 1/4" (162 x 130 cm).
Mrs. Simon Guggenheim Fund, 1956

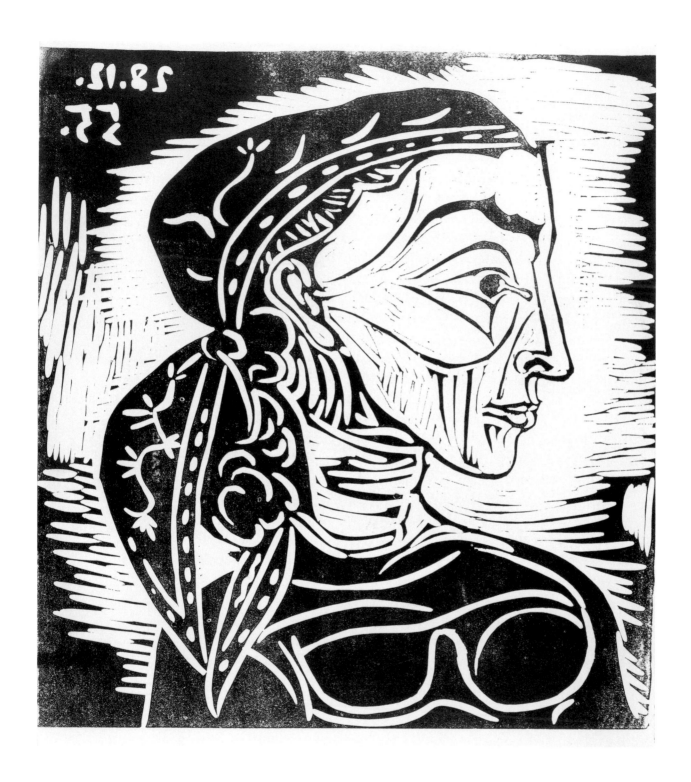

119. JACQUELINE WITH A SCARF.
December 28, 1955. Linoleum cut.
Composition: 21 ³/₄ x 19 ³/₄" (55.2 x 50.2 cm).

Picasso collaborated with Vallauris printer Hidalgo Arnéra for linoleum cuts. His first efforts in the technique were for posters. By the late 1950s, he was more actively working in the medium. This striking composition represents his first major departure from poster work using the technique.[5] It has been said of this image, "No other portrait of Jacqueline in any medium so totally captures [the] tragic aspects of her nature."[6]

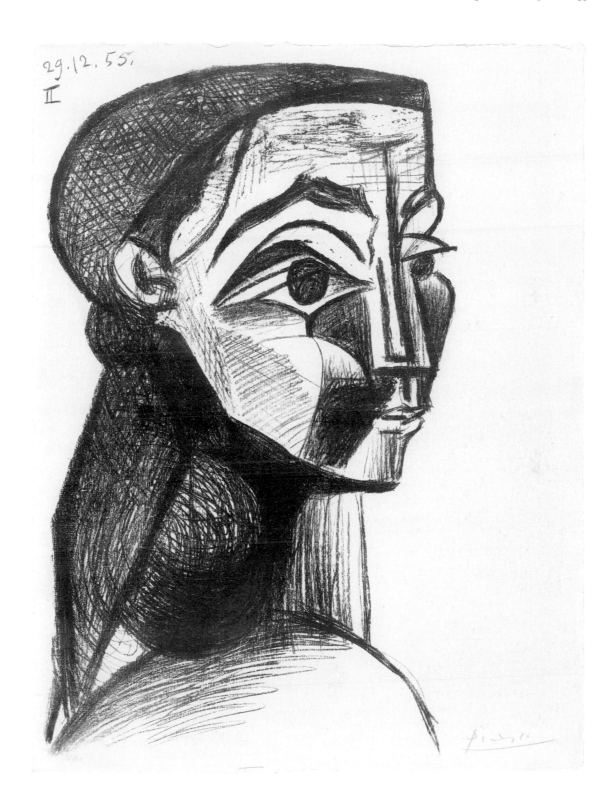

120. PORTRAIT OF A WOMAN.
December 29, 1955. Lithograph.
Sheet: 26 1/8 x 19 3/4" (66.4 x 50.2 cm).

Picasso made this lithographic portrait of Jacqueline on the day after he made the linoleum-cut version on the facing page. The soft strokes of the lithographic crayon contrast dramatically with the stark gouges in the linoleum block. Jacqueline wears a head scarf in both images, yet the characterizations are very different. This view shows her with the haughty glamour of a fashion model, while the other is tinged with sadness.

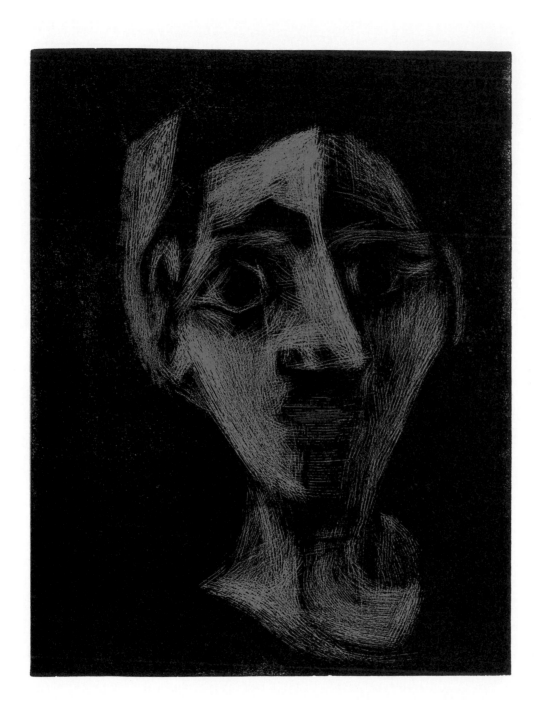

121. JACQUELINE WITH HEADBAND. I, state I. February 13, 1962. Linoleum cut. Composition: 13 3/4 x 10 11/16" (35 x 27.2 cm).

The series beginning with this print was made during the period of Picasso's most active involvement with linoleum cuts. Printer Arnéra called Picasso "a craftsman to the core" for his instinctive grasp of the technique.[7] The artist utilized it for a range of effects, creating the bold, simplified shapes for which it is well suited and best known, but also adapting it to subtle mark-making more typical of etching, as here.

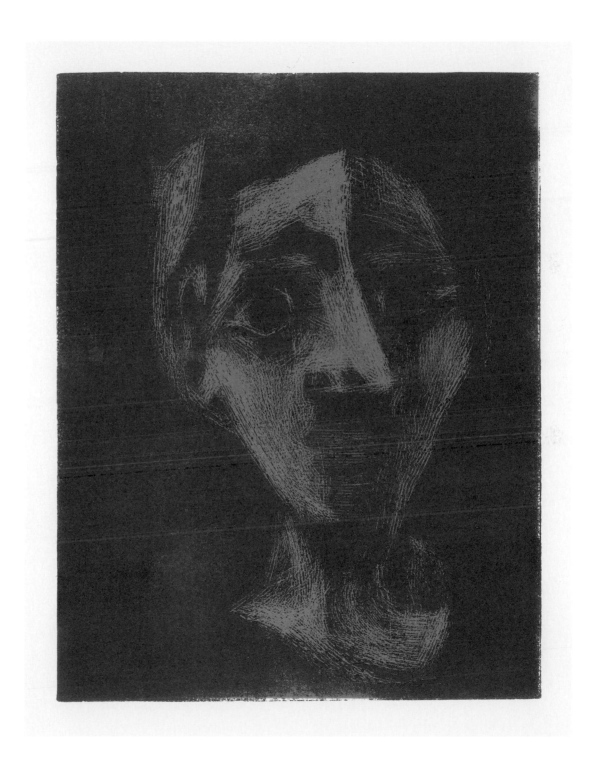

122. JACQUELINE WITH HEADBAND. I, state I. March 2, 1962. Linoleum cut. Composition: 13 ³/₄ x 10 ⁵/₈" (35 x 27 cm).

After making an edition of the mysterious rendering of Jacqueline on the facing page, Picasso went back to his block a few weeks later, printing it now in brown ink over beige. His experimentation continued, as he began to conceive of this enigmatic likeness as part of a more complex and evolving portrait of Jacqueline. With no preparatory studies, according to Arnéra, Picasso simply began gouging the block again.[8]

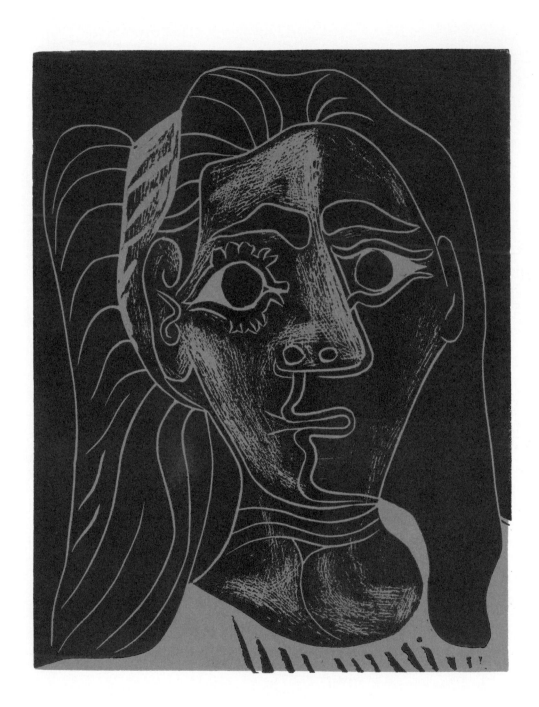

123. JACQUELINE WITH HEADBAND. I, state II. March 6, 1962. Linoleum cut. Composition: 13 ¹³/₁₆ x 10 ¹¹/₁₆" (35.1 x 27.2 cm).

Here, Picasso has added gouged lines to indicate a striped blouse and the texture of hair. But he has also modified the etchinglike lines in the right side of the face. Now, instead of the primarily frontal pose seen in the earlier versions, he has created a variation of his well-known "double face" by delineating a profile as well. The new depiction of the mouth reinforces the effect.

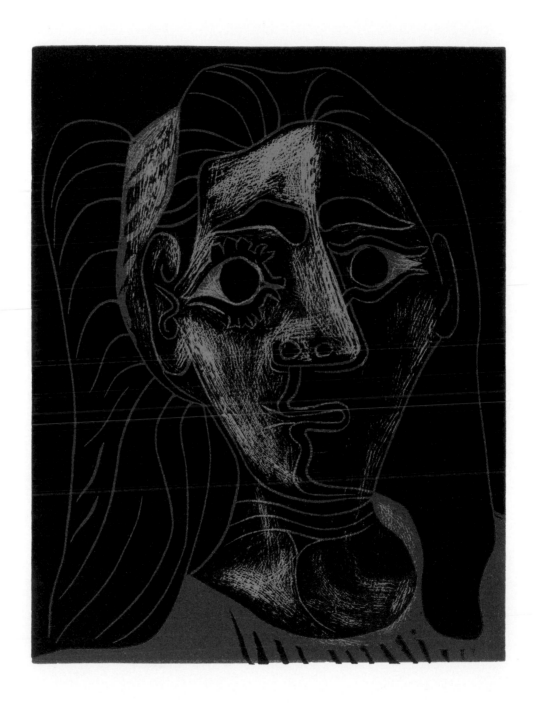

124. JACQUELINE WITH HEADBAND. I, state II over state I. March 6, 1962. Linoleum cut. Composition: 13 ³/₄ x 10 ⁵/₈" (35 x 27 cm).

Picasso began making his "double-face" portraits in the mid-1920s, when Surrealism was taking center stage in the art world. His use of this device has often been interpreted as an expression of the simultaneity of conscious and unconscious realms—a foundation of Surrealist thinking. In this black inking, in particular, the implication is that Jacqueline's intense gaze and placid expression belie a more complicated personality.

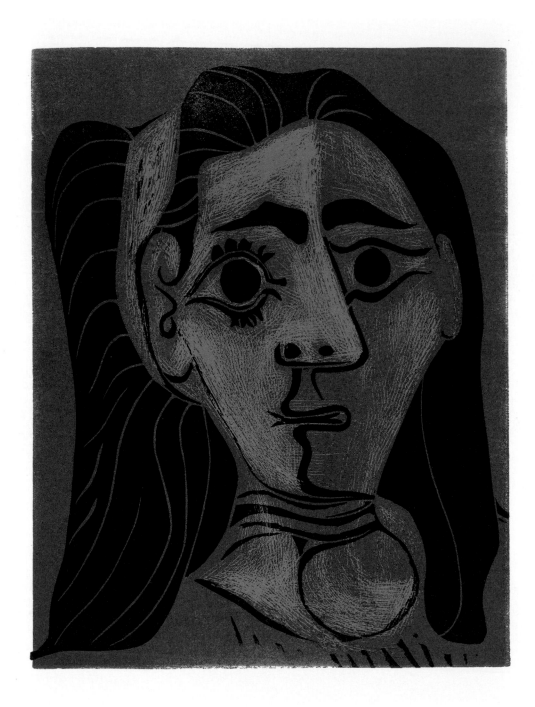

125. JACQUELINE WITH HEADBAND. II, state III over state I. March 6, 1962. Linoleum cut. Composition: 13 ¾ x 10 ⁹/₁₆" (35 x 26.8 cm).

Here, Picasso relieves some of the gloomy mood in the previous prints by cutting away the background of the block, so the portrait head stands out assertively. In the print on the facing page, he goes even further, ridding the block of all the etchinglike lines that shaded the face, neck, and hair band. He has thus completely transformed the portrayal of Jacqueline that started this series.

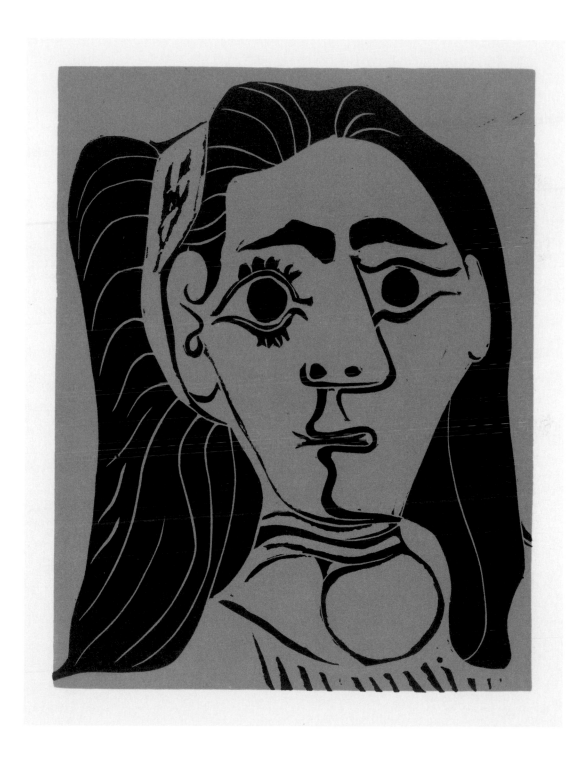

126. JACQUELINE WITH HEADBAND. III, state III. c. March 6, 1962. Linoleum cut. Composition: 13 3/4 x 10 5/8" (35 x 27 cm).

While this is the final print in the series—and an edition was made of it—it is not the only one considered to be "definitive." Picasso also had editions made of the print on the facing page, and of the first in the sequence,

indicating that he wanted to document the metamorphosis of his composition. The creative process was highly significant to Picasso, and printmaking, by its nature, allowed for its documentation.[9]

12. After the Masters

Like virtually all artists, Picasso looked to the history of art for inspiration. In the period from 1954 to 1962, he focused with particular intensity on three individual works by past masters: Eugène Delacroix's *Women of Algiers* (1834), Diego Velázquez's *Las Meninas* (1656), and Édouard Manet's *Luncheon on the Grass* (1863).[1] For each, he created an extensive series of variations, in painting, drawing, and (in the case of the Manet) also in sculpture and linoleum cut.[2] This body of work is so large and wide-ranging that it can be characterized as almost a distinct phase in his career, even as he continued to work in other pictorial modes.

An event in the late 1940s is often cited as a possible spark for Picasso's distinct turn to the historical masters for inspiration. At that point, he had decided to make a gift of some of his paintings to Paris's Musée d'Art Moderne, but they went first to the Louvre for storage. Georges Salles, then director of the Musées de France, suggested that Picasso come to the Louvre on a day when it was closed to the public, to see his paintings placed alongside those in the collection.[3] Picasso agreed, though with some trepidation. However, after seeing his works next to those by Zurbarán, Delacroix, and Courbet, he seemed satisfied with his own achievement.

Picasso's focus on past masters, as a kind of catalyst for his own work, followed a notable pattern. Over the years his artistic imagination was often fueled by particular people and things. A historic partnership with Georges Braque during the development of Cubism is one example. It has also been established that when he became involved with a new woman, changes in his art followed. For printmaking, this pattern may be applied to the master printers who were stimulating goads to his extensive experimentation. Artists of the past filled similarly inspirational roles, especially at this time, when the art world in general was going in directions counter to his own aesthetic concerns. In effect, he found collaborators in historical figures, at a moment when he did not encounter them among younger contemporary artists.

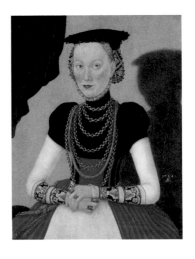

In 1947, Picasso began a lithographic project devoted to Lucas Cranach the Elder's *David and Bathsheba* (1526; fig. 32). His series of prints on the subject comprises thirteen states and variations, and evolved over a two-year period.[4] In a departure from standard printmaking practice—but fairly typical for Picasso— he did not work toward a definitive state at the end of his long process. Instead, he made editions at several stages along the way; it could even be inferred that the whole series together might constitute the work of art.[5] His evolving analysis of subjects in printmaking is paralleled in his variations on the old masters in all

TOP: **FIG. 32.** Lucas Cranach the Elder. *David and Bathsheba.* 1526. Oil on red beech wood. 15 1/4 x 10 1/8" (38.8 x 25.7 cm). Gemäldegalerie, Staatliche Museen zu Berlin

BOTTOM: **FIG. 33.** Lucas Cranach the Younger. *Portrait of a Young Lady.* 1564. Oil and tempera on panel. 32 11/16 x 25 3/16" (83 x 64 cm). Kunsthistorisches Museum, Vienna

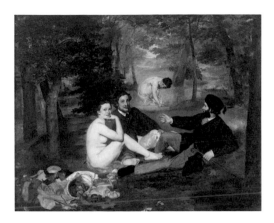

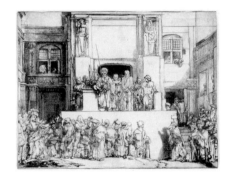

mediums, as one work seemed to be the impetus for the next in a series. Picasso is quoted as having said—as early as the 1930s—that "the metamorphosis of a picture" was of great importance to him.[6] And in fact, this concern led to his practice of carefully dating works in an effort to document the creative process.

In the late 1950s and early 1960s, working in linoleum cut with printer Hidalgo Arnéra in Vallauris, Picasso again turned to the art of past masters for his motifs. In one major example, he looked back at Lucas Cranach the Younger's *Portrait of a Young Lady* (1564; fig. 33). For this composition, he laboriously cut five linoleum blocks, one for each color. He was impatient with the labor-intensive process, and frustrated with the imperfections that came when lining up all the blocks for printing. Later, when he embarked on a series of linoleum-cut variations of Manet's *Luncheon on the Grass* (fig. 34), he had mastered a new approach. Upon Arnéra's suggestion, he worked inventively with a reductive method that involved carving only one linoleum block, in carefully planned-out steps.[7]

In the 1960s and 1970s, during his final years, Picasso returned to the intaglio processes of etching, engraving, drypoint, and aquatint—techniques he had always favored, and that represent the greatest quantity of his prints overall. But the outpouring of prints at this time was due primarily to the fact that the brothers Aldo and Piero Crommelynck, whom Picasso had known in Paris, had set up an intaglio print shop for him in Mougins, close by. That allowed Picasso to work virtually around the clock, as the printers brought plates and proofs back and forth between the shop and his home

In the last phase of Picasso's work, Rembrandt became an especially important resource. He is known to have projected slides of the Dutch master's paintings—including the celebrated *The Night Watch*—onto the wall of his studio, for study.[8] The many "musketeer" figures that populate his late paintings derive from such works, among other sources. Picasso was also stimulated by Rembrandt's etchings, and probably owned catalogues reproducing them.[9] One of his most significant late prints—part of the series known as Suite 156—reenvisioned Rembrandt's c. 1655 etching titled *Christ Presented to the People*, popularly known as *Ecce Homo* (fig. 35). Picasso substituted a secular scene for a religious one by layering on his personal iconography and making the motif his own. Surely he would have appreciated the fact that Rembrandt took his composition through many stages of development. Picasso did the same, slowly filling his scene through evolving states, creating a phantasmagoria of people and motifs from his long life.

TOP: **FIG. 34.** Édouard Manet. *Luncheon on the Grass*. 1863. Oil on canvas. 81 7/8 x 104 1/8" (208 x 264.5 cm). Musée d'Orsay, Paris

BOTTOM: **FIG. 35.** Rembrandt Harmensz van Rijn. *Christ Presented to the People (Ecce Homo)*, state V. c. 1655. Etching. Plate: 14 1/8 x 17 7/8" (35.8 x 45.4 cm). Musée du Louvre, Paris

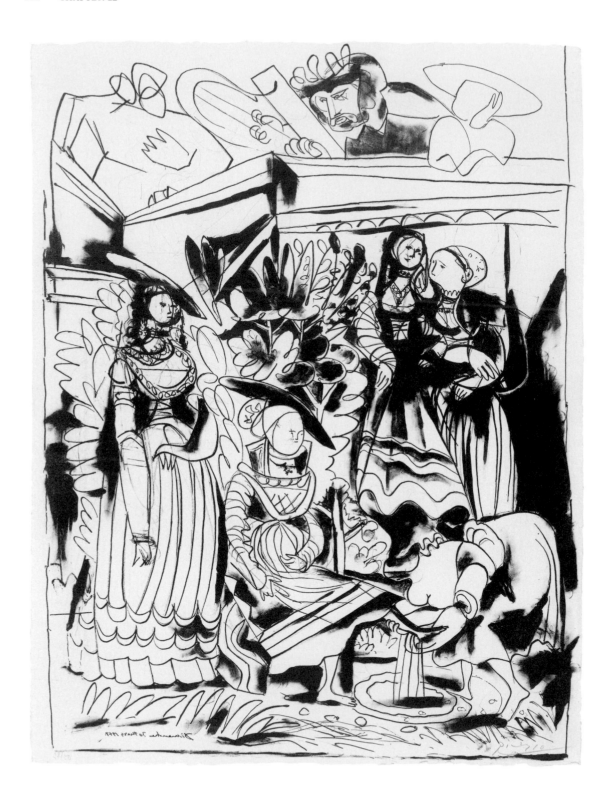

127. DAVID AND BATHSHEBA (AFTER LUCAS CRANACH), state I.
March 30, 1947.
Lithograph. Sheet: 25 ¹³/₁₆ x 19 ³/₄"
(65.5 x 50.2 cm).

During a period of intense experimentation in lithography at the Mourlot workshop in Paris, Picasso embarked on this print, based on a 1526 painting by German master Lucas Cranach the Elder (fig. 32). Picasso's dealer and friend Daniel-Henry Kahnweiler had given him a catalogue that included a reproduction of this painting. The fact that the reproduction was in black and white might have suggested its adaptation as a lithograph.

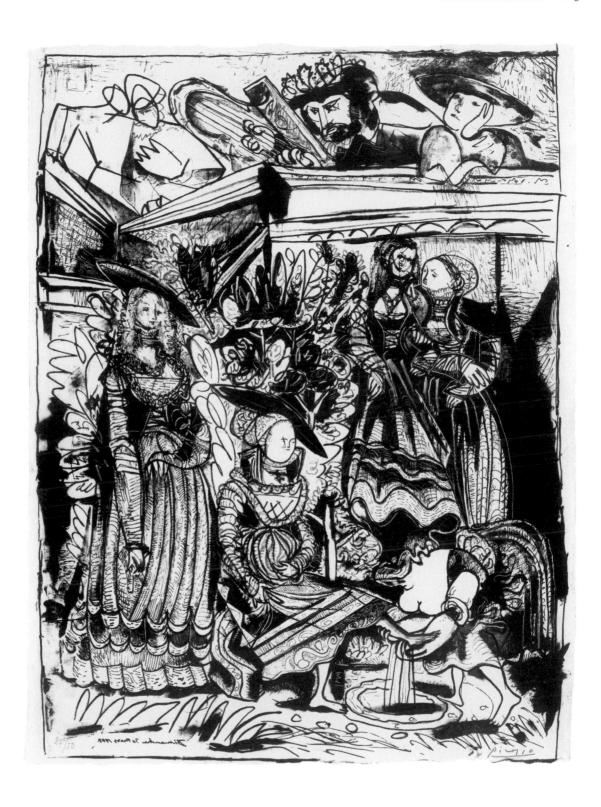

**128. DAVID AND BATHSHEBA
(AFTER LUCAS CRANACH)**, state II.
March 30, 1947.
Lithograph. Sheet: 25 13/16 x 19 5/8"
(65.6 x 49.8 cm).

In the early stages of this series, Picasso exploits the typically painterly potential of lithography, creating a range of texture and patterning, particularly in the finery worn by the ladies. At the top, here, King David is more prominent than he was in the earlier state, looming much larger even than in the Cranach painting. Perhaps Picasso identified with the older king, who would pursue the young woman being bathed.

129. DAVID AND BATHSHEBA (AFTER LUCAS CRANACH), state IV. March 30, 1947. Lithograph. Sheet: 25 13/16 x 19 5/8" (65.5 x 49.8 cm).

This series evolved through thirteen states and variations. Here, Picasso has inked over his previous composition, and scraped out an entirely new linear version of it. The result looks less like a lithograph and more like an etching printed in relief. With the latter method, the surface of the etching plate is inked and the grooves are left empty: after printing, the lines remain white.

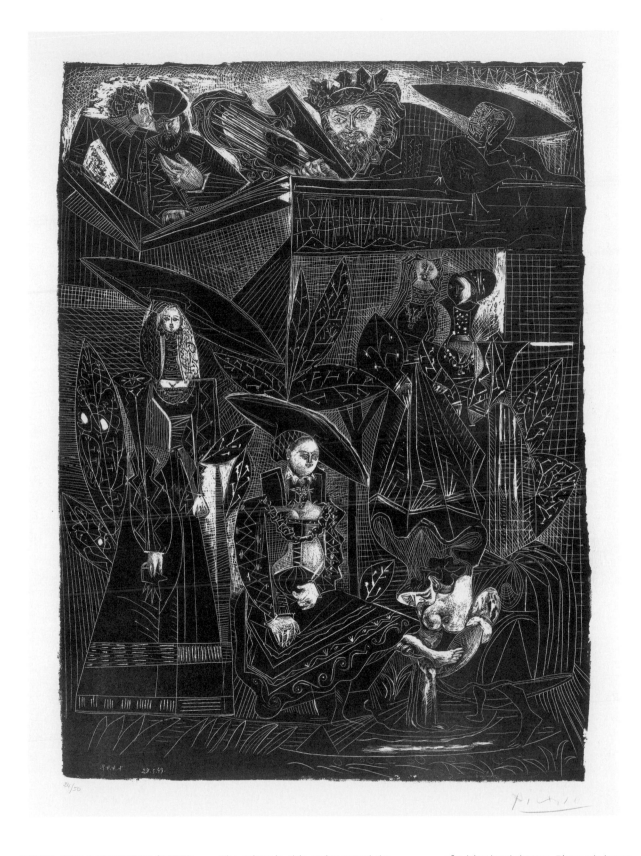

130. DAVID AND BATHSHEBA (AFTER LUCAS CRANACH), state X. May 29, 1949. Lithograph. Composition: 25 ¹¹/₁₆ x 18 ⁷/₈″ (65.3 x 48 cm).

The prints in this series reveal the dialogue between representation and abstraction in Picasso's art. Here, in contrast to the abstracted composition on the facing page, the narrative is emphasized. Details abound, and areas of white lend drama. Picasso's lover at this point was the young Françoise Gilot, whom he sometimes depicted as a flower woman; the sprouting leaves around the maidens may refer to her.

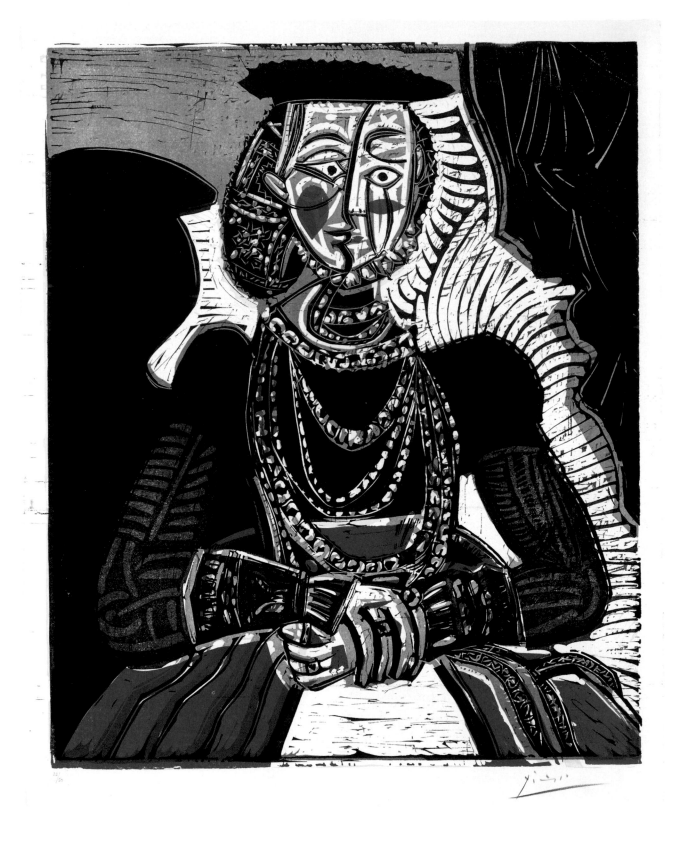

131. PORTRAIT OF A YOUNG LADY, AFTER CRANACH THE YOUNGER. July 4, 1958. Linoleum cut. Composition: 25 $^{11}/_{16}$ x 21 $^{5}/_{16}$" (65.3 x 54.1 cm).

Tacked to his studio wall, Picasso had a reproduction of the 1564 painting by Lucas Cranach the Younger that served as the source for this linoleum cut (fig. 33).[10] The serenity of the woman depicted in the painting has

disappeared in this expressionistic interpretation of Cranach's work. This was Picasso's most ambitious composition to date in the linoleum-cut technique, necessitating five different blocks for the various colors.

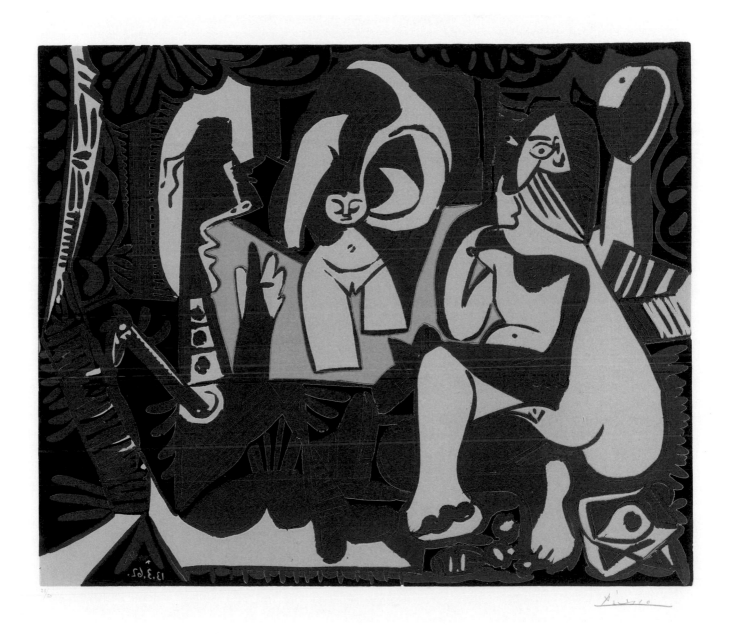

132. LUNCHEON ON THE GRASS, AFTER MANET. January 26–March 13, 1962. Linoleum cut. Composition: 20 15/16 x 25 1/4" (53.2 x 64.2 cm).

Manet's 1863 *Luncheon on the Grass* (fig. 34) was the source of Picasso's most extensive series based on work of a past master, ultimately numbering 27 paintings, 150 drawings, 18 maquettes, and 5 prints. The Manet painting had shocked its first audiences with its strange subject matter and direct paint handling. Picasso ratchets up the color, removes the comforting forest environment, and creates an even more confrontational scene.

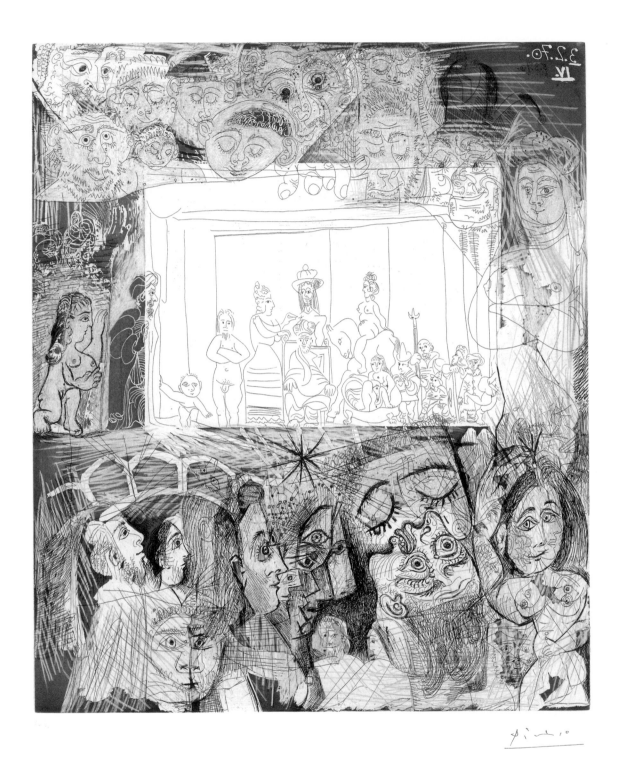

133. "ECCE HOMO," AFTER REMBRANDT.
February 4 and March 5–6, 1970.
Etching and aquatint. Plate: 19 1/2 x 16 1/8"
(49.5 x 41 cm).

In his last years, Picasso returned to intaglio techniques, which involve incising metal. Here, he bases his work on one of Rembrandt's most revered etchings (fig. 35). Picasso reinterprets the scene as a theater filled with the people who had populated his own life and his art. Employing both delicate etched lines and violent scraping, he creates the sense of a dreamlike simultaneity, with memories rushing back to him.

13. Late Work

Picasso continued working at a great pace until just before his death, in 1973, at the age of ninety-one. His final phase is considered to have begun after his recuperation from ulcer surgery in late 1965, an operation that may have foreshadowed the end to him. But he still had much to say artistically in those last years. Living in the South of France, he also kept up with a circle of friends, watched movies and wrestling matches on television, and followed current events during the tumultuous period of strikes and antiwar movements.[1] In terms of trends in the art world, he saw magazines and catalogues, and was well aware that attention had shifted in directions contrary to his own work. Yet he continued to have exhibitions around the world.

Picasso's late painting is characterized by a brash spontaneity, cacophonous colors, and a distinct sense of urgency (fig. 36). It has had mixed reviews from the art press, even by some who were previous supporters. For instance, when his final paintings were exhibited just after his death, one former champion called them "incoherent doodles."[2] But attitudes change, and Picasso's late work has received increasing recognition.[3] Also, it seems very clear that he had complete control over his art in this period: his prints alone demonstrate his agile drawing, attention to detail, and thorough mastery of the etching techniques he endlessly challenged

Printers Aldo and Piero Crommelynck were instrumental to Picasso's last flourishing phase of printmaking. The brothers had known him in Paris and were well aware of his round-the-clock working habits, and the fact that his prints thrived when active collaborators were nearby. They accommodated him by setting up a workshop down the hill from his home. A friend nicknamed the route between the house and the studio "the copper road," since so many copper etching plates traveled along it.[4] The Crommelyncks became part of Picasso's extended family at that time. Piero, who bore a resemblance to Picasso's father, even appears in prints.[5]

The Crommelyncks supplied Picasso with the variously sized plates that led to the period's most important print project: the Suite 347, named for the number of prints it comprises. Astonishingly, this series was created in less than seven months; on certain days Picasso produced up to six prints. He finally stopped only because an exhibition of the series had been previously scheduled.[6]

In the Suite 347, Picasso reveals himself as a consummate storyteller. Allegorical narratives contain people from his life and motifs from his art, both past and present, while also referencing the old masters, including Rembrandt, Goya, Ingres, and Degas, among others. Picasso relished the process,[7] saying, "As soon as the drawing gets underway, a story or an idea is born . . . the story grows, like theater or life . . . I spend hour after hour while I draw, observing my creatures and thinking about the mad things they're up to. Basically, it's my way of writing fiction."[8]

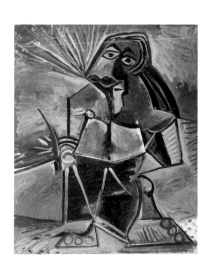

FIG. 36. *At Work*. 1971.
Oil on canvas. 63 ³/₄ x 51 ¹/₄" (161.9 x 130.2 cm).
Gift of Jacqueline Picasso in honor of the
Museum's continuous commitment to Pablo
Picasso's art, 1985

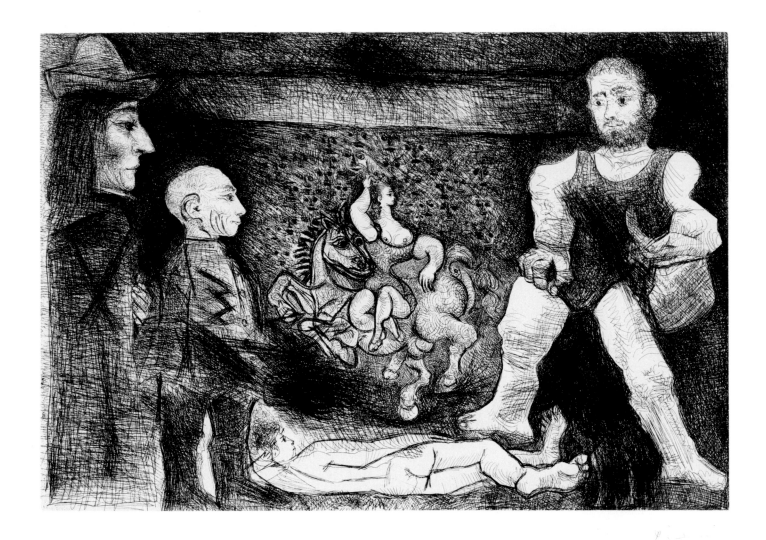

134. NO. 1, from Suite 347. March 16–22, 1968. Etching. Plate: 15 ¹/₂ x 22 ¹/₄" (39.3 x 56.5 cm).

This print initiated Picasso's most extensive series, comprising 347 sheets in a range of etching techniques. He completed the suite in less than seven months, when he was eighty-six years old. The subject matter, with wide-ranging motifs, engages spectacle and theater as Picasso envisions a stage on which to review his life and art.[9] The short figure at left here represents the artist; faces of spectators fill the background.

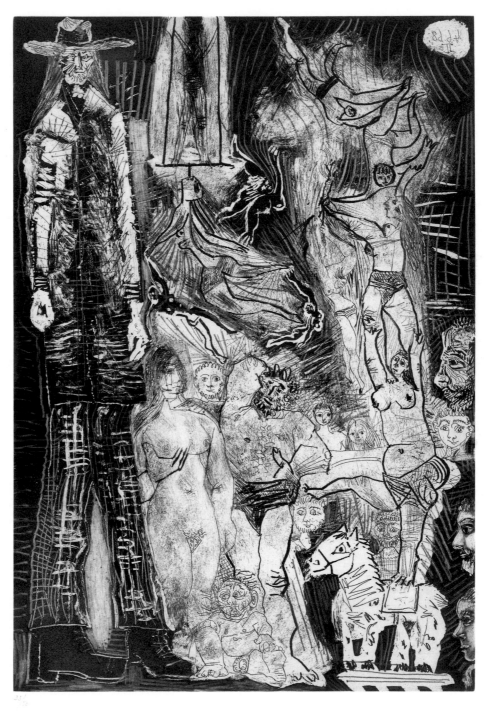

135. NO. 142, from Suite 347. June 4, 1968. Etching, aquatint, and drypoint. Plate: 19 ⁵/₁₆ x 13 ³/₁₆" (49 x 33.5 cm).

Picasso's own presence, in various guises, permeates this series: he appears as a protagonist or as an implied observer of many narratives. Here, the baby with the face of an old man, at bottom center, has been interpreted as symbolizing the artist.[10] He seems to dream about the circus, one of Picasso's earliest motifs. With aquatint and scraping, the artist has created surface effects that mimic the glittering of spotlights.

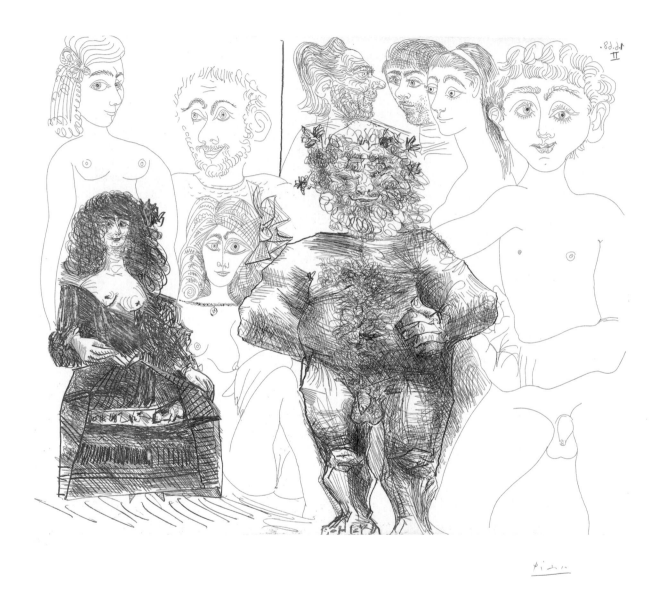

136. NO. 135, from Suite 347. June 1, 1968. Etching. Plate: 16 1/8 x 19 1/2" (41 x 49.5 cm).

Here, shifts in scale, spatial disparities, and figures from different epochs contribute to a sense of simultaneous past and present that infuses the Suite 347. A garlanded artist stands at center. Given its retrospective view of Picasso's life and motifs, the series as a whole may have been prompted by the death of his old friend, Jaime Sabartés, who had served for a time as his secretary.[11]

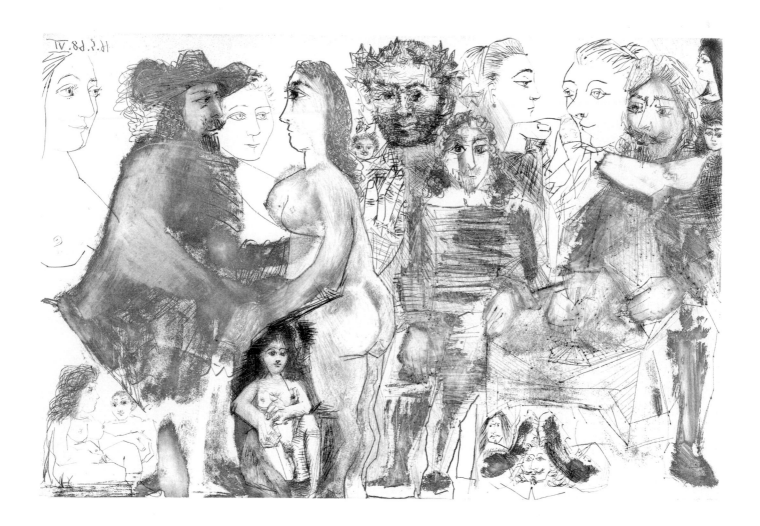

137. NO. 97, from Suite 347. May 16, 1968. Etching and drypoint. Plate: 13 1/4 x 19 3/8" (33.6 x 49.2 cm).

It seems that Picasso knew Alexandre Dumas's classic novel *The Three Musketeers* virtually by heart.[12] His reflections on Rembrandt's work, however, were at this time also a source for the seventeenth-century figures that began to appear in his art.[13] Here, the garlanded artist holds the back of a musketeer's chair, as if relating to him a tale filled with disparate characters.

Notes
Each chapter's endnotes begin with note 1. In some cases, a citation in one chapter refers the reader to an endnote citation (n.) in another chapter in this volume. The catalogues raisonnés for Picasso's prints and books are cited in full at the start of the checklist (see p. 182). For ease of reference, the title of Brigitte Baer's seven-volume *Picasso: Peintre-graveur* is abbreviated here.

INTRODUCTION:
PICASSO'S PRINTMAKING:
A CATALYST FOR CREATIVITY

1. Picasso, quoted in Dore Ashton, *Picasso on Art: A Selection of Views* (New York: Viking, 1972), 43.

2. Picasso, quoted in Marius de Zayas, "Picasso Speaks," *Arts* 3, no. 5 (May 1923): 323, cited in William Rubin, "Reflections on Picasso and Portraiture," in Rubin, ed. *Picasso and Portraiture: Representation and Transformation* (New York: Museum of Modern Art, 1996), 40.

3. In these endnotes, see chap. 9, "Text and Image," nn. 16 and 17.

4. In these endnotes, see chap. 11d, "Jacqueline Roque," n. 3.

5. Picasso, quoted in Françoise Gilot and Carlton Lake, *Life with Picasso* (New York: McGraw-Hill, 1964), 314.

6. In these endnotes, see chap. 1, "Saltimbanques," n. 6.

7. Picasso also seems to have come to the aid of printers who needed income from printing editions. In one instance, it is known that he gave Roger Lacourière forty-two plates to edition in the early 1940s, during the Occupation, even though very few of the prints were ever signed or sold. See Brigitte Baer, *Picasso the Printmaker: Graphics from the Marina Picasso Collection* (Dallas: Dallas Museum of Art, 1983), 59; and Eberhard Kornfeld, "Chronology," in Fernand Mourlot, *Picasso: The Lithographic Work*, vol. 1, *1919–1949* (rev. 2009 by The Picasso Project) (San Francisco: Alan Wofsy Fine Arts, 2009), xx.

8. See for example Picasso's contribution to the 1938 portfolio *Solidarité*, organized by his friend Paul Éluard, in Baer, *Picasso: Peintre-graveur*, vol. III, 141, no. 635; and his contribution to the 1939 portfolio *Pour la Tchécoslovaquie: Hommage à un pays martyr*, in Baer, *Picasso: Peintre-graveur*, vol. III, 310, no. 711.

9. The format of the individual scenes in these prints is thought to derive from the fact that the original plan was for postcards that could be widely distributed. For more information on the portfolio, see Sebastian Goeppert, Herma Goeppert-Frank, and Patrick Cramer, *Pablo Picasso: The Illustrated Books: Catalogue Raisonné* (Geneva: Patrick Cramer, 1983), 82–83, no. 28.

10. Patrick Elliot, *Picasso on Paper* (Edinburgh: National Galleries of Scotland, 2007), 75. While the edition size for sale at the pavilion was 850 examples, there was an additional printing of 150 signed examples, bringing the total to 1,000.

11. When Kahnweiler returned to Paris after World War I, he called his establishment Galerie Simon, after his partner André Simon. During World War II, he renamed his gallery Galerie Louise Leiris. Leiris, who had worked with him since the early 1920s, was Kahnweiler's stepdaughter (although she has often been misidentified as his wife's sister); this fact was kept secret. See John Richardson in collaboration with Marilyn McCully, *A Life of Picasso*, vol. II, *The Cubist Rebel, 1907–1916* (New York: Knopf, 2007), 35.

12. See Goeppert, Goeppert-Frank, and Cramer, *Picasso: Illustrated Books*, 60–63, no. 20.

13. See ibid., 54–57, no. 19.

14. In 1934, Picasso illustrated another book with a classical text: Aristophanes's *Lysistrata*. See ibid., 72–73, no. 24.

15. Picasso, quoted in Roberto Otero, *Forever Picasso: An Intimate Look at His Last Years* (New York: Abrams, 1974), 170.

16. Gary Tinterow, with research by Asher Ethan Miller, "Vollard and Picasso," in Rebecca A. Rabinow, ed., *Cézanne to Picasso: Ambroise Vollard, Patron of the Avant-Garde* (New York: Metropolitan Museum of Art; New Haven: Yale University Press, 2006), 113 and 117 (n. 56).

17. It seems that Vollard intended to gather some of the prints into separate publications with accompanying texts by poet André Suarès; the texts were titled *Minos et Pasiphaë*; *Modèles*; and *Minotaure*. See Rebecca A. Rabinow, "Vollard's *Livres d'Artiste*," in Rabinow, ed., *Cézanne to Picasso*, 206–9, 212 (nn. 72 and 88); see also Tinterow with Miller, "Vollard and Picasso" in Rabinow, ed., *Cézanne to Picasso*, 113–14, 117 (nn. 57 and 58). In addition, a sample title page exists for one of the Suarès texts, with this

information: "*Minos et Pasiphaë* by André Suarès, with original prints by Picasso." See *Old Master, Modern & Contemporary Prints*, Christie's, London, May 14, 2002, 78–81, lot 152.

18. For extensive discussions of the Vollard Suite, see Anita Coles Costello, *Picasso's "Vollard Suite"* (New York: Garland, 1979); Lisa Florman, *Myth and Metamorphosis: Picasso's Classical Prints of the 1930s* (Cambridge, Mass.: MIT, 2000); and *Picasso: Suite Vollard und Minotauromachie* (Madrid: Sociedad Estatal para Exposiciones Internacionales; Rostock, Germany: Kunsthalle Rostock, 2003).

19. Picasso, quoted in Brassaï, *Picasso and Company* (Garden City, N.Y.: Doubleday, 1966), 100.

20. For a thorough discussion on Picasso's printers, see Pat Gilmour, "Picasso & His Printers," *Print Collector's Newsletter* 18, no. 3 (July–Aug. 1987): 81–90. Gilmour later corrected errata in that article, pertaining to the Crommelyncks, in "Late Picasso," *Print Quarterly* 14, no. 2 (June 1997): 211–16.

21. Picasso, quoted in Brassaï, *Picasso and Company*, 46.

22. For background on Lacourière, see chap. VII, "Lacourière," in Baer, *Picasso the Printmaker*, 72–74.

23. "Père" Tutin's first name was either Raymond or Gaston. See Gilmour, "Picasso & His Printers," 86, 90 (n. 41).

24. Célestin said, "There was no stopping him. As lithographers we were astounded by him." See Hélène Parmelin, "Picasso's Iron Wall," in Fernand Mourlot, *Picasso Lithographs* (Boston: Boston Book and Art, 1970), n.p.

25. Picasso, quoted in Gilot and Lake, *Life with Picasso*, 124.

26. Picasso, quoted in Brassaï, *Picasso and Company*, 182.

27. For a discussion of Picasso's experimentation with color, see Brigitte Baer, "The Hand, the Manner of Working," in *Picasso: Suite Vollard und Minotauromachie*, 356.

28. Many texts on Picasso's linoleum cuts credit the artist with the invention of the single-block linoleum-cut process. Gilmour, in "Picasso & His Printers" (88 and 90, n. 59), points out that Gauguin had used this technique. In interviews, the printer Hidalgo Arnéra stated that the technique was known in commercial printing and that he suggested it to Picasso. See Anne-Françoise

Gavanon, Appendix I: "Picasso's Linocuts: the Story of a Collaboration, Interview of Hidalgo Arnéra," in *Picasso's Linocuts: Between Painting and Sculpture?*, M.A. diss. (Courtauld Institute of Art, London, 2004), 47–56; see also Markus Müller, "Interview mit Hidalgo Arnéra," in Müller, ed., *Pablo Picasso und Jacqueline: Vorletzte Gedanken* (Bielefeld: Kerber, 2005), 69–73. I am grateful to London print dealer Frederick Muldor for guiding me to the Gavanon dissertation.

29. Arnéra, quoted in Gilmour, "Picasso & His Printers," 88, 90 (n. 60, referencing Blandine Bouret, "La période des linograveurs," in *Pablo Picasso: L'œuvre gravé 1899–1972* [Paris: Daniel Gervis, 1984], n.p.).

30. Gavanon, *Picasso's Linocuts*, 56.

31. John Richardson, "L'Epoque Jacqueline," in Marie Laure Bernadac et al., *Late Picasso: Paintings, Sculpture, Drawings, Prints, 1953–1972* (London: Tate Gallery, 1988), 26, 28.

32. Picasso, quoted in Jean Leymarie, *Picasso: The Artist of the Century* (New York: Viking, 1972), 89.

1. SALTIMBANQUES

1. Gilmour, in "Picasso & His Printers" (81–82), discusses the printing tradition of the Delâtre workshop and the possibility that Picasso did not like the inking and wiping effects produced in that shop. But since approximately thirty impressions were printed there, and several were given to friends, it is questionable whether Picasso objected to the way they were printed. For the large edition of this print (made in 1913 for the Saltimbanques series published by Vollard), the plate was steel-faced and the printer was Louis Fort. The effects of steel-facing and clean wiping give the prints in that edition a paler, more uniform cast.

2. Guillaume Apollinaire, "The Young: Picasso, Painter," *La Plume* 17, 372 (May 15, 1905): 477–83; cited in Gary Tinterow, *Master Drawings by Picasso* (Cambridge, Mass.: Fogg Art Museum, 1981), 62.

3. Picasso, quoted in John Richardson in collaboration with Marilyn McCully, *A Life of Picasso*, vol. III, *The Triumphant Years, 1917–1932* (New York: Knopf, 2007), 101.

4. Peter Read, *Picasso & Apollinaire: The Persistence of Memory* (Berkeley: University of California Press, 2008), 2.

5. Tinterow with Miller, "Vollard and Picasso," in Rabinow, ed., *Cézanne to Picasso*, 112, 117 (n. 50); John Richardson in collaboration with Marilyn McCully, *A Life of Picasso*, vol. I, *The Prodigy, 1881–1906* (New York: Knopf, 2009), 334 and 508 (n. 19).

6. E. A. Carmean Jr., *Picasso: The Saltimbanques* (Washington, D.C.: National Gallery of Art, 1980), 31. This catalogue provides a thorough discussion of the Saltimbanques theme. For catalogue entries on a range of Saltimbanque's works, see Núria Rivero and Teresa Llorens, "The Rose Period," in M. Teresa Ocaña and Hans Christoph von Tavel, *Picasso, 1905–1906: From the Rose Period to the Ochres of Gósol* (Barcelona: Electa España, 1992), 136–281.

7. Carmean, *Saltimbanques*, 50; and Marilyn McCully, "Chronology," in *Picasso: The Early Years, 1892–1906* (Washington, D.C.: National Gallery of Art, 1997), 47.

8. See Pierre Daix and Georges Boudaille, *Picasso: The Blue and Rose Periods, A Catalogue Raisonné of the Paintings, 1900–1906* (Greenwich, Conn.: New York Graphic Society, 1967), 265.

9. For more on Madeleine's pregnancy, see Johannes M. Fox, "Madeleine and Margot," in Ingrid Mössinger, Beate Ritter, and Kerstin Drechsel, eds., *Picasso et les femmes* (Chemnitz: Kunstsammlungen Chemnitz, 2002), 62–63; also Richardson, *Life of Picasso: Prodigy*, 304–6.

10. Apollinaire, in *La Plume* (May 15, 1905), as cited in McCully, *The Early Years*, 45.

11. Apollinaire, in *The Cubist Painters* (New York: Wittenborn, 1944), as cited in Jean Sutherland Boggs, *Picasso and Man* (Toronto: Art Gallery of Toronto; Montreal: Montreal Museum of Fine Arts, 1964), 40.

12. For a discussion of this print and its relation to a very similar gouache in the Baltimore Museum collection, see Victor I. Carlson, *Picasso: Drawings and Watercolors, 1899–1907* (Baltimore: Baltimore Museum of Art, 1976), 24–25.

13. For a discussion of this print, see Patricia Leighten, "Salomé, from Les Saltimbanques," in Susan Greenberg Fisher, *Picasso and the Allure of Language* (New Haven: Yale University Press, 2009), 32–37.

2. THE CUBIST SPIRIT

1. Georges Braque, quoted in "Georges Braque on the Beginnings of Cubism to Dora Vallier in Conversation," in Richard Friedenthal, *Letters of the Great Artists: From Blake to Pollock* (New York: Random House, 1963), 264.

2. Picasso, quoted in William Rubin, *Picasso in the Collection of The Museum of Modern Art* (New York: Museum of Modern Art, 1972), 72.

3. Daniel-Henry Kahnweiler with Francis Crémieux, *My Galleries and Painters* (New York: Viking, 1971), 48–49.

4. For a broader discussion of Cubist books, including *Saint Matorel*, see Donna Stein, "Cubist Illustrated Books in Context," in Stein, ed., *Cubist Prints/Cubist Books* (New York: Franklin Furnace, 1983), 57–69.

5. Picasso, quoted in Gilot and Lake, *Life with Picasso*, 79.

6. Peter Read, "'Au Rendez-vous des poètes': Picasso, French Poetry, and Theatre, 1900–1906," in McCully, ed., *Picasso: The Early Years*, 211.

7. Babette Deutsch, *Poetry Handbook: A Dictionary of Terms* (New York: Funk and Wagnalls, 1962), 42; cited in L. C. Breunig, ed., *The Cubist Poets in Paris: An Anthology* (Lincoln: University of Nebraska Press, 1995), xxiii.

8. Baer, *Picasso: Peintre-graveur*, vol. I, 355–58, nos. 215–18.

9. See William Rubin, *Picasso and Braque: Pioneering Cubism* (New York: Museum of Modern Art, 1989), in which prints and paintings are interspersed as a way of studying the development of the style. This is the case in other studies as well, such as Douglas Cooper and Gary Tinterow, *The Essential Cubism 1907–1920: Braque, Picasso & Their Friends* (London: Tate Gallery, 1983).

10. See mention of Jean-Baptiste-Camille Corot's influence on Picasso's depiction of the mandolin in Richardson, *Life of Picasso: Cubist Rebel*, 149. Corot's exhibition at the Salon d'Automne was in 1909, which would date this print to the fall of that year. Rubin suggests a similar link between the Corot exhibition and the painting *Girl with a Mandolin (Fanny Teller)* in *Picasso in the Collection of The Museum of Modern Art* (66), pointing out that "the musical instrument would shortly become a focus of Cubist iconography."

11. In 1913 Kahnweiler commissioned Picasso to illustrate *Le siège de Jérusalem*, the third installment in Max Jacob's Victor Matorel trilogy. Picasso's few subsequent Cubist prints were made after Kahnweiler left Paris. Several of these later prints were never editioned, while others were issued decades later by various publishers. See Baer, *Picasso: Peintre-graveur*, vol. I, 85, no. 39; 91, no. 42; 109–12, no. 51.

12. Burr Wallen and Donna Stein, *The Cubist Print* (Santa Barbara: University Art Museum, University of California, 1981), 23. The name of the kind of brandy varies slightly in other sources.

13. According to Anne Baldassari, *Cubist Picasso* (Paris: Réunion des Musées Nationaux, Flammarion, 2007), 343, Picasso began an affair with Eva Gouel in the fall of 1911, even though he was still involved with Fernande Olivier. That would date this print to before the affair began, throwing doubt on the word *marc* as a reference to Gouel.

14. For more information on the titles of the *Saint Matorel* prints, with some revisions of those depicting Léonie, see Hélène Séckel, *Max Jacob et Picasso* (Paris: Réunion des Musées Nationaux, 1994), 319.

15. Baer, *Picasso: Peintre-graveur*, vol. I, 60–62, no. 25.

16. Ibid. does not mention this access to a press, but Richardson, in *Life of Picasso: Cubist Rebel*, 153, 159, says that Picasso's friend Ramón Pichot, in Cadaqués, owned a press.

3. SCULPTOR'S STUDIO

1. For an exploration of the phenomenon of the "return to order," see Elizabeth Cowling and Jennifer Mundy, *On Classic Ground: Picasso, Léger, de Chirico and the New Classicism, 1910–1930* (London: Tate Gallery, 1990).

2. The etchings of the Sculptor's Studio series depict plaster heads resembling sculptures Picasso was making at the time, as well as a range of sculptures from his imagination. Motifs of the latter include full figures, torsos, classical male heads, and tableaux groupings resembling sculptures of the Hellenistic period. See *Picasso: Suite Vollard und Minotauromachie*.

3. For more information on the mask in Picasso's collection, see Peter Stepan,

Picasso's Collection of African and Oceanic Art (Munich: Prestel, 2006), 126. For information regarding its installation in Boisgeloup, see Richardson, *Life of Picasso: Triumphant Years*, 449, and Cowling and Mundy, *On Classic Ground*, 222.

4. Tinterow with Miller, "Vollard and Picasso," in Rabinow, ed., *Cézanne to Picasso*, 113, 117 (n. 56).

5. Classical motifs persisted especially in Picasso's printed work. His illustrated books, Ovid's *Les métamorphoses* (1930–31), and Aristophanes's *Lysistrata* (1934), are prime examples.

6. For discussions of the Sculptor's Studio prints in the Vollard Suite, see Costello, *Picasso's "Vollard Suite"*; Florman, *Myth and Metamorphosis*; and *Picasso: Suite Vollard und Minotauromachie*.

7. Picasso, quoted in Ashton, *Picasso on Art*, 116.

8. Tinterow with Miller, "Vollard and Picasso," in Rabinow, ed., *Cézanne to Picasso*, 113 and 117 (n. 56).

4. THE MINOTAUR

1. Richardson, *Life of Picasso: Triumphant Years*, 354–56.

2. For a discussion of Breton's article "Picasso poète," *Cahiers d'art* (1935): 7–10, see Anne Baldassari, *The Surrealist Picasso* (Paris: Flammarion, 2005), 66. For more on Picasso's poetry see in these endnotes chap. 9, "Text and Image," nn. 16 and 17.

3. Picasso, quoted in Ashton, *Picasso on Art*, 159.

4. Picasso, quoted in David Douglas Duncan, *Picasso's Picassos* (New York: Harper & Brothers, 1961), 111.

5. The print *Minotauromachy* went through seven states, including experiments with color. See Marie-Laure Bernadac, "Minotauromachie," in *Pablo Picasso: La Minotauromachie, All VIII States* (London: Gagosian Gallery, 2006), 5–13.

6. Sebastian Goeppert and Herma C. Goeppert-Frank, *Minotauromachy by Pablo Picasso* (Geneva: Patrick Cramer, 1987), 106, credits Yvonne and Christian Zervos with the title, together with Alfred H. Barr of The Museum of Modern Art. Marie-Laure Bernadac affirms that this title was not given by Picasso. See Bernadac, "Minotauromachie," 5, 13 (n. 4). The title appeared in 1936, in a catalogue

for the Zwemmer Gallery, London (*Picasso: Oil Paintings, Water-Colours, Pastels, Drawings, and Etchings*) and in a catalogue by Alfred H. Barr for The Museum of Modern Art, New York (*Fantastic Art, Dada, and Surrealism*). The London show opened in May and the New York show opened in December.

7. See Goeppert and Goeppert-Frank, *Minotauromachy by Pablo Picasso*, for a book-length discussion of this print, including a fully annotated bibliography.

8. In these endnotes, see Introduction, "Picasso's Printmaking: A Catalyst for Creativity," n. 16.

9. See ibid., n. 17.

10. See interpretive title assigned by Brigitte Baer in this volume's checklist, no. 25 (p. 184).

11. Baer, *Picasso: Peintre-graveur*, vol. II, 202–5, no. 368.

12. Ibid., 189–90, no. 356. The fallen woman also has been interpreted as an Amazon thrown from her horse. See Pat Gilmour, "Late Picasso," *Print Quarterly* 14, no. 2 (June 1997): 216.

13. For a thorough discussion of this theme, see Leo Steinberg, "Picasso's Sleepwatchers," in *Other Criteria: Confrontations with Twentieth-Century Art* (Chicago: University of Chicago Press, 1972), 92–114.

14. Sugar-lift is a form of aquatint, which renders tone rather than line. In standard aquatint, the artist masks out areas around the parts of his composition where he wants tone. Sugar-lift is more direct in that the artist brushes onto the copperplate the areas for tonality. For a discussion of Picasso's use of aquatint, see Burr Wallen, *Picasso Aquatints* (St. Petersburg, Fla.: Museum of Fine Arts, 1984).

15. Brigitte Baer explains that the scraper is a tool "normally handled gently," but that "Picasso's scraper can be recognized out of a thousand. . . . The surface of the plate took on a tortured look." See Baer, "The Hand, the Manner of Working," in *Picasso: Suite Vollard und Minotauromachie*, 353.

16. Pigeons and doves appear frequently in Picasso's art, and he kept both as pets. For a photograph of Marie-Thérèse Walter with doves, see Goeppert and Goeppert-Frank, *Minotauromachy by Pablo Picasso*, 82.

5. REENACTING THE BULLFIGHT

1. For a discussion of the theme of bullfighting in Picasso's art, see Bernardo Laniado-Romero, ed., *Picasso: Toros* (Málaga: Musée Picasso, 2005).

2. Tinterow, *Master Drawings by Picasso*, 220.

3. Françoise Gilot describes bullfight excursions with Picasso in Gilot and Lake, *Life with Picasso*, 243–47.

4. See Goeppert, Goeppert-Frank, and Cramer, *Picasso: Illustrated Books*, 252, no. 100. This illustrated book was published by Gustavo Gili, the son of an earlier Gili who had first commissioned Picasso for a book with this text in the late 1920s. (See Baer, *Picasso: Peintre-graveur*, vol. I, 230–36, nos. 136–41). That earlier version was never completed and the younger Gili sought to rectify the situation with his 1959 publication

5. In the summer of 1934, Picasso would again take his family to Spain where they attended bullfights in several cities.

6. This etching is a preliminary study for the *Death of Orpheus* in Picasso's illustrated *Les métamorphoses*. (See Goeppert, Goeppert-Frank, and Cramer, *Picasso: Illustrated Books*, 54, no. 19.) The published plate is greatly simplified and strictly linear, but an ox and the arched body of the dying Orpheus remain. For more on the link Picasso made between myth and bullfighting, particularly in relation to his *Death of Orpheus*, see Brigitte Baer, *Picasso: The Engraver: Selections from the Musée Picasso, Paris* (London: Thames and Hudson; New York: Metropolitan Museum of Art, 1997), 33, 36–38, 40; Jean Clair, ed., *Picasso: Sous le soleil de Mithra* (Martigny, Switzerland: Fondation Pierre Gianadda, 2001), 58–62; and Betty Rothenstein, "Ovid: The *Metamorphoses*," in Mordechai Omer, *Picasso and Literature* (Tel Aviv: Genia Schreiber University Art Gallery, Tel Aviv University, 1989), 176.

7. Picasso had already used this device of the bullfighter thrown across the back of the bull in the early 1920s. In those early depictions, however, the posture of the figure seems to relate more to ballet than to the violence of the bullring.

8. It has been suggested that Picasso may have seen a female bullfighter on a trip to Barcelona in 1933. See Goeppert and Goeppert-Frank, *Minotauromachy by Pablo Picasso*, 23.

9. Picasso, quoted in Gilot and Lake, *Life with Picasso*, 270.

10. Although included in Picasso's illustrated edition of Balzac's *Le chef d'œuvre inconnu*, this print probably derives from his aborted book on bullfighting of the late 1920s (see n. 4). It is not known why Picasso and publisher Ambroise Vollard decided to use the print in *Le chef d'œuvre inconnu*, but it may be that Vollard was rushing to ensure that his book appeared no later than Albert Skira's *Les métamorphoses* of Ovid, also illustrated by Picasso and being produced at the same time. Vollard's annoyance with Skira is noted in Richardson, *Life of Picasso: Triumphant Years*, 431.

11. See Britannica.com, "Bullfighting."

12. Baer, *Picasso: Peintre-graveur*, vol. II, 292, no. 425; and Goeppert and Goeppert-Frank, *Minotauromachy by Pablo Picasso*, 66.

13. Baer, *Picasso: Peintre-graveur*, vol. V, 261, no. 1227, gives the date of this print as August 30, 1959, but Arnéra gives April 14, 1959, and links that date to Picasso's color choices. See Arnéra, in Sandra Benadretti-Pellard, "Entretien avec Hidalgo Arnéra," in *Picasso à Vallauris: Linogravures* (Paris: Réunion des Musées Nationaux, 2001), 19.

6. ABSTRACTING THE BULL

1. In these endnotes, see Introduction, "Picasso's Printmaking," n. 23.

2. Célestin, quoted in Parmelin, "Picasso's Iron Wall," in Mourlot, *Picasso Lithographs*, n.p.

3. In 1949 Picasso took up a similar analysis of the bull in sanguine drawings. See Laniado-Romero, ed., *Picasso: Toros*, 124–25.

4. For an excellent study of this series, see Irving Lavin in "Picasso's Bull(s): Art History in Reverse," *Art in America* 81 (March 1993): 76–93, 121, 23. Lavin describes the process as Picasso setting out "to tell a story, an epic narrative that recounted the life history of a work of art" (78), and goes on to call it a "creation drama" (79).

5. On the subject of caricature, see Valeriano Bozal et al., *Picasso: From Caricature to Metamorphosis of Style* (Hampshire, U.K.: Lund Humphries, 2003).

6. Mourlot, quoted in Parmelin, "Picasso's Iron Wall," in Mourlot, *Picasso Lithographs*, n.p.

7. Ibid.

8. Maurice Sanchez, of Derrière l'Étoile Studios print shop in New York, is an expert lithographer and examined this print at MoMA in August 2009.

9. Mourlot, *Lithographic Work*, vol. 1, 59–64, no 17.

10. Emmanuel Benador, *Picasso, Printmaker: A Perpetual Metamorphosis. The Myra and Sandy Kirschenbaum Collection* (New York: City University of New York, 2008), 96–98, no 43.

11. Mourlot, quoted in Parmelin, "Picasso's Iron Wall," in Mourlot, *Picasso Lithographs*, n.p.

12. Mourlot, quoting Célestin, in "The Artist and the Printer," in Domenico Porzio, ed., *Lithography: 200 Years of Art, History and Technique* (New York: Abrams, 1983), 188.

7. FAUNS AND SATYRS

1. The characterization of Gilot in this print, and in the two that follow, has much in common with the imagery of *Joy of Life*, a major painting created by Picasso in Antibes at the Château Grimaldi, where he was offered studio space in fall 1946. (This château eventually became a museum devoted to Picasso's work.) For a discussion of that painting, including its relationship to other faun and satyr imagery in Picasso's work at the time, see Markus Müller, ed., *Pablo Picasso: Joy of Life* (Berlin: Deutscher Kunstverlag, 2007).

2. The *aulos* is an instrument used by the satyr Marsyas, who is linked to the lascivious and debauching Dionysus. See John Boardman, ed., *The Oxford History of Classical Art* (Oxford: Oxford University Press, 1993), 106, for an illustration showing the reconstruction of a painting with Marsyas holding this double-flute.

3. Picasso, quoted in Roland Penrose, *Picasso: His Life and Work* (London: Victor Gollancz, 1958), 144.

4. John Richardson, "Picasso and Ramón Reventós: A Catalan Source of Antipolis," in Gary Tinterow, ed., *Picasso classico* (Málaga: Palacio Episcopal, 1992), 361–64. Gertje Utley takes up Richardson's discussion of Reventós in Utley, "Picasso and the French Post-War 'Renaissance': A Questioning of National Identity," in Jonathan Brown, ed., *Picasso and the Spanish Tradition* (New Haven: Yale University Press, 1996), 95–117. Here, Utley also discusses Picasso's situation in the postwar period in relation to his

Spanish heritage, which made him a subject of nationalistic discussions. She asserts that "Picasso instinctively reacted to some of the nationalistic nostalgia of Reventós's tales," and suggests that he may have been drawn to the Mediterranean coast because it was "common to both France and Spain" (115).

5. For a description of the two versions and Picasso's opportunity to work on them, see Goeppert, Goeppert-Frank, and Cramer, *Picasso: Illustrated Books*, 124–27, nos. 44 and 45. Both versions are in the collection of MoMA.

6. The steps for the rinsing technique are as follows: the linoleum block is printed in white ink; next, the surface of this printed sheet is covered with black ink; finally, the black ink is rinsed off the sheet under a shower. What remains of the black ink is a staining in any areas of the sheet that were not printed, as well as a residue in printed areas. Picasso's wife Jacqueline helped him with this process. See Baer, *Picasso: The Printmaker*, 153 and 160, for a discussion of the rinsing technique. See also Gavanon, "Interview of Hidalgo Arnéra," in *Picasso's Linocuts*, 55.

7. For a full description of his process, see Baer, *Picasso: Peintre-graveur*, vol. V, 339–41, no. 1264.

8. ANIMALS REAL AND IMAGINED

1. For a photograph of Picasso with the owl, see Margarida Cortadella, ed., *Picasso: War & Peace* (Barcelona: Museu Picasso, 2004), 149.

2. For a monographic study of the subject of animals in Picasso's art, see Neil Cox and Deborah Povey, *A Picasso Bestiary* (London: Academy, 1995).

3. For a discussion of the horse as a motif in Picasso's art, see Mordechai Omer, "Picasso's Horse: Its Iconography," *Print Collector's Newsletter* 2, no. 4 (September–October 1971): 73–77.

4. Doves appear in Picasso's posters from 1949 to 1962. For a study of Picasso's posters overall, see Luis Carlos Rodrigo, *Picasso in His Posters, Image and Work*, 4 vols. (Madrid: Arte Ediciones, 1992).

5. For an excellent discussion of Picasso's use of the dove in Communist-related works, see chap. 7, "Poster Artist for the Party," in

Gertje R. Utley, *Picasso: The Communist Years* (New Haven: Yale University Press, 2000), 117–33.

6. Asher Ethan Miller, "Catalogue," in Rabinow, ed., *Cézanne to Picasso*, 392, no. 160.

7. Baer, *Picasso: The Printmaker*, 102–3.

8. For a detailed description of the process, see Baer, *Picasso, Peintre-graveur*, vol. IV, 184–86, no. 896.

9. For an overview of the illustrated books published by Iliazd, see Audrey Isselbacher, *Iliazd and the Illustrated Book* (New York: Museum of Modern Art, 1987).

10. "Hélène d'Oettingen," in Breunig, ed., *The Cubist Poets in Paris*, 247. For a discussion of d'Oettingen's literary work, see ibid., 247–53. For background on d'Oettingen's place in the social life of the period, see Richardson, *Life of Picasso: Cubist Rebel*, 260–64.

9. TEXT AND IMAGE

1. John Golding, chap. 12, "Picasso's *Góngora*," in Golding, *Visions of the Modern* (Berkeley: University of California Press, 1994), 203.

2. Ibid., 205.

3. For a thorough accounting of Picasso's book projects with prints, see Goeppert, Goeppert-Frank, and Cramer, *Picasso: Illustrated Books*. Entries include information on how the books originated and on the relationships of the authors and texts to the artistic components. For a discussion of the general subject of text and textual syntax in Picasso's work, see Fisher, *Picasso and the Allure of Language*; this volume also includes essays on the Reverdy and Góngora volumes discussed here: Irene Small, "Le chant des morts (The Song of the Dead)" (162–69), and Susan Greenberg Fisher, "Soneto burlesco (Burlesque Sonnet) for Luis de Góngora y Argote's *Vingt poems de Góngora* (Twenty Poems by Góngora)" (170–75).

4. For examples of Picasso's letters, see Richardson, *Life of Picasso: Prodigy*, 158, 249, and 454.

5. For commentary on fig. 22, *Bulls in Vallauris*, see Rodrigo, *Picasso in His Posters*, vol. III, 1655, no. 97; for other examples of such posters, see Rodrigo, vol. 1, 94, no. 33; 148, no. 60; and 196, no. 84.

6. For background on Tériade, see Rebecca A. Rabinow, *The Legacy of la Rue Férou: Livres d'Artiste Created for Tériade by Rouault, Bonnard, Matisse, Léger, Le Corbusier, Chagall, Giacometti,*

and Miró, Ph.D. diss. (New York University, Institute of Fine Arts, New York, 1995), 7–22.

7. Tériade, in Claude Laugier, "Le chant des morts," in *Tériade et les livres de peintres* (Le Cateau-Cambrésis, France: Musée Matisse, 2002), 173.

8. English translations of the Góngora texts are provided in John Russell, *Pablo Picasso: Gongora*, trans. Alan S. Trueblood (New York: Braziller, 1985). In Picasso's Góngora volume, the marginalia occasionally relates to titles of the sonnets (which appear on separate pages of the volume); there is little relation between his illustrations and the sonnets themselves.

9. Already in the late 1930s, with Ambroise Vollard as publisher, Picasso had begun to work on a deluxe edition of his own poetry, with text in his handwriting, marginalia, and aquatint illustrations. For an example of the text pages as Picasso envisioned them, see Baer, *Picasso: Peintre-graveur*, vol. III, 224–25, no. 661. For examples of the portraits of Dora Maar that were intended as illustrations, see plates 101–4 in this volume. Probably due to the death of Vollard, that project was never completed.

10. Golding, *Visions of the Modern*, 207.

11. Russell, *Picasso: Gongora*, n.p.

12. Riva Castleman, *A Century of Artists Books* (New York: Museum of Modern Art, 1994), 129.

13. Picasso, quoted in Gilot and Lake, *Life with Picasso*, 193.

14. Gilot and Lake, *Life with Picasso*, 194.

15. Ibid., 193.

16. For a thorough discussion of Picasso's poetry, see Christine Piot, "Picasso and the Practice of Writing," in Marie-Laure Bernadac, ed., and Christine Piot, *Picasso: Collected Writings* (New York: Abbeville, 1989), xxvii–xxxiii.

17. English translations of Picasso's poems, including *Poèmes et lithographies*, are found in Jerome Rothenberg and Pierre Joris, eds. *The Burial of the Count of Orgaz & Other Poems by Pablo Picasso* (Cambridge, Mass.: Exact Change, 2004), 239–62.

18. Tristan Tzara, "Picasso et la poésie," *Commentari* 4, no. 3 (July–September 1953): 181–203, as cited in Bernadac, ed., and Piot, *Picasso: Collected Writings*, xxix.

19. Picasso, quoted in Ashton, *Picasso on Art*, 130.

10. PORTRAITS: VOLLARD, KAHNWEILER, BALZAC

1. For an early, but still significant, guide to Vollard's publishing activities, see Una E. Johnson, *Ambroise Vollard, Editeur: Prints, Books, Bronzes* (New York: Museum of Modern Art, 1977). For the most up-to-date research, see Rabinow, ed., *Cézanne to Picasso*.

2. For a thorough study of Picasso's portraits, see Rubin, *Picasso and Portraiture*.

3. On the other hand, his friendship with Uhde did not continue. See Richardson, *Life of Picasso: Prodigy*, 390–91.

4. For an overview on Vollard, see Ann Dumas, "Ambroise Vollard, Patron of the Avant-Garde" (2–27); and on Vollard's relationship to Picasso, see Tinterow with Miller, "Vollard and Picasso" (100–117), both in Rabinow, ed., *Cézanne to Picasso*.

5. For background on Kahnweiler, and Picasso's relationship to him, see Kahnweiler with Crémieux, *My Galleries and Painters*; and Pierre Assouline, "Kahnweiler and Picasso," in *An Artful Life: A Biography of D. H. Kahnweiler, 1884–1979* (New York: Grove Weidenfeld, 1990), 324–39.

6. Gilot and Lake, *Life with Picasso*, 49.

7. In these endnotes, see Introduction, "Picasso's Printmaking" nn. 16 and 18. It has been suggested that Picasso's portraits of Vollard were based on a photograph; see Miller, "Catalogue," in Rabinow, ed., *Cézanne to Picasso*, 391, no. 158.

8. Johnson, *Vollard, Editeur*, 39.

9. Picasso's relationship to reading is in question: some say that they never saw him with a book, others that he probably read at night, still others that he picked up his knowledge of literature from conversations with his friends, many of whom were poets and authors. See Abraham Horodisch, *Picasso as a Book Artist* (Cleveland: World, 1962), 18; Rubin, "Reflections on Picasso and Portraiture," in *Picasso and Portraiture*, 36; John Richardson et al. *Picasso: Mosqueteros* (New York: Gagosian Gallery, 2009), 19.

10. Leiris's wife, Louise, was the stepdaughter of Kahnweiler and assistant in his gallery from 1921. In these endnotes, see Introduction, "Picasso's Printmaking," n. 11.

11. Goeppert, Goeppert-Frank, and Cramer, in *Picasso: Illustrated Books*, 224, no. 86. For a further discussion of this portfolio, see Irene Small, "balzacs en bas de casse et picassos sans majuscule (balzacs in lowercase and picassos without capitals)" in Fisher, *Picasso and the Allure of Language*, 209–17.

12. The photograph is by Louis-Auguste Bisson. See Jane M. Rabb, ed., *Literature & Photography, Interactions, 1840–1990: A Critical Anthology* (Albuquerque: University of New Mexico Press, 1995), 7.

11. PORTRAITS: LOVERS AND WIVES

1. The term "autobiographical" portrait comes from Rubin, "Reflections on Picasso and Portraiture," in *Picasso and Portraiture*, 15.

2. For more information on Madeleine, see Johannes M. Fox, "Madeleine and Margot," in Mössinger, Ritter, and Drechsel, eds., *Picasso et les femmes*, 60–65.

3. Richardson, *Life of Picasso: Prodigy*, 315.

4. See a photograph of Olivier in Pierre Daix, "Portraiture in Picasso's Primitivism and Cubism," in Rubin, *Picasso and Portraiture*, 256.

5. Gauguin's approach to woodcut was atypical. At this time, printing from woodblocks was mostly confined to wood engraving, a technique known for producing refined details and usually the domain of book illustrators.

6. In April 1906, Picasso visited the home of Gustave Fayet, who collected Gauguin's work, including his prints. See Anne Baldassari, chap. 5, in Elizabeth Cowling et al., *Matisse Picasso* (London: Tate Publishing; New York: Museum of Modern Art, 2002), 67.

7. Ibid. For further discussion of Fauve woodcuts at this time, with parallels drawn to Picasso's *Head of a Young Woman*, see Stephen Coppel, "The Fauve Woodcut," *Print Quarterly* 16, no. 1 (March 1999): 3–33.

8. Ibid., 15. For further discussion of the links between the Fauve artists and Oceanic and African wood sculpture, see Daix, "Portraiture in Picasso's Primitivism and Cubism," in Rubin, *Picasso and Portraiture*, 268–72. It has been suggested that Picasso was also influenced at this time by a medieval wood Madonna located in Gósol, where he spent the summer of 1906. See Richardson, *Life of Picasso: Prodigy*, 451–52.

11a. MARIE-THÉRÈSE WALTER

1. Since his relationship with Walter was so clandestine, it is surprising that Picasso would allow this image to appear in the very public venue of a frontispiece for a book on his work, written by his friend and collector André Level: *Picasso* (Paris: G. Crès, 1928).

2. For some examples of earlier works depicting someone resembling Walter, see Baer, *Picasso: Peintre-graveur*, vol. I, 385, no. 240 and Arnold Glimcher and Marc Glimcher, eds., *Je Suis le Cahier: The Sketchbooks of Picasso* (Boston: Atlantic Monthly Press; New York: Pace Gallery, 1986), 125, 126, 128.

3. The controversy around the meeting date is summarized in Diana Widmaier-Picasso, "Marie-Thérèse Walter," in Mössinger, Ritter, and Drechsel, eds., *Picasso et les femmes*, 162–91. Widmaier-Picasso argues for the January 8, 1927, meeting, but notes that, as early as the 1960s, the likeness of Walter was identified in works dated before. She discusses the research of Dr. Herbert Schwarz, an amateur art historian, who argues for an earlier meeting. (See Herbert T. Schwarz, *Picasso and Marie-Thérèse Walter, 1925–1927* [Sillery, Canada: Isabeau, 1988.]) Widmaier-Picasso points out that established art historians such as William Rubin and Robert Rosenblum were convinced by Schwarz's argument. See Rubin, *Picasso and Portraiture*, 60–62, 339–41. Widmaier-Picasso gives further evidence for a meeting on January 8, 1927 in "Marie-Thérèse Walter and Pablo Picasso: New Insights into a Secret Love," in Markus Müller, ed., *Pablo Picasso and Marie-Thérèse Walter: Between Classicism and Surrealism* (Bielefeld: Kerber, 2004), 28–29.

4. Rosalind E. Krauss, in "Life with Picasso, Sketchbook No. 92, 1926," in Glimcher and Glimcher, eds., *Je Suis le Cahier*, 113–39, posits the idea that Picasso created a facial type and then found someone who matched it. She maintains this thesis in *The Picasso Papers* (New York: Farrar, Straus and Giroux, 1998), 228.

5. Picasso, quoted in Gilot and Lake, *Life with Picasso*, 49.

6. For a discussion of the many paintings with Walter's likeness, especially those exhibited in Picasso's June 1932 exhibition at the Galeries Georges Petite, when the relationship was very much a secret, see Michael FitzGerald, "A Question of Identity," in *Picasso's Marie-Thérèse* (New York: Acquavella Galleries, 2008), 8–29.

7. Picasso, quoted in Gilot and Lake, *Life with Picasso*, 211.

8. Picasso, quoted in ibid., 236.

11b. DORA MAAR

1. This meeting is recounted in Gilot and Lake, *Life with Picasso* (84–86), and has been repeated by later scholars. See Judi Freeman, *Picasso and the Weeping Women: The Years of Marie-Thérèse Walter & Dora Maar* (Los Angeles: Los Angeles County Museum of Art, 1994), 174; and Mary Ann Caws, *Dora Maar: With & Without Picasso, A Biography* (London: Thames and Hudson, 2000), 81.

2. Françoise Gilot discusses the triangle consisting of Picasso, Walter, and Maar in Gilot and Lake, *Life with Picasso* (236–41): "Even though Marie-Thérèse entered his work before Dora, this phase of his painting, which seems to alternate between happiness and unhappiness, needed them both for completeness." Gilot also describes a tussle between Walter and Maar in Picasso's studio that the artist seemed to enjoy (210–11).

3. Rubin, "Reflections on Picasso and Portraiture," in *Picasso and Portraiture*, 88–89.

4. For an overview of Maar's photography and reproductions of several of her paintings, see Victoria Combalía, *Dora Maar, Fotógrafa* (Valencia: Centre Cultural Bancaixa, 1995).

5. Maar, quoted in James Lord, *Picasso and Dora: A Personal Memoir* (New York: Farrar, Straus and Giroux, 1993), 123. William Rubin suggests that the distorted depictions of Maar may serve "as a vehicle for Picasso's own anxieties." See Rubin, "Reflections on Picasso and Portraiture," in *Picasso and Portraiture*, 74.

6. Brigitte Baer offers alternative interpretations of this print and discusses a variety of sources for the pose of the figure in *Picasso the Engraver*, 43–44.

7. Picasso, quoted in Gilot and Lake, *Life with Picasso*, 122.

8. A contract between Vollard and Picasso states that a book with Picasso as author will be produced. See Rabinow, "Vollard's *Livres d'Artiste*," in Rabinow, ed., *Cézanne to Picasso*, 212 (n. 74).

9. See Baer, *Picasso: Peintre-graveur*, vol. III, 218–20, nos. 656–58.

10. Picasso preferred black-and-white prints, but experimented with color from time to time. He made various color monoprints, and occasionally daubed parts of his intaglio plates with color. He also made a certain number of color lithographs. The artist's most active work with color prints, however, was in the linoleum-cut technique. His frustrations with color printing are discussed in Baer, "The Hand, the Manner of Working," in *Picasso: Suite Vollard und Minotauromachie*, 356.

11. A link between Rouault's color printing at Lacourière's workshop and Picasso's attempts at color is suggested in Castleman, *A Century of Artists Books*, 45.

11c. FRANÇOISE GILOT

1. For a discussion of the relationship between Picasso and Matisse, and Gilot's own friendship with Matisse, see Françoise Gilot, *Matisse and Picasso: A Friendship in Art* (New York: Doubleday, 1990).

2. For an overview of Picasso's work during his years with Gilot, see Markus Müller, ed., *Pablo Picasso: The Time with Françoise Gilot* (Bielefeld: Kerber, 2002). Also see Mössinger, Ritter, and Drechsel, eds., *Picasso et les femmes*, which includes an essay on Gilot by Evelyn Weiss (238–45), and a text by Gilot herself (246–50). For more on Gilot's own work, see Mel Yoakum, et al., *Françoise Gilot: Monograph, 1940–2000* (Lausanne: Acatos, c. 2000).

3. See Müller, ed., *Pablo Picasso: Joy of Life*.

4. On the frequency of visits between Picasso and Matisse during these years, see Anne Baldassari, et al., "Chronology," in Elizabeth Cowling, et al., *Matisse Picasso*, 384–89.

5. Gilot and Lake, *Life with Picasso*, 336.

6. For a discussion of this theme, see Steinberg, "Picasso's Sleepwatchers," in *Other Criteria*, 92–114.

7. Gilot and Lake, *Life with Picasso*, 92.

8. There are discrepancies in the documentation of total states and variants of this print. See *Old Master, Modern & Contemporary Prints*, Christie's, London, September,

17, 2009, 62–63, Lot 91; Benador, *Picasso Printmaker*, 99–103; Ulrike Gauss, ed., *Pablo Picasso Lithographs* (Münster: Hatje Cantz, 2000), 42–47; Mourlot, *Lithographic Work*, vol. 1, 48–58.

9. Images of eight of these abstracted drawings appear in Steinberg, "Picasso's Sleepwatchers," in *Other Criteria*, 108–9.

10. Gilot and Lake, *Life with Picasso*, 92.

11. For lithographs incorporating comparable white lines, see plates 129 and 130 in this volume (*David and Bathsheba*, states IV and X). For an earlier example of Picasso's experimentation with etching printed in relief, see *Paris, 14 Juillet 42*, 1942, in Baer, *Picasso: Peintre-graveur*, vol. III, 255–58, no. 682.

12. Gilot and Lake, *Life with Picasso*, 337.

13. Baer, *Picasso: Peintre-graveur*, vol. IV, 210–11, no. 906.

11d. JACQUELINE ROQUE

1. In these endnotes, see Introduction, "Picasso's Printmaking," n. 20.

2. For a discussion of Jacqueline as a subject, see Rubin, "The Jacqueline Portraits in the Pattern of Picasso's Art," in *Picasso and Portraiture*, 446–84.

3. See Richardson, "L'Epoque Jacqueline," in Bernadac et al., *Late Picasso*, 17–48.

4. For interviews with Hildago Arnéra, see Müller, *Picasso und Jacqueline*, 69–73; and Gavanon, *Picasso's Linocuts*, 47–56.

5. Picasso made one other linoleum cut, in 1939, for a portfolio protesting the invasion of Czechoslovakia by German troops. See Goeppert, Goeppert-Frank, and Cramer, *Picasso: Illustrated Books*, 92–93, no. 31.

6. Rubin, "The Jacqueline Portraits," in *Picasso and Portraiture*, 464.

7. Gavanon, *Picasso's Linocuts*, 49.

8. Ibid.

9. Picasso, quoted in Gilot and Lake, *Life with Picasso* (124): "I have reached the moment . . . when the movement of my thought interests me more than the thought itself." As quoted in Brassaï, *Picasso and Company* (182): "If it were possible, I would leave it as it is, while I began over and carried it to a more advanced state on another canvas. Then I would do the same thing with that one. There would never be a 'finished' canvas, but just the different 'states' of a single painting, which normally disappear in the course of work."

12. AFTER THE MASTERS

1. Several studies explore Picasso's work after past masters. See, for example, Susan Grace Galassi, *Picasso's Variations on the Masters: Confrontations with the Past* (New York: Abrams, 1996); and Elizabeth Cowling et al., *Picasso: Challenging the Past* (London: National Gallery, 2009).

2. In the case of the Delacroix, Picasso made a few experimental prints, but no editions. See Mourlot, *Lithographic Work*, vol. II, 124–27, nos. 265 and 266; and Baer, *Picasso: Peintre-graveur*, vol. IV, 220–29, nos. 915–18.

3. Accounts of this event differ. This is the recollection of Françoise Gilot, who was living with Picasso at the time. See Gilot and Lake, *Life with Picasso*, 202–3.

4. For illustrations of the entire series, see Mourlot, *Lithographic Work*, vol. I, 166–79. For a discussion of the series, see Galassi, *Picasso's Variations on the Masters*, 100–113. There have been several German-language studies devoted to Picasso's prints after Cranach. See, for example, Marlies Schmidt, ed., *Picasso trifft Cranach: Pablo Picassos Lithographien zu Lucas Cranach* (Lutherstadt Wittenberg: Cranach-Stiftung Wittenberg, 2004); and Kerstin Drechsel, ed., *Pablo Picasso: David und Bathseba, 1947–1949, Venus und Amor, 1949* (Berlin: Kulturstiftung der Länder; Chemnitz: Sächsiche Landesstelle für Museumswesen, 2005).

5. As an indication of Picasso's thinking about his various series after the old masters, it should be noted that he gave the entire group based on Velázquez's *Las Meninas* to one institution, which would eventually become the Museu Picasso in Barcelona. He clearly saw the importance of keeping the works together.

6. Picasso used this phrase in 1935; see Rubin, *Picasso in the Collection of The Museum of Modern Art*, 170. Picasso's careful dating of his works can also be seen in light of his interest in creative process. He said, "I want to leave to posterity a documentation that will be as complete as possible. That's why I put a date on everything I do." See Brassaï, *Picasso and Company*, 100.

7. In these endnotes, see Introduction, "Picasso's Printmaking," n. 28.

8. Picasso's practice of using a slide projector to look at works of art is mentioned in Hélène Parmelin, *Picasso: Women, Cannes and Mougins, 1954–63* (London: Weidenfeld and Nicolson, 1965), 10.

9. On the relationship of Picasso's work to Rembrandt's, see Janie Cohen, *Picasso Rembrandt Picasso: Prints and Drawings by Picasso Inspired by Works of Rembrandt* (Amsterdam: Museum het Rembrandthuis, 1990); and Isadora Rose-de Viejo and Janie Cohen, *Etched on the Memory: The Presence of Rembrandt in the Prints of Goya and Picasso* (Blaricum, Netherlands: V + K; Amsterdam: Rembrandt House Museum; Aldershot, U.K.: Lund Humphries, 2000).

10. Galassi, *Picasso's Variations on the Masters*, 98.

13. LATE WORK

1. Dakin Hart makes the case that Picasso's longtime pacifism made him sympathetic to the antiwar movement of this period, and that the concurrent sexual revolution and hippie culture also found resonance in his work. See Hart, "Peace and Love Picasso," in Richardson et al., *Picasso: Mosqueteros*, 239–71. (In Picasso's printmaking, there was much erotic subject matter at this time.)

2. The full quote by Douglas Cooper is particularly unkind: "These are incoherent doodles done by a frenetic dotard in the anteroom of death." See Richardson, "L'Epoque Jacqueline," in Bernadac et al., *Late Picasso*, 26.

3. Over the years, Picasso's late work has had its supporters. See Gert Schiff, *Picasso: The Last Years, 1963–1973* (New York: Braziller in association with Grey Art Gallery & Study Center, New York University, 1983); and Bernadec et al., *Late Picasso*. During the era of Neo-Expressionism in the 1980s, the late work was seen as especially relevant to contemporary painting. An exhibition in New York in spring 2009, *Picasso: Mosqueteros* at the Gagosian Gallery, curated by John Richardson, received huge crowds and extremely positive reviews.

4. The term is attributed to Hélène Parmelin, a close friend of Picasso in these years. See Ann Hindry, "The Ultimate Graphic Feast," in Werner Spies, ed., *Picasso: Painting Against Time* (Ostfildern: Hatje Cantz, 2007), 249.

5. The place of the Crommelyncks in Picasso's circle is discussed by Hindry, "The Ultimate Graphic Feast," 251–53; and by Richardson, "L'Epoque Jacqueline," in Bernadac et al., *Late Picasso*, 26–28.

6. For explorations of Suite 347, see Memory Holloway, *Making Time: Picasso's Suite 347* (New York: Peter Lang, 2006); Memory Holloway, "Compulsive Attraction: The Late Works on Paper," in Richardson et al., *Picasso: Mosqueteros*, 171–232; and Janie Cohen, "Memory, Transformation, and Encounter in Picasso's Late Prints," in Cohen, ed., *Picasso: Inside the Image. Prints from the Ludwig Museum, Cologne* (London: Thames and Hudson, 1995), 88–99.

7. See Aldo Crommelynck, "Recollections on Printmaking with Picasso," in *Picasso: Inside the Image*, 16.

8. Picasso, quoted in Otero, *Forever Picasso*, 170.

9. Many observers have noted that these prints constitute a conception of the world as a stage. See for example Baer, "Seven Years of Printmaking: The Theatre and Its Limits," in *Late Picasso*, 95–135.

10. See interpretive title assigned by Brigitte Baer in this volume's checklist, no. 135 (p. 192).

11. Picasso signed "Pour Sabartés" on each print in one set of the Suite 347. He gave that set to the museum in Barcelona that would later become the Museu Picasso. Jaime Sabartés had given much of his own Picasso collection to the city of Barcelona, eventually destined for that museum. See Holloway, "Compulsive Attraction," in Richardson et al., *Picasso: Mosqueteros*, 178.

12. Richardson, "Great Late Picasso," in ibid., 20.

13. In a further interpretation, Dakin Hart sees the musketeer character from the martial point of view, and as a general emblem of Picasso's antiwar stance. See Hart, "Peace and Love Picasso," in ibid., 254.

Checklist

The checklist numbers correspond to the illustration plate numbers in this volume. Each checklist entry is followed by an abbreviated reference to a standard catalogue raisonné of Picasso prints or illustrated books (full citations for these references follow here).

The titles cited here are taken verbatim from the pertinent catalogues raisonnés; for those titles in French or Spanish, English translations are provided. The titles of Picasso's prints were assigned by his cataloguers, not by the artist himself—in fact, he objected to titling his prints. (A discussion of the problematic nature of some interpretive titles in Brigitte Baer's catalogue raisonné is found in Pat Gilmour's review of the final volumes of that raisonné: "Late Picasso," in *Print Quarterly* 14, no. 2 [June 1997]: 211–16.)

The date of each work is taken from the print itself or from the catalogues raisonnés. If the catalogues raisonnés indicate a specific month or date, it is cited here; seasons are not. Where qualifiers are given for the dates of works in the catalogues raisonnés, here the uncertainty is indicated with "c[irca]." The state number of a print is provided only if there is more than one example of evolving states of a given work, or if the number is needed to identify the print in the pertinent catalogue raisonné. The word "proof" is used if the print is not part of a published edition. In the cited dimensions, height precedes width. In rare cases where the information differs from that in a catalogue raisonné, a question mark is added in parentheses.

All works are from the collection of The Museum of Modern Art; the accession numbers, which include the year the object was acquired, are noted at the end of each entry, before the catalogue raisonné reference.

Catalogues raisonnés and other sources cited in the checklist:

Baer

Geiser, Bernhard, rev. Brigitte Baer. *Picasso peintre-graveur*. Vols. 1 and 2. Bern: Éditions Kornfeld, 1990–92.
and
Baer, Brigitte. *Picasso peintre-graveur*. Vols. 3–7 and *Addendum*. Extending the 2-volume work of Bernhard Geiser. Bern: Éditions Kornfeld, 1986–96.

Dallas

Baer, Brigitte. *Picasso the Printmaker: Graphics from the Marina Picasso Collection*. Dallas: Dallas Museum of Art, 1983.

Goeppert

Goeppert, Sebastian, Herma Corinna Goeppert-Frank, and Patrick Cramer. *Pablo Picasso: The Illustrated Books: Catalogue Raisonné*. Geneva: Patrick Cramer, 1983.

Mourlot

Mourlot, Fernand. *Picasso: The Lithographic Work*. Vol. I, *1919–1949* and vol. II, *1949–1969*. Revised 2009 by The Picasso Project. San Francisco: Alan Wofsy Fine Arts, 2009.

1. SALTIMBANQUES

1. *Le repas frugal* (*The Frugal Repast*). September 1904. Etching. PLATE: 18 $^3/_{16}$ x 14 $^7/_8$" (46.2 x 37.8 cm). SHEET: 24 $^3/_{16}$ x 17 $^5/_{16}$" (61 x 44 cm). PUBLISHER: unpublished. PRINTER: Delâtre, Paris. EDITION: approx. 30 proofs before the 1913 edition of 250 from the Saltimbanques series. Gift of Thomas T. Solley with Mary Ellen Meehan, and purchase through the Vincent d'Aquila and Harry Soviak Bequest, and with contributions from Lily Auchincloss, The Associates Fund, The Philip and Lynn Straus Foundation Fund, and John S. Newberry (by exchange). 683.1993 (Baer 2)

2. *Le saltimbanque au repos* (*The Acrobat in Repose*). 1905. From the Saltimbanques series, published 1913. Drypoint. PLATE: 4 $^3/_4$ x 3 $^7/_{16}$" (12 x 8.8 cm). SHEET: 19 $^5/_{16}$ x 12 $^{15}/_{16}$" (49 x 32.8 cm). PUBLISHER: Vollard, Paris. PRINTER: Fort, Paris. EDITION: 250. Gift of Abby Aldrich Rockefeller. 499.1940 (Baer 12)

3. *Les deux saltimbanques* (*The Two Acrobats*). 1905. From the Saltimbanques series, published 1913. Drypoint. PLATE: 4 $^3/_4$ x 3 $^9/_{16}$" (12 x 9 cm). SHEET: 18 $^7/_8$ x 12 $^7/_8$" (48 x 32.7 cm). PUBLISHER: Vollard, Paris. PRINTER: Fort, Paris. EDITION: 250. Gift of Abby Aldrich Rockefeller. 500.1940 (Baer 6)

4. *Au cirque* (*At the Circus*). 1905–6. From the Saltimbanques series, published 1913. Drypoint. PLATE: 8 $^5/_8$ x 5 $^9/_{16}$" (21.9 x 14.2 cm). SHEET: 20 $^1/_{16}$ x 12 $^{15}/_{16}$" (51 x 32.8 cm). PUBLISHER: Vollard, Paris. PRINTER: Fort, Paris. EDITION: 250. Gift of Abby Aldrich Rockefeller. 501.1940 (Baer 11)

5. *La toilette de la mère* (*Mother at Her Toilette*). 1905. From the Saltimbanques series, published 1913. Etching. PLATE: 9 1/4 x 7" (23.5 x 17.8 cm). SHEET: 20 x 12 15/16" (50.8 x 32.8 cm). PUBLISHER: Vollard, Paris. PRINTER: Fort, Paris. EDITION: 250. Gift of Abby Aldrich Rockefeller. 490.1940 (Baer 15)

6. *Le bain* (*The Bath*). 1905. From the Saltimbanques series, published 1913. Drypoint. PLATE: 13 7/16 x 11 5/16" (34.2 x 28.7 cm). SHEET: 18 1/8 x 13 7/8" (46 x 35.2 cm). PUBLISHER: Vollard, Paris. PRINTER: Fort, Paris. EDITION: 250. Gift of Edwin I. Marks. 812.1965 (Baer 14)

7. *Les saltimbanques* (*The Acrobats*). 1905. From the Saltimbanques series, published 1913. Drypoint. PLATE: 11 1/4 x 12 7/8" (28.6 x 32.7 cm). SHEET: 20 1/16 x 26" (51 x 66 cm). PUBLISHER: Vollard, Paris. PRINTER: Fort, Paris. EDITION: 250. Gift of Abby Aldrich Rockefeller. 502.1940 (Baer 9)

8. *Salomé*. 1905. From the Saltimbanques series, published 1913. Drypoint. PLATE: 15 7/8 x 13 11/16" (40.3 x 34.7 cm). SHEET: 25 5/16 x 20 1/16" (64.3 x 51 cm). PUBLISHER: Vollard, Paris. PRINTER: Fort, Paris. EDITION: 250. Lillie P. Bliss Collection. 89.1934 (Baer 17 and *Addendum*)

2. THE CUBIST SPIRIT

9. *Deux figures nues: femme à la guitare et garçon à la coupe* (*Two Nudes: Woman with Guitar and Boy with Cup*). 1909, published 1912. Drypoint. PLATE: 5 1/8 x 4 5/16" (13 x 11 cm). SHEET: 24 x 17 1/4" (61 x 43.8 cm). PUBLISHER: Kahnweiler, Paris. PRINTER: Delâtre, Paris. EDITION: 100. Purchase. 156.1949 (Baer 21)

10. *Tête d'homme à la pipe* (*Head of a Man with Pipe*). 1912. Etching. PLATE: 5 1/8 x 4 5/16" (13 x 11 cm). SHEET: 17 5/8 x 13 11/16" (44.7 x 34.8 cm). PUBLISHER: Kahnweiler, Paris. PRINTER: Delâtre, Paris. EDITION: 100. Gift of Abby Aldrich Rockefeller. 486.1940 (Baer 32)

11. *Nature morte à la bouteille de marc* (*Still Life with Bottle of Marc*). 1911, published 1912. Drypoint. PLATE: 19 5/8 x 12" (49.8 x 30.5 cm). SHEET: 24 7/16 x 16 11/16" (62 x 42.4 cm). PUBLISHER: Kahnweiler, Paris. PRINTER: Delâtre, Paris. EDITION: 100. Acquired through the Lillie P. Bliss Bequest. 21.1947 (Baer 33)

12. *Mademoiselle Léonie*. August 1910. From *Saint Matorel*, by Max Jacob, published 1911. Etching. PLATE: 7 13/16 x 5 9/16" (19.8 x 14.2 cm). PAGE: 10 1/4 x 8 9/16" (26 x 21.7 cm). PUBLISHER: Kahnweiler, Paris. PRINTER: Delâtre, Paris. EDITION: 100. Abby Aldrich Rockefeller Fund. 507.1949.1 (Baer 23; Goeppert 2)

13. *La table* (*The Table*). August 1910. From *Saint Matorel*, by Max Jacob, published 1911. Etching. PLATE: 7 7/8 x 5 9/16" (20 x 14.2 cm). PAGE: 10 5/16 x 8 7/16" (26.2 x 21.4 cm). PUBLISHER: Kahnweiler, Paris. PRINTER: Delâtre, Paris. EDITION: 100. Abby Aldrich Rockefeller Fund. 507.1949.2 (Baer 24; Goeppert 2)

14. *Mademoiselle Léonie sur une chaise longue* (*Mademoiselle Léonie in a Lounge Chair*). August 1910. From *Saint Matorel*, by Max Jacob, published 1911. Etching and drypoint. PLATE: 7 3/4 x 5 9/16" (19.7 x 14.2 cm). PAGE: 10 3/8 x 8 3/8" (26.3 x 21.2 cm). PUBLISHER: Kahnweiler, Paris. PRINTER: Delâtre, Paris. EDITION: 100. Abby Aldrich Rockefeller Fund. 507.1949.3 (Baer 25; Goeppert 2)

15. *Le couvent* (*The Convent*). August 1910. From *Saint Matorel*, by Max Jacob, published 1911. Etching. PLATE: 7 13/16 x 5 9/16" (19.9 x 14.2 cm). PAGE: 10 1/4 x 8 1/8" (26.1 x 20.6 cm). PUBLISHER: Kahnweiler, Paris. PRINTER: Delâtre, Paris. EDITION: 100. Abby Aldrich Rockefeller Fund. 507.1949.4 (Baer 26; Goeppert 2)

3. SCULPTOR'S STUDIO

16. *Sculpteur avec son modèle, sa sculpture et un bol d'anémones* (*Sculptor with His Model, His Sculpture, and a Bowl of Anemones*). March 23, 1933. From the Vollard Suite, printed 1939. Etching. PLATE: 10 1/2 x 7 5/8" (26.7 x 19.4 cm). SHEET: 17 11/16 x 13 7/16" (45 x 34.1 cm). PUBLISHER: Vollard, Paris. PRINTER: Lacourière, Paris. EDITION: 260. Abby Aldrich Rockefeller Fund. 257.1949 (Baer 308)

17. *Jeune sculpteur finissant un plâtre* (*Young Sculptor Finishing a Plaster*). March 23, 1933. From the Vollard Suite, printed 1939. Etching. PLATE: 10 1/2 x 7 5/8" (26.7 x 19.4 cm). SHEET: 17 9/16 x 13 1/2" (44.6 x 34.3 cm). PUBLISHER: Vollard, Paris. PRINTER: Lacourière, Paris. EDITION: 260. Abby Aldrich Rockefeller Fund. 193.1949 (Baer 309)

18. *Modèle et sculpteur avec sa sculpture* (*Model and Sculptor with His Sculpture*). March 17, 1933. From the Vollard Suite, printed 1939. Etching. PLATE: 10 1/2 x 7 5/8" (26.7 x 19.3 cm). SHEET: 17 1/2 x 13 3/8" (44.4 x 33.9 cm). PUBLISHER: Vollard, Paris. PRINTER: Lacourière, Paris. EDITION: 260. Abby Aldrich Rockefeller Fund. 258.1949 (Baer 300)

19. *Deux femmes regardant une tête sculptée* (*Two Women Looking at a Sculpted Head*). March 21, 1933. From the Vollard Suite, printed 1939. Etching. PLATE: 10 1/2 x 7 5/8" (26.7 x 19.3 cm). SHEET: 17 7/16 x 13 3/8" (44.3 x 33.9 cm). PUBLISHER: Vollard, Paris. PRINTER: Lacourière, Paris. EDITION: 260. Abby Aldrich Rockefeller Fund. 189.1949 (Baer 302)

20. *Sculpteur et son autoportrait sculpté servant de socle à une tête de Marie-Thérèse* (*Sculptor and His Self-Portrait Serving as a Pedestal for the Head of Marie-Thérèse*). March 26, 1933. From the Vollard Suite, printed 1939. Etching. PLATE: 10 1/2 x 7 5/8" (26.7 x 19.4 cm). SHEET: 17 7/16 x 13 3/8" (44.3 x 34 cm). PUBLISHER: Vollard, Paris.

PRINTER: Lacourière, Paris. EDITION: 260. Abby Aldrich Rockefeller Fund. 195.1949 (Baer 310)

21. *Vieux sculpteur au travail. II (Old Sculptor at Work. II).* March 26, 1933. From the Vollard Suite, printed 1939. Etching. PLATE: 10 1/2 x 7 5/8" (26.7 x 19.4 cm). SHEET: 17 5/16 x 13 3/8" (44 x 34 cm). PUBLISHER: Vollard, Paris. PRINTER: Lacourière, Paris. EDITION: 260. Abby Aldrich Rockefeller Fund. 194.1949 (Baer 311)

22. *Sculpteur, modèle, sculpture et poisson rouge (Sculptor, Model, Sculpture, and Goldfish).* March 21, 1933. From the Vollard Suite, printed 1939. Etching. PLATE: 10 1/2 x 7 5/8" (26.7 x 19.4 cm). SHEET: 17 7/16 x 13 3/8" (44.3 x 33.9 cm). PUBLISHER: Vollard, Paris. PRINTER: Lacourière, Paris. EDITION: 260. Abby Aldrich Rockefeller Fund. 188.1949 (Baer 304)

23. *Sculpteur et son modèle avec la tête sculptée du modèle (Sculptor and His Model with the Sculpted Head of the Model).* April 2, 1933. From the Vollard Suite, printed 1939. Etching. PLATE: 7 5/8 x 10 9/16" (19.3 x 26.8 cm). SHEET: 13 5/16 x 17 7/16" (33.8 x 44.3 cm). PUBLISHER: Vollard, Paris. PRINTER: Lacourière, Paris. EDITION: 260. Abby Aldrich Rockefeller Fund. 208.1949 (Baer 324)

4. THE MINOTAUR

24. *Le repos du Minotaure: Champagne et amante (The Minotaur's Repose: Champagne and Mistress).* May 17, 1933. From the Vollard Suite, printed 1939. Etching. PLATE: 7 5/8 x 10 9/16" (19.3 x 26.9 cm). SHEET: 13 3/8 x 17 1/2" (34 x 44.4 cm). PUBLISHER: Vollard, Paris. PRINTER: Lacourière, Paris. EDITION: 260. Abby Aldrich Rockefeller Fund. 225.1949 (Baer 349)

25. *Autoportrait sous trois formes: Peintre couronné, sculpteur en buste et Minotaure amoreux (Self-Portrait in Three Forms: Crowned Painter, Bust of the Sculptor, and Amorous Minotaur).* May 18, 1933. From the Vollard Suite, printed 1939. Etching. PLATE: 11 11/16 x 14 1/2" (29.7 x 36.8 cm). SHEET: 13 x 17 1/2" (33 x 44.5 cm). PUBLISHER: Vollard, Paris. PRINTER: Lacourière, Paris. EDITION: 260. Abby Aldrich Rockefeller Fund. 226.1949 (Baer 350)

26. *Scène bacchique au Minotaure (Bacchanal with Minotaur).* May 18, 1933. From the Vollard Suite, printed 1939. Etching. PLATE: 11 3/4 x 14 7/16" (29.8 x 36.7 cm). SHEET: 13 7/16 x 17 11/16" (34.2 x 45 cm). PUBLISHER: Vollard, Paris. PRINTER: Lacourière, Paris. EDITION: 260. Abby Aldrich Rockefeller Fund. 228.1949 (Baer 351)

27. *Marie-Thérèse rêvant de métamorphoses: Elle-même et le sculpteur buvant avec un jeune acteur grec jouant le rôle du Minotaure (Marie-Thérèse Dreaming of Metamorphoses: Herself and the Sculptor Drinking with a Young Greek Actor Playing the Role of Minotaur).* June 18, 1933. From the Vollard Suite, printed 1939. Drypoint, etching, and engraving. PLATE: 11 11/16 x 14 3/8" (29.7 x 36.5 cm). SHEET: 13 3/8 x 17 7/16" (34 x 44.3 cm). PUBLISHER: Vollard, Paris. PRINTER: Lacourière, Paris. EDITION: 260. Abby Aldrich Rockefeller Fund. 235.1949 (Baer 368)

28. *Minotaure amoureux d'une femme-centaure (Minotaur Ravishing a Female Centaur).* May 23, 1933. From the Vollard Suite, printed 1939. Etching. PLATE: 7 9/16 x 10 9/16" (19.2 x 26.8 cm). SHEET: 13 7/16 x 17 1/2" (34.2 x 44.5 cm). PUBLISHER: Vollard, Paris. PRINTER: Lacourière, Paris. EDITION: 260. Abby Aldrich Rockefeller Fund. 230.1949 (Baer 356)

29. *Minotaure blessé. VI (Wounded Minotaur. VI).* May 26, 1933. From the Vollard Suite, printed 1939. Etching. PLATE: 7 5/8 x 10 1/2" (19.3 x 26.6 cm). SHEET: 13 7/16 x 17 1/2" (34.2 x 44.5 cm). PUBLISHER: Vollard, Paris. PRINTER: Lacourière, Paris. EDITION: 260. Abby Aldrich Rockefeller Fund. 231.1949 (Baer 363)

30. *Minotaure caressant du mufle la main d'une dormeuse (Minotaur Caressing the Hand of a Sleeping Girl with His Face).* June 18, 1933. From the Vollard Suite, printed 1939. Drypoint. PLATE: 11 5/8 x 14 7/16" (29.6 x 36.6 cm). SHEET: 13 7/16 x 17 1/2" (34.2 x 44.5 cm). PUBLISHER: Vollard, Paris. PRINTER: Lacourière, Paris. EDITION: 260. Abby Aldrich Rockefeller Fund. 236.1949 (Baer 369)

31. *Faune dévoilant une dormeuse (Jupiter et Antiope, d'après Rembrandt) (Faun Unveiling a Sleeping Girl [Jupiter and Antiope, after Rembrandt]).* June 12, 1936. From the Vollard Suite, printed 1939. Aquatint and engraving. PLATE: 12 7/16 x 16 7/16" (31.6 x 41.7 cm). SHEET: 13 3/8 x 17 1/2" (34 x 44.4 cm). PUBLISHER: Vollard, Paris. PRINTER: Lacourière, Paris. EDITION: 260. Abby Aldrich Rockefeller Fund. 267.1949 (Baer 609 and *Addendum*)

32. *Minotaure aveugle guidé par une petite fille aux fleurs (Blind Minotaur Guided by a Little Girl with Flowers).* September 22, 1934. From the Vollard Suite, printed 1939. Drypoint and engraving. PLATE: 9 15/16 x 13 11/16" (25.2 x 34.7 cm). SHEET: 13 7/16 x 17 1/2" (34.1 x 44.4 cm). PUBLISHER: Vollard, Paris. PRINTER: Lacourière, Paris. EDITION: 260. Abby Aldrich Rockefeller Fund. 255.1949 (Baer 434)

33. *Minotaure aveugle guidé dans la nuit par une petite fille au pigeon (Blind Minotaur Guided in the Night by a Little Girl with a Pigeon).* October 23, 1934. From the Vollard Suite, printed 1939. Etching. PLATE: 9 3/8 x 11 3/4" (23.8 x 29.8 cm).

SHEET: 13 7/16 x 17 11/16" (34.2 x 45 cm).
PUBLISHER: Vollard, Paris. PRINTER:
Lacourière, Paris. EDITION: 260. Abby
Aldrich Rockefeller Fund. 256.1949
(Baer 435)

34. *Minotaure aveugle guidé par Marie-
Thérèse au pigeon dans une nuit étoilée* (*Blind
Minotaur Guided through a Starry Night by
Marie-Thérèse with a Pigeon*). c. December 3,
1934 or c. January 1, 1935. From the Vollard
Suite, printed 1939. Aquatint, drypoint,
and engraving. PLATE: 9 3/4 x 13 11/16"
(24.7 x 34.7 cm). SHEET: 14 15/16 x 19 11/16"
(38 x 50 cm). PUBLISHER: Vollard, Paris.
PRINTER: Lacourière, Paris. EDITION: 260.
Abby Aldrich Rockefeller Fund. 90.1949
(Baer 437)

35. *La Minotauromachie* (*Minotauromachy*).
March 23, 1935. Etching and engraving.
PLATE: 19 1/2 x 27 3/8" (49.6 x 69.6 cm).
SHEET: 22 5/8 x 29 3/16" (57.4 x 74.2 cm).
PUBLISHER: the artist, Paris. PRINTER:
Lacourière, Paris. EDITION: approx. 55
(inscribed 50). Abby Aldrich Rockefeller
Fund. 20.1947 (Baer 537 and *Addendum*)

36. *Dans l'arène. Jeune homme achevant le
Minotaure* (*In the Arena. Young Man Putting
the Minotaur to Death*). May 29, 1933. From
the Vollard Suite, printed 1939. Etching.
PLATE: 7 5/8 x 10 5/8" (19.3 x 27 cm). SHEET:
13 3/8 x 17 7/16" (34 x 44.3 cm). PUBLISHER:
Vollard, Paris. PRINTER: Lacourière, Paris.
EDITION: 260. Abby Aldrich Rockefeller
Fund. 232.1949 (Baer 365)

37. *Minotaure mourant et jeune femme pitoy-
able* (*Dying Minotaur and Compassionate
Young Woman*). May 30, 1933. From the
Vollard Suite, printed 1939. Etching.
PLATE: 7 5/8 x 10 9/16" (19.3 x 26.8 cm).
SHEET: 13 7/16 x 17 11/16" (34.1 x 45 cm).
PUBLISHER: Vollard, Paris. PRINTER:
Lacourière, Paris. EDITION: 260. Abby
Aldrich Rockefeller Fund. 233.1949
(Baer 366)

5. REENACTING THE BULLFIGHT

38. *Taureau et cheval dans l'arène* (*Bull and
Horse in the Arena*). 1929. From *Le chef-
d'œuvre inconnu*, by Honoré de Balzac, pub-
lished 1931. Etching. PLATE: 7 5/8 x 10 7/8"
(19.4 x 27.7 cm). SHEET: 9 13/16 x 12 15/16"
(25 x 32.8 cm). PUBLISHER: Vollard, Paris.
PRINTER: Fort, Paris. EDITION: 340.
The Louis E. Stern Collection. 967.1964.11
(Baer 125 and *Addendum*; Goeppert 20)

39. *Corrida. Femme torero blessée. III*
(*Bullfight. Wounded Female Bullfighter. III*).
November 8, 1933. From the Vollard
Suite, printed 1939. Etching and dry-
point. PLATE: 7 13/16 x 10 7/8" (19.8 x 27.7
cm). SHEET: 13 1/4 x 17 3/8" (33.7 x 44.1 cm).
PUBLISHER: Vollard, Paris. PRINTER:
Lacourière, Paris. EDITION: 260. Abby
Aldrich Rockefeller Fund. 239.1949
(Baer 384)

40. *Marie-Thérèse en femme torero* (*Marie-
Thérèse as Female Bullfighter*). June 20, 1934.
From the Vollard Suite, printed 1939.
Etching. PLATE: 11 3/4 x 9 3/8" (29.8 x 23.8
cm). SHEET: 17 5/8 x 13 3/8" (44.7 x 33.9
cm). PUBLISHER: Vollard, Paris. PRINTER:
Lacourière, Paris. EDITION: 260. Abby
Aldrich Rockefeller Fund. 253.1949
(Baer 426)

41. *Femme torero. Dernier baiser?* (*Female
Bullfighter. Last Kiss?*). June 12, 1934.
Etching. PLATE: 19 x 26 11/16" (48.3 x 67.8
cm). SHEET: 24 5/8 x 32" (62.5 x 81.3 cm).
PUBLISHER: unpublished. PRINTER:
Lacourière, Paris. EDITION: 5 proofs out-
side the edition of 50 (3 printed on vel-
lum). Acquired through the Lillie P. Bliss
Bequest. 243.1947 (Baer 425 and *Addendum*)

42. *La grande corrida, avec femme torero* (*The
Large Bullfight, with Female Bullfighter*).
September 8, 1934. Etching. PLATE:
19 7/16 x 27 1/16" (49.4 x 68.7 cm). SHEET:
22 3/16 x 30 1/4" (56.3 x 76.8 cm). PUBLISHER
and PRINTER: Lacourière, Paris. EDITION:
50. Acquired through the Lillie P. Bliss
Bequest. 244.1947 (Baer 433 and *Addendum*)

43. *La pique* (*Picador*). August 30, 1959 (?),
published 1960. Linoleum cut.
COMPOSITION: 20 13/16 x 25 3/16" (52.9 x 64
cm). SHEET: 24 7/16 x 29 1/2" (62.1 x 75 cm).
PUBLISHER: Leiris (Kahnweiler), Paris.
PRINTER: Arnéra, Vallauris, France.
EDITION: approx. 20 proofs outside the
edition of 50. David S. Orentreich Fund.
348.2009 (Baer 1227)

44. *Picador*. c. August 30, 1959, published
1960. Linoleum cut. COMPOSITION:
20 7/8 x 25 1/4" (53.1 x 64.2 cm). SHEET:
24 7/16 x 29 5/8" (62.1 x 75.2 cm). PUBLISHER:
Leiris (Kahnweiler), Paris. PRINTER:
Arnéra, Vallauris, France. EDITION: 50.
General Print Fund and Riva Castleman
Endowment Fund. 738.2006 (Baer 1226)

6. ABSTRACTING THE BULL

45. *The Bull* (*Le taureau*), state III. December
12, 1945. Lithograph. COMPOSITION: 12 5/8 x
17" (32.1 x 43.2 cm). SHEET: 13 1/16 x 17"
(33.2 x 43.2 cm). PUBLISHER: unpublished.
PRINTER: Mourlot, Paris. EDITION: out-
side the edition of 18 proofs. Mrs. Gilbert
W. Chapman Fund. 149.1979 (Mourlot 17;
Dallas 86)

46. *The Bull* (*Le taureau*), state IV. December
18, 1945. Lithograph. COMPOSITION: 12 3/8 x
18 7/8" (31.4 x 48 cm). SHEET: 13 5/16 x
20 5/16" (33.8 x 51.6 cm). PUBLISHER:
unpublished. PRINTER: Mourlot, Paris.
EDITION: outside the edition of 18 proofs.
Mrs. Gilbert W. Chapman Fund. 150.1979
(Mourlot 17; Dallas 87)

47. *The Bull* (*Le taureau*), state VII.
December 26, 1945. Lithograph.
COMPOSITION: 12 x 17 1/2" (30.5 x 44.4 cm).
SHEET: 12 15/16 x 17 1/2" (32.8 x 44.4 cm).
PUBLISHER: unpublished. PRINTER:
Mourlot, Paris. EDITION: 18 proofs.
Mrs. Gilbert W. Chapman Fund. 151.1979
(Mourlot 17; Dallas 90)

48. *The Bull* (*Le taureau*), state VII, variant. December 26, 1945. Lithograph. COMPOSITION: 12 3/16 x 18 7/16" (31 x 46.8 cm). SHEET: 13 1/16 x 19 7/16" (33.2 x 49.3 cm). PUBLISHER: unpublished. PRINTER: Mourlot, Paris. EDITION: outside the edition of 18 proofs. Mrs. Gilbert W. Chapman Fund. 152.1979 (Mourlot 17; Dallas 90)

49. *The Bull* (*Le taureau*), state X, counter-proof. December 28, 1945. Lithograph. COMPOSITION: 12 5/8 x 17 15/16" (32.1 x 45.5 cm). SHEET: 15 11/16 x 20 9/16" (39.9 x 52.2 cm). PUBLISHER: unpublished. PRINTER: Mourlot, Paris. EDITION: outside the edition of 18 proofs. Mrs. Gilbert W. Chapman Fund. 153.1979 (Mourlot 17; Dallas 91)

50. *The Bull* (*Le taureau*), state XI. January 2, 1946. Lithograph. COMPOSITION: 12 7/16 x 19 3/16" (31.6 x 48.8 cm). SHEET: 13 x 22 1/8" (33 x 56.2 cm). PUBLISHER: unpublished. PRINTER: Mourlot, Paris. EDITION: outside the edition of 18 proofs. Mrs. Gilbert W. Chapman Fund. 154.1979 (Mourlot 17; Dallas 92)

51. *The Bull* (*Le taureau*), state XIV. January 17, 1946. Lithograph. COMPOSITION: 11 1/2 x 15 15/16" (29.2 x 40.5 cm). SHEET: 13 1/16 x 17 1/2" (33.2 x 44.4 cm). PUBLISHER: Leiris (Kahnweiler), Paris. PRINTER: Mourlot, Paris. EDITION: 50. Acquired through the Lillie P. Bliss Bequest. 256.1947 (Mourlot 17; Dallas 95)

7. FAUNS AND SATYRS

52. *Faune flûtiste et danseuse à la maraca et au tambourin* (*Faun with Flute and Dancer with Maraca and Tambourine*). September 24, 1945. Etching. PLATE: 10 7/16 x 13 11/16" (26.5 x 34.7 cm). SHEET: 12 5/8 x 19 11/16" (32 x 50 cm). PUBLISHER: unpublished. PRINTER: Fort, Golfe-Juan, France. EDITION: 9 proofs. Gift of Abby Aldrich Rockefeller (by exchange). 85.1952 (Baer 702)

53. *Les pipeaux* (*The Pipes*), state I. c. August–September 1946. Etching and drypoint. PLATE: 10 9/16 x 13 15/16" (26.8 x 35.4 cm). SHEET: 12 13/16 x 19 11/16" (32.6 x 50 cm). PUBLISHER: unpublished. PRINTER: Fort, Golfe-Juan, France. EDITION: 4 proofs. Mrs. Bertram Smith Fund. 768.1956 (Baer 731)

54. *Les pipeaux* (*The Pipes*), state VI. c. August–September 1946. Etching and drypoint. PLATE: 10 11/16 x 13 15/16" (27.2 x 35.4 cm). SHEET: 13 x 18 5/16" (33 x 46.5 cm). PUBLISHER: unpublished. PRINTER: Fort, Golfe-Juan, France. EDITION: 11 proofs (5 printed in green). Acquired through the Lillie P. Bliss Bequest. 241.1947 (Baer 731)

55. *Bacchanale à l'acrobate* (*Bacchanal with Acrobat*). November 1959, published 1960. Linoleum cut. COMPOSITION: 20 11/16 x 25" (52.5 x 63.5 cm). SHEET: 24 x 29 1/2" (61 x 75 cm). PUBLISHER: Leiris (Kahnweiler), Paris. PRINTER: Arnéra, Vallauris, France. EDITION: 50. Gift of Mr. and Mrs. Daniel Saidenberg. 376.1962 (Baer 1264)

56. *Danse nocturne avec un hibou* (*Nocturnal Dance with an Owl*). November 18, 1959. Linoleum cut. COMPOSITION: 20 9/16 x 25 1/4" (52.3 x 64.2 cm). SHEET: 24 x 29 11/16" (61 x 75.4 cm). PUBLISHER: Leiris (Kahnweiler), Paris. PRINTER: Arnéra, Vallauris, France. EDITION: 50. Gift of Mr. and Mrs. Daniel Saidenberg. 375.1962 (Baer 1256)

57. *Danse nocturne avec un hibou* (*Nocturnal Dance with an Owl*). November 18, 1959, rinsed 1963–64. Linoleum cut, rinsed. COMPOSITION and SHEET: 24 x 29 1/4" (61 x 74.3 cm). PUBLISHER: unpublished. PRINTER: Arnéra, Vallauris, and the artist, Mougins, France. EDITION: 5 rinsed proofs. Gift of the Associates of the Department of Prints and Illustrated Books. 59.1999 (Baer 1256)

58. *Danse nocturne avec un hibou* (*Nocturnal Dance with an Owl*). November 18, 1959, rinsed 1963–64. Linoleum cut, rinsed. COMPOSITION and SHEET: 24 7/16 x 29 7/16" (62 x 74.8 cm). PUBLISHER: unpublished. PRINTER: Arnéra, Vallauris, and the artist, Mougins, France. EDITION: 5 rinsed proofs. The Associates Fund. 684.1996 (Baer 1256)

8. ANIMALS REAL AND IMAGINED

59. *The Dove*. January 9, 1949. Lithograph. COMPOSITION and SHEET: 21 5/8 x 27 3/16" (55 x 69.1 cm). PUBLISHER: Leiris (Kahnweiler), Paris. PRINTER: Mourlot, Paris. EDITION: 50. Gift of the Estate of Mrs. George Acheson. 37.1979 (Mourlot 141)

60. *L'autruche* (*The Ostrich*). 1936. From *Histoire naturelle (Textes de Buffon)*, by Georges-Louis Leclerc, Comte de Buffon, published 1942. Aquatint and drypoint. COMPOSITION: 10 7/16 x 8 9/16" (26.5 x 21.8 cm). PAGE: 14 3/16 x 11 1/4" (36 x 28.5 cm). PUBLISHER: Fabiani, Paris. PRINTER: Lacourière, Paris. EDITION: 226. The Louis E. Stern Collection. 976.1964.16 (Baer 590 and *Addendum*; Goeppert 37)

61. *Le cheval* (*The Horse*). 1936. From *Histoire naturelle (Textes de Buffon)*, by Georges-Louis Leclerc, Comte de Buffon, published 1942. Aquatint and drypoint. COMPOSITION: 10 3/4 x 8 7/16" (27.3 x 21.4 cm). PAGE: 14 3/16 x 11 1/4" (36 x 28.5 cm). PUBLISHER: Fabiani, Paris. PRINTER: Lacourière, Paris. EDITION: 226. The Louis E. Stern Collection. 976.1964.1 (Baer 575 and *Addendum*; Goeppert 37)

62. *Le singe* (*The Monkey*). February 9, 1936. From *Histoire naturelle (Textes de Buffon)*, by Georges-Louis Leclerc, Comte de Buffon, published 1942. Aquatint and drypoint. COMPOSITION: 10 13/16 x 8 11/16" (27.5 x 22 cm). PAGE: 14 3/16 x 11 1/4" (36 x 28.5 cm).

PUBLISHER: Fabiani, Paris. PRINTER: Lacourière, Paris. EDITION: 226. The Louis E. Stern Collection. 976.1964.12 (Baer 586 and *Addendum*; Goeppert 37)

63. *Le belier* (*The Ram*). 1936. From *Histoire naturelle* (*Textes de Buffon*), by Georges-Louis Leclerc, Comte de Buffon, published 1942. Aquatint and drypoint. COMPOSITION: 10 5/$_8$ x 8 3/$_8$" (27 x 21.2 cm). PAGE: 14 3/$_{16}$ x 11 1/$_4$" (36 x 28.5 cm). PUBLISHER: Fabiani, Paris. PRINTER: Lacourière, Paris. EDITION: 226. The Louis E. Stern Collection. 976.1964.5 (Baer 579 and *Addendum*; Goeppert 37)

64. *Le chat* (*The Cat*). 1936. From *Histoire naturelle* (*Textes de Buffon*), by Georges-Louis Leclerc, Comte de Buffon, published 1942. Aquatint, drypoint, and engraving. COMPOSITION: 11 3/$_4$ x 8 1/$_4$" (29.9 x 20.9 cm). PAGE: 14 3/$_{16}$ x 11 1/$_4$" (36 x 28.5 cm). PUBLISHER: Fabiani, Paris. PRINTER: Lacourière, Paris. EDITION: 226. The Louis E. Stern Collection. 976.1964.6 (Baer 580 and *Addendum*; Goeppert 37)

65. *Le pigeon* (*The Pigeon*). February 7, 1936. From *Histoire naturelle* (*Textes de Buffon*), by Georges-Louis Leclerc, Comte de Buffon, published 1942. Aquatint and drypoint. COMPOSITION: 10 7/$_{16}$ x 8 3/$_8$" (26.5 x 21.3 cm). PAGE: 14 3/$_{16}$ x 11 1/$_4$" (36 x 28.5 cm). PUBLISHER: Fabiani, Paris. PRINTER: Lacourière, Paris. EDITION: 226. The Louis E. Stern Collection. 976.1964.20 (Baer 594 and *Addendum*; Goeppert 37)

66. *La poule* (*The Hen*), state II. June 23 and 25, 1952. Aquatint and drypoint. PLATE: 20 5/$_{16}$ x 26 1/$_4$" (51.6 x 66.7 cm). SHEET: 22 5/$_{16}$ x 29 15/$_{16}$" (56.7 x 76 cm). PUBLISHER: unpublished. PRINTER: Lacourière, Paris. EDITION: 3 proofs. The Associates Fund. 1091.1979 (Baer 896)

67. *La poule* (*The Hen*), state VI. June 23 and 25, 1952. Aquatint and drypoint. PLATE: 20 1/$_4$ x 26 3/$_{16}$" (51.5 x 66.5 cm). SHEET: 22 5/$_{16}$ x 30 1/$_8$" (56.7 x 76.5 cm). PUBLISHER: Leiris (Kahnweiler), Paris. PRINTER: Lacourière, Paris. EDITION: 50. Curt Valentin Bequest. 368.1955 (Baer 896)

68. Untitled. c. April 1955(?). From *Chevaux de minuit*, by Roch Grey (Baroness Hélène d'Oettingen), published 1956. Engraving and drypoint. PLATE: 8 3/$_{16}$ x 6 1/$_{16}$" (20.8 x 15.4 cm). PAGE: 12 x 8 1/$_4$" (30 x 21 cm). PUBLISHER: Le Degré Quarante et Un (Iliazd), Paris and Cannes. PRINTER: Lacourière, Paris. EDITION: 52. The Louis E. Stern Collection. 1009.1964.7 (Baer 940 and *Addendum*; Goeppert 73)

69. Untitled. c. April 6–30, 1956. From *Chevaux de minuit*, by Roch Grey (Baroness Hélène d'Oettingen), published 1956. Engraving. PLATE: 9 1/$_8$ x 6 1/$_{16}$" (23.2 x 15.4 cm). PAGE: 11 13/$_{16}$ x 8 1/$_4$" (30 x 21 cm). PUBLISHER: Le Degré Quarante et Un (Iliazd), Paris and Cannes. PRINTER: Lacourière, Paris. EDITION: 52. The Louis E. Stern Collection. 1009.1964.13 (Baer 946 and *Addendum*; Goeppert 73)

70. Untitled. c. April 6–30, 1956. From *Chevaux de minuit*, by Roch Grey (Baroness Hélène d'Oettingen), published 1956. Engraving. PLATE: 9 1/$_8$ x 6 1/$_{16}$" (23.2 x 15.4 cm). PAGE: 11 13/$_{16}$ x 8 1/$_4$" (30 x 21 cm). PUBLISHER: Le Degré Quarante et Un (Iliazd), Paris and Cannes. PRINTER: Lacourière, Paris. EDITION: 52. The Louis E. Stern Collection. 1009.1964.2 (Baer 935 and *Addendum*; Goeppert 73)

9. TEXT AND IMAGE

71. *Soneto funebre* (*Funeral Sonnet*). February 6, 1948. From *Vingt poèmes*, by Luis de Góngora y Argote, published 1948. Drypoint. PAGE: 14 x 9 15/$_{16}$" (35.6 x 25.2 cm). PUBLISHER: Les Grands Peintres Modernes et le Livre, Paris. PRINTER: Lacourière, Paris. EDITION: 235. The Louis E. Stern Collection. 988.1964.37 (Baer 774 and *Addendum*; Goeppert 51)

72. *Soneto III* (*Sonnet III*). February 6, 1948. From *Vingt poèmes*, by Luis de Góngora y Argote, published 1948. Drypoint. PAGE: 14 1/$_8$ x 10 1/$_{16}$" (35.8 x 25.5 cm). PUBLISHER: Les Grands Peintres Modernes et le Livre, Paris. PRINTER: Lacourière, Paris. EDITION: 235. The Louis E. Stern Collection. 988.1964.41 (Baer 778 and *Addendum*; Goeppert 51)

73. *Soneto XVII* (*Sonnet XVII*). June 25, 1947. From *Vingt poèmes*, by Luis de Góngora y Argote, published 1948. Drypoint. PAGE: 13 1/$_2$ x 9 1/$_2$" (34.3 x 24.2 cm). PUBLISHER: Les Grands Peintres Modernes et le Livre, Paris. PRINTER: Lacourière, Paris. EDITION: 235. The Louis E. Stern Collection. 988.1964.7 (Baer 744 and *Addendum*; Goeppert 51)

74 and 75. Pages 20 and 21. 1945–48. From *Le chant des morts*, by Pierre Reverdy, published 1948. Lithograph. PAGE: 16 9/$_{16}$ x 12 5/$_8$" (42 x 32 cm). PUBLISHER: Tériade, Paris. PRINTER: Mourlot, Paris. EDITION: 250. The Louis E. Stern Collection. 990.1964.20 and 990.1964.21 (Mourlot 117; Goeppert 50)

76 and 77. Pages 28 and 29. 1945–48. From *Le chant des morts*, by Pierre Reverdy, published 1948. Lithograph. PAGE: 16 9/$_{16}$ x 12 5/$_8$" (42 x 32 cm). PUBLISHER: Tériade, Paris. PRINTER: Mourlot, Paris. EDITION: 250. The Louis E. Stern Collection. 990.1964.28 and 990.1964.29 (Mourlot 117; Goeppert 50)

78. **Untitled**. May 14–16, 1949. Sheet 6 from *Poèmes et lithographies*, by Pablo Picasso, published 1954. Lithograph. SHEET: 25 ⁷/₈ x 19 ¹³/₁₆" (65.8 x 50.4 cm). PUBLISHER: Leiris (Kahnweiler), Paris. PRINTER: Mourlot, Paris. EDITION: 50. The Louis E. Stern Collection. 1006.1964.6 (Mourlot 180; Goeppert 69)

79. **Untitled**. May 24–25, 1949. Sheet 12 from *Poèmes et lithographies*, by Pablo Picasso, published 1954. Lithograph. SHEET: 26 x 19 ¹³/₁₆" (66 x 50.3 cm). PUBLISHER: Leiris (Kahnweiler), Paris. PRINTER: Mourlot, Paris. EDITION: 50. The Louis E. Stern Collection. 1006.1964.12 (Mourlot 180; Goeppert 69)

10. PORTRAITS: VOLLARD, KAHNWEILER, BALZAC

80. *Portrait de Vollard. I* (*Portrait of Vollard. I*). March 4, 1937. From the Vollard Suite, printed 1939. Aquatint and engraving. PLATE: 13 ⁵/₈ x 9 ³/₄" (34.6 x 24.8 cm). SHEET: 17 ¹/₂ x 13 ⁵/₁₆" (44.5 x 33.8 cm). PUBLISHER: Vollard, Paris. PRINTER: Lacourière, Paris. EDITION: 260. Gift of Klaus G. Perls, in memory of Frank Perls, Art Dealer (by exchange). 229.1983 (Baer 617 and *Addendum*)

81. *Portrait de Vollard. II* (*Portrait of Vollard. II*). March 4, 1937. From the Vollard Suite, printed 1939. Aquatint. PLATE: 13 ¹¹/₁₆ x 9 ³/₄" (34.8 x 24.7 cm). SHEET: 17 ¹¹/₁₆ x 13 ³/₁₆" (45 x 33.5 cm). PUBLISHER: Vollard, Paris. PRINTER: Lacourière, Paris. EDITION: 260. Acquired through the Lillie P. Bliss Bequest. 253.1947 (Baer 618 and *Addendum*)

82. *Portrait de Vollard. III* (*Portrait of Vollard. III*). March 4, 1937. From the Vollard Suite, printed 1939. Etching. PLATE: 13 ⁵/₈ x 9 ³/₄" (34.6 x 24.8 cm). SHEET: 17 ⁷/₁₆ x 13 ³/₈" (44.3 x 34 cm). PUBLISHER: Vollard, Paris. PRINTER: Lacourière, Paris. EDITION: 260. The Marnie Pillsbury Fund. 46.2004 (Baer 619 and *Addendum*)

83. *Portrait de Vollard. IV* (*Portrait of Vollard. IV*), state I. March 4, 1937. Aquatint and etching. PLATE: 13 ⁹/₁₆ x 9 ¹¹/₁₆" (34.5 x 24.6 cm). SHEET: 17 ⁷/₁₆ x 13 ³/₈" (44.3 x 34 cm). PUBLISHER: unpublished. PRINTER: Lacourière, Paris. EDITION: 2 proofs. Acquired through the generosity of Marie-Josée and Henry Kravis. 34.2009 (Baer 620)

84. *Portrait of D. H. Kahnweiler I* (*Portrait de D. H. Kahnweiler I*). June 3, 1957. Lithograph. COMPOSITION: 25 ¹/₂ x 19 ¹¹/₁₆" (64.8 x 50 cm). SHEET: 25 ⁹/₁₆ x 19 ¹⁵/₁₆" (65 x 50.6 cm). PUBLISHER: Leiris (Kahnweiler), Paris. PRINTER: Mourlot, Paris. EDITION: 50. Gift of Mr. and Mrs. Daniel Saidenberg. 61.1958 (Mourlot 295)

85. *Portrait of D. H. Kahnweiler II* (*Portrait de D. H. Kahnweiler II*). June 3, 1957. Lithograph. COMPOSITION: 25 ¹¹/₁₆ x 19 ¹/₂" (65.3 x 49.5 cm). SHEET: 25 ⁷/₈ x 19 ¹⁵/₁₆" (65.8 x 50.7 cm). PUBLISHER: Leiris (Kahnweiler), Paris. PRINTER: Mourlot, Paris. EDITION: 50. Gift of Mr. and Mrs. Daniel Saidenberg. 60.1958 (Mourlot 296)

86. *Portrait of D. H. Kahnweiler III* (*Portrait de D. H. Kahnweiler III*). June 3, 1957. Lithograph. COMPOSITION: 25 x 19 ⁵/₁₆" (63.5 x 49 cm). SHEET: 25 ¹¹/₁₆ x 19 ¹⁵/₁₆" (65.3 x 50.6 cm). PUBLISHER: Leiris (Kahnweiler), Paris. PRINTER: Mourlot, Paris. EDITION: 50. Gift of Mr. and Mrs. Daniel Saidenberg. 62.1958 (Mourlot 297)

87. *Portrait of Balzac III* (*Portrait de Balzac III*). November 25, 1952. From *balzacs en bas de casse et picassos sans majuscule*, by Michel Leiris, published 1957. Lithograph. COMPOSITION: 8 ⁷/₈ x 6 ⁹/₁₆" (22.6 x 16.7 cm). SHEET: 13 x 9 ¹⁵/₁₆" (33 x 25.3 cm). PUBLISHER: Leiris (Kahnweiler), Paris. PRINTER: Mourlot, Paris. EDITION: 100. The Louis E. Stern Collection. 1014.1964.2 (Mourlot 218; Goeppert 86)

88. *Portrait of Balzac V* (*Portrait de Balzac V*). November 25, 1952. From *balzacs en bas de casse et picassos sans majuscule*, by Michel Leiris, published 1957. Lithograph. COMPOSITION: 8 ⁷/₈ x 6 ⁹/₁₆" (22.5 x 16.7 cm). SHEET: 12 ¹⁵/₁₆ x 9 ¹⁵/₁₆" (33 x 25.3 cm). PUBLISHER: Leiris (Kahnweiler), Paris. PRINTER: Mourlot, Paris. EDITION: 100. The Louis E. Stern Collection. 1014.1964.4 (Mourlot 220; Goeppert 86)

89. *Portrait of Balzac VIII* (*Portrait de Balzac VIII*). November 25, 1952. From *balzacs en bas de casse et picassos sans majuscule*, by Michel Leiris, published 1957. Lithograph. COMPOSITION: 8 ⁷/₈ x 6 ⁹/₁₆" (22.6 x 16.7 cm). SHEET: 13 x 9 ¹⁵/₁₆" (33 x 25.3 cm). PUBLISHER: Leiris (Kahnweiler), Paris. PRINTER: Mourlot, Paris. EDITION: 100. The Louis E. Stern Collection. 1014.1964.7 (Mourlot 223; Goeppert 86)

90. *Portrait of Balzac [IX]* (*Portrait de Balzac [IX]*). December 7, 1952. From *balzacs en bas de casse et picassos sans majuscule*, by Michel Leiris, published 1957. Lithograph. COMPOSITION: 8 ⁷/₈ x 6 ⁹/₁₆" (22.5 x 16.7 cm). SHEET: 13 x 9 ¹⁵/₁₆" (33 x 25.3 cm). PUBLISHER: Leiris (Kahnweiler), Paris. PRINTER: Mourlot, Paris. EDITION: 100. The Louis E. Stern Collection. 1014.1964.8 (Mourlot 224; Goeppert 86)

11. PORTRAITS: LOVERS AND WIVES

91. *Tête de femme, de profil (Head of Woman, in Profile)*. c. February 1905. Drypoint. PLATE: 11 $^7/_{16}$ x 9 $^{13}/_{16}$" (29.1 x 25 cm). SHEET: 18 $^3/_{16}$ x 12 $^5/_8$" (46.2 x 32.1 cm). PUBLISHER: unpublished. PRINTER: Fort, Paris. EDITION: approx. 13 proofs before the 1913 edition of 250 from the Saltimbanques series. Lillie P. Bliss Collection. 94.1934 (Baer 7 and *Addendum*)

92. *Buste de jeune femme de trois quarts (Bust of Young Woman in Three-Quarter View)*. 1906, printed 1933. Woodcut. COMPOSITION AND SHEET: 20 $^3/_{16}$ x 13 $^1/_2$" (51.3 x 34.3 cm). PUBLISHER: unpublished. PRINTER: the artist, Paris. EDITION: 15 proofs. Abby Aldrich Rockefeller Fund. 386.1951 (Baer 212)

11a. MARIE-THÉRÈSE WALTER

93. *Visage de Marie-Thérèse (Face of Marie-Thérèse)*. c. October 1928. Lithograph. COMPOSITION: 8 x 5 $^9/_{16}$" (20.3 x 14.1 cm). SHEET: 19 $^3/_{16}$ x 13 $^3/_8$" (48.8 x 33.9 cm). PUBLISHER: Percier, Paris. PRINTER: Marchizet, Paris. EDITION: 75. Gift of Abby Aldrich Rockefeller. 480.1940 (Baer 243; Mourlot 23)

94. *Peintre avec deux modèles regardant une toile (Painter With Two Models Looking at a Canvas)*. 1927. From *Le chef-d'œuvre inconnu*, by Honoré de Balzac, published 1931. Etching. PLATE: 7 $^5/_8$ x 10 $^7/_8$" (19.3 x 27.7 cm). SHEET: 9 $^5/_{16}$ x 12 $^{13}/_{16}$" (25.2 x 32.6 cm). PUBLISHER: Vollard, Paris. PRINTER: Fort, Paris. EDITION: 340. The Louis E. Stern Collection. 967.1964.7 (Baer 124 and *Addendum*; Goeppert 20)

95. *Trois femmes nues et une coupe d'anémones (Three Nude Women and a Bowl of Anemones)*. April 6, 1933. From the Vollard Suite, printed 1939. Etching. PLATE: 14 $^1/_2$ x 11 $^3/_4$" (36.8 x 29.8 cm). SHEET: 17 $^5/_{16}$ x 13 $^3/_8$" (44 x 34 cm). PUBLISHER: Vollard, Paris. PRINTER: Lacourière, Paris. EDITION: 260. Abby Aldrich Rockefeller Fund. 213.1949 (Baer 329)

96. *Femme au fauteuil songeuse, la joue sur la main (Dreaming Woman in Armchair, Her Cheek on Her Hand)*. March 9, 1934. From the Vollard Suite, printed 1939. Etching. PLATE: 10 $^{15}/_{16}$ x 7 $^{13}/_{16}$" (27.8 x 19.8 cm). SHEET: 17 $^3/_8$ x 13 $^5/_{16}$" (44.2 x 33.8 cm). PUBLISHER: Vollard, Paris. PRINTER: Lacourière, Paris. EDITION: 260. Abby Aldrich Rockefeller Fund. 251.1949 (Baer 423)

97. *Sculpture. Tête de Marie-Thérèse (Sculpture. Head of Marie-Thérèse)*. February 18, 1933. Drypoint. PLATE: 12 $^1/_2$ x 9" (31.8 x 22.8 cm). SHEET: 17 $^7/_{16}$ x 13 $^5/_{16}$" (44.3 x 33.8 cm). PUBLISHER: the artist, Paris. PRINTER: Lacourière, Paris. EDITION: 55. Gift of the Associates of the Department of Prints and Illustrated Books. 1382.2009. (Baer 288 and *Addendum*)

11b. DORA MAAR

98. *Portrait de Dora Maar au chignon. I (Portrait of Dora Maar with Chignon. I)*. October 21, 1936. Drypoint and engraving. PLATE: 13 $^1/_2$ x 9 $^1/_2$" (34.3 x 24.2 cm). SHEET: 17 $^5/_{16}$ x 13 $^5/_{16}$" (44 x 33.8 cm). PUBLISHER: the artist, Paris. PRINTER: Lacourière, Paris. EDITION: 57. Gift of the Associates of the Department of Prints and Illustrated Books. 60.1990 (Baer 611 and *Addendum*)

99. *La femme au tambourin (The Woman with Tambourine)*. 1939, published 1943. Aquatint(?). PLATE: 26 $^1/_4$ x 20 $^3/_{16}$" (66.7 x 51.2 cm). SHEET: 29 $^{15}/_{16}$ x 22 $^1/_4$" (76 x 56.5 cm). PUBLISHER: Leiris (Kahnweiler), Paris. PRINTER: Lacourière, Paris. EDITION: 30. Acquired through the Lillie P. Bliss Bequest. 165.1945 (Baer 646 and *Addendum*)

100. *La femme qui pleure. I (The Weeping Woman. I)*. July 1, 1937. Etching, aquatint, and drypoint. PLATE: 27 $^1/_8$ x 19 $^1/_2$" (68.9 x 49.5 cm). SHEET: 30 $^5/_{16}$ x 22 $^5/_{16}$" (77 x 56.7 cm). PUBLISHER: the artist, Paris. PRINTER: Lacourière, Paris. EDITION: 15. Acquired through the generosity of the Katsko Suzuki Memorial Fund, the Riva Castleman Endowment Fund, David Rockefeller, The Philip and Lynn Straus Foundation Fund, and Agnes Gund and Daniel Shapiro, Linda and Bill Goldstein, Mr. and Mrs. Herbert D. Schimmel, the Edward John Noble Foundation, and the Associates of the Department of Prints and Illustrated Books, The Cowles Charitable Trust, Nelson Blitz, Jr. with Catherine Woodard and Perri and Allison Blitz, Mary Ellen Meehan, and Anna Marie and Robert F. Shapiro and Ruth and Louis Aledort, Carol and Bert Freidus, David S. Orentreich, M.D., and Susan and Peter Ralston. 445.1999 (Baer 623 and *Addendum*)

101. *Tête de femme No. 2. Portrait de Dora Maar (Head of a Woman No. 2. Portrait of Dora Maar)*. March–April 1939. Aquatint and drypoint. PLATE: 11 $^3/_4$ x 9 $^5/_{16}$" (29.8 x 23.7 cm). SHEET: 17 $^3/_8$ x 13 $^5/_{16}$" (44.2 x 33.8 cm). PUBLISHER: Vollard, Paris. PRINTER: Lacourière, Paris. EDITION: 80. Richard A. Epstein Fund, Miles O. Epstein Fund, Sarah C. Epstein Fund, Philip and Lynn Straus Foundation Fund, and the Robert and Anna Marie Shapiro Fund. 61.1999 (Baer 650)

102. *Tête de femme No. 4. Portrait de Dora Maar (Head of a Woman No. 4. Portrait of Dora Maar)*. April–May 1939. Aquatint. PLATE: 11 $^{13}/_{16}$ x 9 $^5/_{16}$" (30 x 23.7 cm). SHEET: 17 $^5/_8$ x 13 $^7/_{16}$" (44.7 x 34.2 cm). PUBLISHER: Vollard, Paris. PRINTER: Lacourière, Paris. EDITION: 80. Gift of Mrs. Melville Wakeman Hall. 315.1985 (Baer 652)

103. *Tête de femme No. 5. Portrait de Dora Maar* (*Head of a Woman No. 5. Portrait of Dora Maar*). January–June, 1939. Aquatint and drypoint. PLATE: 11 3/4 x 9 3/8" (29.8 x 23.8 cm). SHEET: 17 5/8 x 13 3/8" (44.7 x 34 cm). PUBLISHER: Vollard, Paris. PRINTER: Lacourière, Paris. EDITION: 80. Lily Auchincloss Fund and The Riva Castleman Endowment Fund. 62.1999 (Baer 653)

104. *Tête de femme No. 6. Portrait de Dora Maar* (*Head of a Woman No. 6. Portrait of Dora Maar*). January–June, 1939. Aquatint. PLATE: 11 3/4 x 9 5/16" (29.8 x 23.6 cm). SHEET: 17 11/16 x 13 3/8" (45 x 34 cm). PUBLISHER: Vollard, Paris. PRINTER: Lacourière, Paris. EDITION: 80. Gift of the Associates of the Department of Prints and Illustrated Books. 63.1999 (Baer 654)

11c. FRANÇOISE GILOT

105. *Françoise with a Bow in Her Hair* (*Françoise au nœud dans les cheveux*). June 14, 1946. Lithograph. COMPOSITION: 24 3/4 x 18 3/8" (62.9 x 46.7 cm). SHEET: 26 x 19 5/8" (66 x 49.8 cm). PUBLISHER: Leiris (Kahnweiler), Paris. PRINTER: Mourlot, Paris. EDITION: 50. Purchase. 153.1949 (Mourlot 41)

106. *Two Nude Women* (*Les deux femmes nues*), state IX. January 10, 1946. Lithograph. COMPOSITION: 10 5/8 x 14 1/4" (27 x 36.2 cm). SHEET: 12 13/16 x 17 7/16" (32.5 x 44.3 cm). PUBLISHER: unpublished. PRINTER: Mourlot, Paris. EDITION: 19 proofs. Riva Castleman Endowment Fund. 565.1997 (Mourlot 16)

107. *Two Nude Women* (*Les deux femmes nues*), state XI. January 21, 1946. Lithograph. COMPOSITION: 10 5/8 x 14 3/8" (27 x 36.5 cm). SHEET: 12 15/16 x 17 3/8" (32.9 x 44.1 cm). PUBLISHER: unpublished. PRINTER: Mourlot, Paris. EDITION: 19 proofs. Riva Castleman Endowment Fund. 566.1997 (Mourlot 16)

108. *Two Nude Women* (*Les deux femmes nues*), state XVI. February 6, 1946. Lithograph. COMPOSITION: 10 13/16 x 15 1/2" (27.5 x 39.4 cm). SHEET: 12 7/8 x 17 3/8" (32.7 x 44.1 cm). PUBLISHER: unpublished. PRINTER: Mourlot, Paris. EDITION: 19 proofs. Riva Castleman Endowment Fund. 567.1997 (Mourlot 16)

109. *Two Nude Women* (*Les deux femmes nues*), state XVIII. February 12, 1946. Lithograph. COMPOSITION: 12 5/8 x 16 15/16" (32 x 43 cm). SHEET: 13 1/16 x 17 1/2" (33.2 x 44.4 cm). PUBLISHER: Leiris (Kahnweiler), Paris. PRINTER: Mourlot, Paris. EDITION: 50. Acquired through the Lillie P. Bliss Bequest. 263.1947 (Mourlot 16)

110. *Portrait de Françoise au long cou. I* (*Portrait of Françoise with Long Neck. I*), state II. 1946. Aquatint and engraving. PLATE: 13 1/2 x 9 3/4" (34.5 x 24.8 cm). SHEET: 19 3/8 x 14 15/16" (49.2 x 38 cm). PUBLISHER: unpublished. PRINTER: Lacourière, Paris. EDITION: 5 proofs. Riva Castleman Endowment Fund. 568.1997 (Baer 733)

111. *Portrait de Françoise au long cou. I* (*Portrait of Françoise with Long Neck. I*), state III. 1946. Aquatint and engraving. PLATE: 13 9/16 x 9 3/4" (34.5 x 24.8 cm). SHEET: 20 3/8 x 14 15/16" (51.8 x 37.9 cm). PUBLISHER: unpublished. PRINTER: Lacourière, Paris. EDITION: unique proof. Riva Castleman Endowment Fund. 569.1997 (Baer 733)

112. *Portrait de Françoise au long cou. I* (*Portrait of Françoise with Long Neck. I*), state IV. 1946. Aquatint and engraving. PLATE: 13 9/16 x 9 5/8" (34.5 x 24.8 cm). SHEET: 19 11/16 x 12 13/16" (50 x 32.5 cm). PUBLISHER: unpublished. PRINTER: Lacourière, Paris. EDITION: 5 proofs. Riva Castleman Endowment Fund. 570.1997 (Baer 733)

113. *Portrait de Françoise au long cou. I* (*Portrait of Françoise with Long Neck. I*), state IV. 1946. Aquatint and engraving, printed in relief. PLATE: 13 11/16 x 9 3/4" (34.8 x 24.8 cm). SHEET: 17 5/16 x 12 7/8" (44 x 32.7 cm). PUBLISHER: unpublished. PRINTER: Lacourière, Paris. EDITION: 3 proofs. Gift of the Associates. 1086.2007 (Baer 733)

114. *Armchair Woman No. 1* (*La femme au fauteuil No. 1*) or *The Polish Coat* (*Le manteau polonais*) (from the red plate of Mourlot 133). December 30, 1948. Lithograph. COMPOSITION: 27 3/8 x 20 1/2" (69.5 x 52 cm). SHEET: 29 15/16 x 22 7/16" (76 x 57 cm). PUBLISHER: Leiris (Kahnweiler), Paris. PRINTER: Mourlot, Paris. EDITION: 50. Curt Valentin Bequest. 361.1955 (Mourlot 134)

115. *Armchair Woman No. 4* (*La femme au fauteuil No. 4*) (from the violet plate of Mourlot 133). January 3, 1949. Lithograph. COMPOSITION: 27 1/2 x 21 9/16" (69.8 x 54.8 cm). SHEET: 30 x 22 1/4" (76 x 56.5 cm). PUBLISHER: Leiris (Kahnweiler), Paris. PRINTER: Mourlot, Paris. EDITION: 50. Curt Valentin Bequest. 362.1955 (Mourlot 137)

116. *La femme à la fenêtre* (*The Woman at the Window*). May 17, 1952. Aquatint. PLATE: 34 13/16 x 18 5/8" (88.4 x 47.3 cm). SHEET: 35 7/16 x 25 1/16" (90 x 63.7 cm). PUBLISHER: Leiris (Kahnweiler), Paris. PRINTER: Lacourière, Paris. EDITION: 50. Curt Valentin Bequest. 367.1955 (Baer 891)

117. *L'Égyptienne* (*The Egyptian*). May 11, 1953. Aquatint. PLATE: 32 11/16 x 18 9/16" (83.1 x 47.1 cm). SHEET: 35 5/8 x 25 1/16" (90.5 x 63.7 cm). PUBLISHER: Leiris (Kahnweiler), Paris. PRINTER: Lacourière, Paris. EDITION: 50. Gift of Porter McCray. 243.1996 (Baer 906)

11d. JACQUELINE ROQUE

118. *Jacqueline en mariée, de face. I (Jacqueline as a Bride, frontal view. I)*, state XIV. March 24, 1961. Aquatint, drypoint, and engraving. PLATE: 15 11/$_{16}$ x 11 5/$_8$" (39.8 x 29.6 cm). SHEET: 19 3/$_4$ x 16" (50.2 x 40.7 cm). PUBLISHER: unpublished. PRINTER: Frélaut, Cannes(?). EDITION: 9 proofs. Johanna and Leslie J. Garfield Fund. 1384.2009 (Baer 1089)

119. *Profil de Jacqueline au foulard (Profile of Jacqueline with a Scarf)*. December 28, 1955. Linoleum cut. COMPOSITION: 21 3/$_4$ x 19 3/$_4$" (55.2 x 50.2 cm). SHEET: 26 3/$_8$ x 19 3/$_4$" (67 x 50.2 cm). PUBLISHER: unpublished. PRINTER: Arnéra, Vallauris, France. EDITION: 8 proofs. Acquired through the generosity of Mrs. Edmond J. Safra and the General Print Fund. 178.2003 (Baer 1033 and *Addendum*)

120. *Portrait of a Woman II (Jacqueline Roque) (Portrait de femme II [Jacqueline Roque])*. December 29, 1955. Lithograph. COMPOSITION: 25 9/$_{16}$ x 14 7/$_8$" (65 x 37.8 cm). SHEET: 26 1/$_8$ x 19 3/$_4$" (66.4 x 50.2 cm). PUBLISHER: Leiris (Kahnweiler), Paris. PRINTER: Mourlot, Paris. EDITION: 50. Gift of Mr. and Mrs. Daniel Saidenberg. 59.1958 (Mourlot 272)

121. *Jacqueline au bandeau. I (Jacqueline with Headband. I)*, state I. February 13, 1962. Linoleum cut. COMPOSITION: 13 3/$_4$ x 10 11/$_{16}$" (35 x 27.2 cm). SHEET: 24 13/$_{16}$ x 17 1/$_2$" (63 x 44.5 cm). PUBLISHER: unpublished. PRINTER: Arnéra, Vallauris, France. EDITION: 2–3 proofs outside the edition of 50. Eugene Mercy, Jr. Fund, Riva Castleman Endowment Fund, and Louise Reinhardt Smith Bequest (by exchange). 2515.2001 (Baer 1297)

122. *Jacqueline au bandeau. I (Jacqueline with Headband. I)*, state I. March 2, 1962. Linoleum cut. COMPOSITION: 13 3/$_4$ x 10 5/$_8$" (35 x 27 cm). SHEET: 24 3/$_4$ x 17 7/$_{16}$" (62.9 x 44.3 cm). PUBLISHER: unpublished. PRINTER: Arnéra, Vallauris, France. EDITION: 1–2 proofs. Eugene Mercy, Jr. Fund, Riva Castleman Endowment Fund, and Louise Reinhardt Smith Bequest (by exchange). 2517.2001 (Baer 1297)

123. *Jacqueline au bandeau. I (Jacqueline with Headband. I)*, state II. March 6, 1962. Linoleum cut. COMPOSITION: 13 13/$_{16}$ x 10 11/$_{16}$" (35.1 x 27.2 cm). SHEET: 24 3/$_4$ x 17 7/$_{16}$" (62.9 x 44.3 cm). PUBLISHER: unpublished. PRINTER: Arnéra, Vallauris, France. EDITION: unique proof. Eugene Mercy, Jr. Fund, Riva Castleman Endowment Fund, and Louise Reinhardt Smith Bequest (by exchange). 2519.2001 (Baer 1297)

124. *Jacqueline au bandeau. I (Jacqueline with Headband. I)*, state II over state I. March 6, 1962. Linoleum cut. COMPOSITION: 13 3/$_4$ x 10 5/$_8$" (35 x 27 cm). SHEET: 24 13/$_{16}$ x 17 1/$_2$" (63 x 44.5 cm). PUBLISHER: unpublished. PRINTER: Arnéra, Vallauris, France. EDITION: 2–3 proofs. Eugene Mercy, Jr. Fund, Riva Castleman Endowment Fund, and Louise Reinhardt Smith Bequest (by exchange). 2518.2001 (Baer 1297)

125. *Jacqueline au bandeau. II (Jacqueline with Headband. II)*, state III over state I. March 6, 1962. Linoleum cut. COMPOSITION: 13 3/$_4$ x 10 9/$_{16}$" (35 x 26.8 cm). SHEET: 24 5/$_8$ x 17 5/$_{16}$" (62.5 x 44 cm). PUBLISHER: unpublished. PRINTER: Arnéra, Vallauris, France. EDITION: 2–3 proofs outside the edition of 50. Eugene Mercy, Jr. Fund, Riva Castleman Endowment Fund, and Louise Reinhardt Smith Bequest (by exchange). 2521.2001 (Baer 1297)

126. *Jacqueline au bandeau. III (Jacqueline with Headband. III)*, state III. c. March 6, 1962. Linoleum cut. COMPOSITION: 13 3/$_4$ x 10 5/$_8$" (35 x 27 cm). SHEET: 24 3/$_4$ x 17 1/$_2$" (62.8 x 44.5 cm). PUBLISHER: unpublished. PRINTER: Arnéra, Vallauris, France. EDITION: 2 proofs outside the edition of 50. Eugene Mercy, Jr. Fund, Riva Castleman Endowment Fund, and Louise Reinhardt Smith Bequest (by exchange). 2522.2001 (Baer 1297)

12. AFTER THE MASTERS

127. *David and Bathsheba (after Lucas Cranach) (David et Bethsabée [d'après Lucas Cranach])*, state I. March 30, 1947. Lithograph. COMPOSITION: 25 1/$_2$ x 19 1/$_{16}$" (64.7 x 48.4 cm). SHEET: 25 13/$_{16}$ x 19 3/$_4$" (65.5 x 50.2 cm). PUBLISHER: Leiris (Kahnweiler), Paris. PRINTER: Mourlot, Paris. EDITION: 50. Mrs. Bertram Smith Fund. 776.1956 (Mourlot 109)

128. *David and Bathsheba (after Lucas Cranach) (David et Bethsabée [d'après Lucas Cranach])*, state II. March 30, 1947. Lithograph. COMPOSITION: 25 13/$_{16}$ x 19 3/$_{16}$" (65.6 x 48.8 cm). SHEET: 25 13/$_{16}$ x 19 5/$_8$" (65.6 x 49.8 cm). PUBLISHER: Leiris (Kahnweiler), Paris. PRINTER: Mourlot, Paris. EDITION: 50. Acquired through the Lillie P. Bliss Bequest. 254.1947 (Mourlot 109)

129. *David and Bathsheba (after Lucas Cranach) (David et Bethsabée [d'après Lucas Cranach])*, state IV a. March 30, 1947. Lithograph. COMPOSITION: 25 3/$_8$ x 18 13/$_{16}$" (64.5 x 47.8 cm). SHEET: 25 13/$_{16}$ x 19 5/$_8$" (65.5 x 49.8 cm). PUBLISHER: Leiris (Kahnweiler), Paris. PRINTER: Mourlot, Paris. EDITION: 50. Acquired through the Lillie P. Bliss Bequest. 255.1947 (Mourlot 109)

130. *David and Bathsheba (after Lucas Cranach)* (*David et Bethsabée [d'après Lucas Cranach]*), state X a or bis. May 29, 1949. Lithograph. COMPOSITION: 25 9/16 x 18 7/8" (65 x 48 cm). SHEET: 29 15/16 x 22 1/8" (76 x 56.2 cm). PUBLISHER: Leiris (Kahnweiler), Paris. PRINTER: Mourlot, Paris. EDITION: 50. Curt Valentin Bequest. 363.1955 (Mourlot 109)

131. *Portrait de jeune fille, d'après Cranach le Jeune. II (Portrait of Young Lady, after Cranach the Younger. II)*. July 4, 1958. Linoleum cut. COMPOSITION: 25 11/16 x 21 5/16" (65.3 x 54.1 cm). SHEET: 30 1/4 x 22 5/8" (76 x 57.5 cm). PUBLISHER: Leiris (Kahnweiler), Paris. PRINTER: Arnéra, Vallauris, France. EDITION: 50. Gift of Mr. and Mrs. Daniel Saidenberg. 631.1959 (Baer 1053 and *Addendum*)

132. *Le déjeuner sur l'herbe, d'après Manet. I (Luncheon on the Grass, after Manet. I)*. January 26–March 13, 1962, published 1963. Linoleum cut. COMPOSITION: 20 15/16 x 25 1/4" (53.2 x 64.2 cm). SHEET: 24 7/16 x 29 5/8" (62 x 75.3 cm). PUBLISHER: Leiris (Kahnweiler), Paris. PRINTER: Arnéra, Vallauris, France. EDITION: 50. Gift of Mr. and Mrs. Daniel Saidenberg. 2184.1967 (Baer 1287)

133. *"Ecce Homo," d'après Rembrandt ("Ecce Homo," after Rembrandt)*. No. 10 from Suite 156. February 4 and March 5–6, 1970, published 1978. Etching and aquatint. PLATE: 19 1/2 x 16 1/8" (49.5 x 41 cm). SHEET: 26 13/16 x 22 5/16" (68.1 x 56.7 cm). PUBLISHER: Leiris (Kahnweiler), Paris. PRINTER: Crommelynck, Paris. EDITION: 50. Edgar Wachenheim III Fund. 1385.2009 (Baer 1870)

13. LATE WORK

134. *Picasso, son œuvre, et son public (Picasso, His Work, and His Public)*. No. 1 from Suite 347. March 16–22, 1968. Etching. PLATE: 15 1/2 x 22 1/4" (39.3 x 56.5 cm). SHEET: 22 1/16 x 28 1/4" (56 x 71.8 cm). PUBLISHER: unpublished. PRINTER: Crommelynck, Mougins, France. EDITION: 17 proofs outside the edition of 50. Gift of the Bibliothèque Nationale de France (by exchange). 624.1983 (Baer 1496)

135. *Souvenirs: Cirque, avec El Gigante et autoportrait en bébé-vieillard (Memories: Circus, with El Gigante and Self-Portrait as a Baby–Old Man)*. No. 142 from Suite 347. June 4, 1968. Etching, aquatint, and drypoint. PLATE: 19 5/16 x 13 3/16" (49 x 33.5 cm). SHEET: 25 13/16 x 18 3/8" (65.5 x 46.6 cm). PUBLISHER: Leiris (Kahnweiler), Paris. PRINTER: Crommelynck, Mougins, France. EDITION: 50. Acquired through the generosity of Marie-Josée and Henry Kravis. 351.2009 (Baer 1638)

136. *Sexe à l'ancienne et à la moderne (Sex in the Traditional and Modern Ways)*. No. 135 from Suite 347. June 1, 1968. Etching. PLATE: 16 1/8 x 19 1/2" (41 x 49.5 cm). SHEET: 22 5/16 x 25 3/8" (56.6 x 64.5 cm). PUBLISHER: Leiris (Kahnweiler), Paris. PRINTER: Crommelynck, Mougins, France. EDITION: 50. Sharon Percy Rockefeller Fund. 350.2009 (Baer 1631)

137. *Mousquetaire attablé avec un jeune garçon, évoquant sa vie (Musketeer Sitting Down with a Young Boy and Recalling His Life)*. No. 97 from Suite 347. May 16, 1968. Etching and drypoint. PLATE: 13 1/4 x 19 3/8" (33.6 x 49.2 cm). SHEET: 19 11/16 x 25 13/16" (50 x 65.6 cm). PUBLISHER: unpublished. PRINTER: Crommelynck, Mougins, France. EDITION: 17 proofs outside the edition of 50. John M. Shapiro Fund. 349.2009 (Baer 1593)

Chronology

1881
Pablo Picasso born October 25, Málaga, Spain.

1899
Becomes part of avant-garde circle at café Els Quatre Gats, Barcelona.

Makes first print, *El Zurdo*.

1900
Visits Paris for first time.

1901
Again in Paris, exhibits work in two-person show, arranged by Spanish art dealer Pedro Mañach, held at Ambroise Vollard's gallery.

Meets poet Max Jacob.

1904
Moves to Paris permanently.

Has affair with artist's model known as Madeleine. Meets Fernande Olivier, also artist's model; they begin affair. (Picasso stays with Olivier until early 1912.)

Meets poet Guillaume Apollinaire.

Begins working with printer Auguste Delâtre.

1905
Makes etching series that will later be published by Vollard as Saltimbanques. (Vollard employs printer Louis Fort.) A Saltimbanque etching becomes frontispiece for collection of poems by friend André Salmon; this is Picasso's first book illustration.

1906
Meets Henri Matisse.

1907
Paints *Les Demoiselles d'Avignon*.

Meets art-dealer Daniel-Henry Kahnweiler; also artist Georges Braque.

Auguste Delâtre dies; Picasso continues to work with son Eugène Delâtre until 1920s.

Acquires small printing press.

1910
Creates Cubist etchings as illustrations for Jacob's *Saint Matorel*, to be published by Kahnweiler in 1911.

1911
Meets Eva Gouel (Marcelle Humbert); they begin affair.

1912
Signs contract with Galerie Kahnweiler.

1913
Vollard publishes Saltimbanques series.

1914
World War I breaks out, August. Braque, Apollinaire, and other friends join military.

1915
Meets poet Jean Cocteau.

Gouel dies in December.

1917
Travels with Cocteau to Rome; meets collaborators for ballet *Parade*.

Meets Ballets Russes dancer Olga Khokhlova.

1918
Marries Khokhlova.

1921
Son Paulo is born.

1924
André Breton publishes first *Surrealist Manifesto*.

1925
Participates in first Surrealist exhibition, Galerie Pierre, Paris.

1927
Meets seventeen-year-old Marie-Thérèse Walter; they begin affair.

1930
Buys château at Boisgeloup, outside Paris.

Creates first etching of one-hundred-print series, made 1930–37, in trade arrangement with Vollard (later known as Vollard Suite).

1931
Illustrated books, *Les métamorphoses* (*Metamorphoses*) by Ovid, and *Le chef-d'œuvre inconnu* (*The Unknown Masterpiece*) by Honoré de Balzac, published by Albert Skira and Vollard respectively. These projects, together with Vollard Suite, mark start of intense involvement with printmaking, which continues for remaining career.

Sets up sculpture studio at Boisgeloup château.

1933
Creates cover design for first issue of periodical *Minotaure*.

1934
Begins working in print shop of Roger Lacourière, who inspires experimentation in intaglio techniques, particularly aquatint.

Sets up printing press, bought from printer Louis Fort after his retirement, in Boisgeloup; later moves it to other residences.

1935
Wife Olga, with son Paulo, leaves Picasso. Walter gives birth to Picasso's daughter Maya.

Despairing over personal circumstances, Picasso gives up painting for period; begins writing poetry in Surrealist mode.

Creates only one print, the etching *Minotauromachy*, widely considered a twentieth-century masterwork.

1936
Meets photographer Dora Maar (winter 1935–36); they begin affair.

Spanish Civil War starts.

1937
Paints *Guernica* in response to bombing of small Spanish town; in conjunction, creates monumental etching *The Weeping Woman*.

1939
Vollard dies as result of car accident.

France and England declare war on Germany.

1940
Germans occupy Paris.

1943
Meets young painter Françoise Gilot; later, they begin affair.

1944
Joins Communist party.

1945
Begins working at Mourlot lithography workshop, Paris.

1946
Gilot moves in with Picasso.

1947
Begins making ceramics at Madoura workshop, in Vallauris, South of France.

Claude, son of Picasso and Gilot, is born.

1949
Paloma, daughter of Picasso and Gilot, is born.

1953
Meets Jacqueline Roque, through Madoura ceramics workshop; they begin affair (he stays with her until his death, in 1973).

1955
Wife Olga (whom Picasso never divorced) dies.

Having already made linoleum-cut posters, Picasso creates *Jacqueline with a Scarf*, first major work in linoleum cut with printer Hidalgo Arnéra. Works intensely in linoleum cut, late 1950s–early 1960s.

1961
Marries Roque.

1963
Brothers Aldo and Piero Crommelynck set up intaglio print workshop for Picasso's convenience near his home in Mougins, in South of France.

1965
Undergoes ulcer surgery at hospital near Paris.

1963
Intensive printmaking with Crommelyncks includes Suite 347, named for number of prints completed between March and October.

1970
Begins print series Suite 156.

1972
Completes Suite 156 (series is published after his death), including last print, known as *Femme au miroir*, on March 25.

1973
Dies April 8, Mougins.

Selected Bibliography

The primary references on Picasso's prints and illustrated books are the catalogues raisonnés cited at the start of the checklist (p. 182).

This selected bibliography does not include titles of individual essays and articles that have been published in books on Picasso's art; only the full book titles are cited here. Please refer to this volume's endnotes (pp. 174–81) for more specifics.

Ashton, Dore. *Picasso on Art: A Selection of Views.* New York: Viking, 1972.

Assouline, Pierre. *An Artful Life: A Biography of D. H. Kahnweiler, 1884–1979.* New York: Grove Weidenfeld, 1990.

Baer, Brigitte. *Picasso: The Engraver, Selections from the Musée Picasso, Paris.* London: Thames and Hudson, 1997.

_____. *Picasso the Printmaker: Graphics from the Marina Picasso Collection.* Dallas: Dallas Museum of Art, 1983.

Baldassari, Anne. *Cubist Picasso.* Paris: Réunion des Musées Nationaux, Flammarion, 2007.

_____. *The Surrealist Picasso.* Paris: Flammarion, 2005.

Benador, Emmanuel. *Picasso, Printmaker: A Perpetual Metamorphosis. The Myra and Sandy Kirschenbaum Collection.* New York: City University of New York, 2008.

Benadretti-Pellard, Sandra. *Picasso à Vallauris: Linogravures.* Paris: Réunion des Musées Nationaux, 2001.

Bernadac, Marie-Laure. *Pablo Picasso: La Minotauromachie, All VIII States.* London: Gagosian Gallery, 2006.

Bernadac, Marie-Laure, et al. *Late Picasso: Paintings, Sculpture, Drawings, Prints 1953–1972.* London: Tate Gallery, 1988.

Bernadac, Marie-Laure, ed., and Christine Piot. *Picasso: Collected Writings.* New York: Abbeville, 1989.

Boggs, Jean Sutherland. *Picasso and Man.* Toronto: Art Gallery of Toronto; Montreal: Museum of Fine Arts, 1964.

Bozal, Valeriano, et al. *Picasso: From Caricature to Metamorphosis of Style.* Hampshire, U.K.: Lund Humphries, 2003.

Brassaï. *Picasso and Company.* Garden City, New York: Doubleday, 1966.

Breunig, L. C., ed. *The Cubist Poets in Paris: An Anthology.* Lincoln: University of Nebraska Press, 1995.

Brown, Jonathan, ed. *Picasso and the Spanish Tradition.* New Haven: Yale University Press, 1996.

Carlson, Victor I. *Picasso: Drawings and Watercolors, 1899–1907.* Baltimore: Baltimore Museum of Art, 1976.

Carmean, Jr., E. A. *Picasso: The Saltimbanques.* Washington, D.C.: National Gallery of Art, 1980.

Castleman, Riva. *A Century of Artists Books.* New York: Museum of Modern Art, 1994.

Caws, Mary Ann. *Dora Maar: With & Without Picasso, A Biography.* London: Thames and Hudson, 2000.

Clair, Jean, ed. *Sous le soleil de Mithra.* Martigny, Switzerland: Fondation Pierre Gianadda, 2001.

Cohen, Janie. *Picasso Rembrandt Picasso: Prints and Drawings by Picasso Inspired by Works of Rembrandt.* Amsterdam: Museum het Rembrandthuis, 1990.

Cohen, Janie, ed. *Picasso: Inside the Image, Prints from the Ludwig Museum, Cologne.* London: Thames and Hudson, 1995.

Combalía, Victoria. *Dora Maar, Fotógrafa.* Valencia: Centre Cultural Bancaixa, 1995.

Cooper, Douglas, and Gary Tinterow. *The Essential Cubism, 1907–1920: Braque, Picasso & Their Friends.* London: Tate Gallery, 1983.

Coppel, Stephen. "The Fauve Woodcut." *Print Quarterly* XVI, no. 1 (March 1999): 3–33.

Cortadella, Margarida, ed. *Picasso: War & Peace.* Barcelona: Museu Picasso, 2004.

Costello, Anita Coles. *Picasso's "Vollard Suite."* New York: Garland, 1979.

Cowling, Elizabeth. *Picasso: Style and Meaning.* London: Phaidon, 2002.

Cowling, Elizabeth, et al. *Matisse Picasso.* London: Tate Publishing; New York: Museum of Modern Art, 2002.

Cowling, Elizabeth, et al. *Picasso: Challenging the Past.* London: National Gallery, 2009.

Cowling, Elizabeth, and Jennifer Mundy. *On Classic Ground: Picasso, Léger, de Chirico and the New Classicism, 1910–1930.* London: Tate Gallery, 1990.

Cox, Neil, and Deborah Povey. *A Picasso Bestiary.* London: Academy, 1995.

Daix, Pierre, and Georges Boudaille. *Picasso: The Blue and Rose Periods. A Catalogue Raisonné of the Paintings, 1900–1906.* Greenwich, Connecticut: New York Graphic Society Ltd., 1967.

Duncan, David Douglas. *Picasso's Picassos.* New York: Harper & Brothers, 1961.

Elliott, Patrick. *Picasso on Paper.* Edinburgh: National Galleries of Scotland, 2007.

Fisher, Susan Greenberg. *Picasso and the Allure of Language.* New Haven: Yale University Press, 2009.

FitzGerald, Michael. *Picasso's Marie-Thérèse.* New York: Acquavella Galleries, 2008.

Florman, Lisa. *Myth and Metamorphosis: Picasso's Classical Prints of the 1930s*. Cambridge, Mass.: MIT, 2000.

Freeman, Judi. *Picasso and the Weeping Women: The Years of Marie-Thérèse Walter & Dora Maar*. Los Angeles: Los Angeles County Museum of Art, 1994.

Fryberger, Betsy G. *Picasso: Graphic Magician, Prints from the Norton Simon Museum*. London: Philip Wilson Publishers, in association with Iris & B. Gerald Cantor Center for Visual Arts at Stanford University, 1998.

Galassi, Susan Grace. *Picasso's Variations on the Masters: Confrontations with the Past*. New York: Abrams, 1996.

Gauss, Ulrike, ed. *Pablo Picasso: Lithographs*. Münster: Hatje Cantz, 2000.

Gavanon, Anne-Françoise. *Picasso's Linocuts: Between Painting and Sculpture?*, M.A. diss. Courtauld Institute of Art, London, 2004.

Gilmour, Pat. "Late Picasso." *Print Quarterly* 14, no. 2 (June 1997): 211–16.

_____. "Picasso & His Printers." *Print Collector's Newsletter* 18, no. 3 (July–August 1987): 81–90.

Gilot, Françoise. *Matisse and Picasso: A Friendship in Art*. New York: Doubleday, 1990.

Gilot, Françoise, and Carlton Lake. *Life with Picasso*. New York: McGraw-Hill, 1964.

Glimcher, Arnold, and Marc Glimcher, eds. *Je Suis le Cahier: The Sketchbooks of Picasso*. Boston: Atlantic Monthly Press; New York: Pace Gallery, 1986.

Goeppert, Sebastian, and Herma C. Goeppert-Frank. *Minotauromachy by Pablo Picasso*. Geneva: Patrick Cramer, 1987.

Holloway, Memory. *Making Time: Picasso's Suite 347*. New York: Peter Lang, 2006.

Horodisch, Abraham. *Picasso as a Book Artist*. Cleveland: World, 1962.

Isselbacher, Audrey. *Iliazd and the Illustrated Book*. New York: Museum of Modern Art, 1987.

Johnson, Una E. *Ambroise Vollard, Editeur: Prints, Books, Bronzes*. New York: Museum of Modern Art, 1977.

Kahnweiler, Daniel-Henry, with Francis Crémieux. *My Galleries and Painters*. New York: Viking, 1971.

Karshan, Donald H. *Picasso Linocuts, 1958–1963*. New York: Tudor, 1968.

Koutsomallis, Kyriakos, Jean Clair, et al. *Picasso and Greece*. New York: Farrar, Straus and Giroux, 1998.

Krauss, Rosalind E. *The Picasso Papers*. New York: Farrar, Straus and Giroux, 1998.

Laniado-Romero, Bernardo, ed. *Picasso: Toros*. Málaga: Musée Picasso, 2005.

Lavin, Irving. "Picasso's Bull(s): Art History in Reverse." *Art in America* 81 (March 1993): 76–93, 121, 123.

Leymarie, Jean. *Picasso: The Artist of the Century*. New York: Viking, 1972.

Lord, James. *Picasso and Dora: A Personal Memoir*. New York: Farrar, Straus and Giroux, 1993.

McCully, Marilyn, ed. *Picasso: The Early Years, 1892–1906*. Washington, D.C.: National Gallery of Art, 1997.

Mössinger, Ingrid, Beate Ritter, and Kerstin Drechsel, eds., *Picasso et les femmes*. Chemnitz: Kunstsammlungen Chemnitz, 2002.

Mourlot, Fernand. *Picasso Lithographs*. Boston: Boston Book and Art, 1970.

Müller, Markus, ed. *Pablo Picasso and Marie-Thérèse Walter: Between Classicism and Surrealism*. Bielefeld: Kerber, 2004.

_____. *Pablo Picasso: Joy of Life*. Berlin: Deutscher Kunstverlag, 2007.

_____. *Pablo Picasso: The Time with Françoise Gilot*. Bielefeld: Kerber, 2002.

_____. *Pablo Picasso und Jacqueline: Vorletzte Gedanken*. Bielefeld: Kerber, 2005.

Ocaña, M. Teresa, and Hans Christoph von Tavel. *Picasso, 1905–1906: From the Rose Period to the Ochres of Gósol*. Barcelona: Electa España, 1992.

Omer, Mordechai. *Picasso and Literature*. Tel Aviv: Genia Schreiber University Art Gallery, Tel Aviv University, 1989.

_____. "Picasso's Horse: Its Iconography." *Print Collector's Newsletter* 2, no. 4 (September–October 1971): 73–77.

Otero, Robert. *Forever Picasso: An Intimate Look at His Last Years*. New York: Abrams, 1974.

Pablo Picasso: L'œuvre gravé, 1899–1972. Paris: Daniel Gervis, 1984.

Parmelin, Hélène. *Picasso: Women, Cannes and Mougins, 1954–63*. London: Weidenfeld and Nicolson, 1965.

Penrose, Roland. *Picasso: His Life and Work*. London: Victor Gollancz, 1958.

Picasso: Suite Vollard und Minotauromachie. Madrid: Sociedad Estatal para Exposiciones Internacionales; Rostock, Germany: Kunsthalle Rostock, 2003.

Rabinow, Rebecca A. *The Legacy of la Rue Férou: Livres d'Artiste Created for Tériade by Rouault, Bonnard, Matisse, Léger, Le Corbusier, Chagall, Giacometti, and Miró*. Ph.D. diss., New York University, Institute of Fine Arts, New York, 1995.

Rabinow, Rebecca A., ed. *Cézanne to Picasso: Ambroise Vollard, Patron of the*

Avant-Garde. New York: Metropolitan Museum of Art; New Haven: Yale University Press, 2006.

Read, Peter. *Picasso & Apollinaire: The Persistence of Memory*. Berkeley: University of California Press, 2008.

Richardson, John, in collaboration with Marilyn McCully. *A Life of Picasso*, vol. I, *The Prodigy, 1881–1906*. New York: Knopf, 2009.

_____. *A Life of Picasso*, vol. II, *The Cubist Rebel, 1907–1916*. New York: Knopf, 2007.

_____. *A Life of Picasso*, vol. III, *The Triumphant Years, 1917–1932*. New York: Knopf, 2007.

Richardson, John, et al. *Picasso: Mosqueteros*. New York: Gagosian Gallery, 2009.

Rodrigo, Luis Carlos. *Picasso in His Posters, Image and Work*, 4 vols. Madrid: Arte Ediciones, 1992.

Rose-de Viejo, Isadora, and Janie Cohen. *Etched on the Memory: The Presence of Rembrandt in the Prints of Goya and Picasso*. Blaricum, Netherlands: V + K; Amsterdam: Rembrandt House Museum; Aldershot, U.K.: Lund Humphries, 2000.

Rothenberg, Jerome, and Pierre Joris, eds. *The Burial of the Count of Orgaz & Other Poems by Pablo Picasso*. Cambridge, Mass.: Exact Change, 2004.

Rubin, William. *Picasso and Braque: Pioneering Cubism*. New York: The Museum of Modern Art, 1989.

_____. *Picasso in the Collection of The Museum of Modern Art*. New York: The Museum of Modern Art, 1972.

Rubin, William, ed. *Picasso and Portraiture: Representation and Transformation*.

New York: The Museum of Modern Art, 1996.

Russell, John. *Pablo Picasso: Gongora*. Trans. by Alan S. Trueblood. New York: Braziller, 1985.

Schiff, Gert. *Picasso: The Last Years, 1963–1973*. New York: Braziller in association with Grey Art Gallery & Study Center, New York University, 1983.

Schwarz, Herbert T. *Picasso and Marie-Thérèse Walter, 1925–1927*. Sillery, Canada: Isabeau, 1988.

Séckel, Hélène. *Max Jacob et Picasso*. Paris: Réunion des Musées Nationaux, 1994.

Spies, Werner, ed. *Picasso: Painting Against Time*. Ostfildern: Hatje Cantz, 2007.

Stein, Donna, ed. *Cubist Prints/Cubist Books*. New York: Franklin Furnace, 1983.

Steinberg, Leo. "Picasso's Sleepwatchers." In *Other Criteria: Confrontations with Twentieth-Century Art*. Chicago: University of Chicago Press, 1972, 92–114.

Stepan, Peter. *Picasso's Collection of African & Oceanic Art*. Munich: Prestel, 2006.

Tériade et les livres de peintres. Le Cateau-Cambrésis, France: Musée Matisse, 2002.

Tinterow, Gary. *Master Drawings by Picasso*. Cambridge, Mass.: Fogg Art Museum, 1981.

Tinterow, Gary, ed. *Picasso classico*. Málaga: Palacio Episcopal, 1992.

Utley, Gertje R. *Picasso: The Communist Years*. New Haven: Yale University Press, 2000.

Varnedoe, Kirk, and Pepe Karmel. *Picasso: Masterworks from The Museum of Modern*

Art. New York: The Museum of Modern Art, 1997.

Wallen, Burr. *Picasso Aquatints*. St. Petersburg, Fla.: Museum of Fine Arts, 1984.

Wallen, Burr, and Donna Stein. *The Cubist Print*. Santa Barbara: University Art Museum, University of California, 1981.

Yoakum, Mel, et al. *Françoise Gilot: Monograph, 1940–2000*. Lausanne: Acatos, c. 2000.

Index